American Politicians

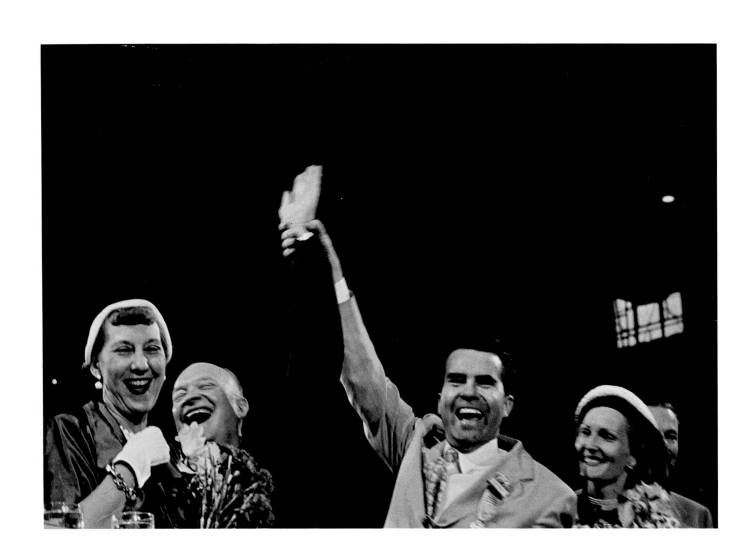

American Politicians

Photographs from 1843 to 1993

Susan Kismaric

The Museum of Modern Art, New York

Distributed by Harry N. Abrams, Inc., New York

Published in conjunction with the exhibition *American Politicians: Photographs from 1843 to 1993* at The Museum of Modern Art, New York, October 6, 1994, to January 3, 1995, organized by Susan Kismaric, Curator, Department of Photography

This exhibition and its accompanying publication are supported in part by a grant from Agnes Gund and Daniel Shapiro.

Produced by the Department of Publications
The Museum of Modern Art, New York
Osa Brown, Director of Publications
Edited by Christopher Lyon
Designed by Jody Hanson
Production by Amanda W. Freymann
Duotone separations by Robert J. Hennessey
Printed by Meridian Printing, East Greenwich, R.I.
Bound by Acme Bookbinding Company, Inc., Charlestown, Mass.

Front cover: Brown Brothers. *Theodore Roosevelt Speaking at Grant's Tomb, Decoration Day.* 1910. Gelatin-silver print, printed later. 14⁹⁄₁₆ x 19¹¹⁄₁₆" (37 x 50 cm). The Museum of Modern Art, New York. Courtesy Brown Brothers

Frontispiece: George Skadding (born 1905; deceased)/*Life* Magazine. *Republican Convention: The Eisenhowers and the Nixons Acknowledge Victory.* July 1952. Gelatin-silver print. 9¼ x 13⁹⁄₁₆" (23.5 x 35.5 cm). Lent by the Time Inc. Picture Collection.

Contents

Foreword

The photographs in this book and the exhibition it accompanies are not intended to illustrate the history of American politics. Rather, they are an attempt to trace how photography has pictured—and helped transform—the American politician. Despite the importance of the subject, it has received relatively little attention. The most useful prior studies in this area are *The Power of Photography* (1991) by Vicki Goldberg and a series of critical articles by Carol Squiers published over the past ten years in such periodicals as *Artforum* and *American Photographer.*

There are millions of photographs of American politicians in government archives, collections of museums and historical societies, files of picture agencies and magazines, newspaper morgues, and the personal records of politicians and the many photographers who have photographed them. The task of assessing this vast body of work, made over a century and a half, is daunting. Nevertheless, I have attempted a general survey, choosing pictures that represent significant stages of photography's history when developments in photographic technology or means of disseminating photographs helped alter the image of the politician. For example, there is an extensive selection of pictures of Theodore Roosevelt because the photographs of him are rich in their representation of how the halftone process affected his political persona. For the most part, I have restricted my subject to elected politicians, but I found that in order to represent certain essential aspects of American political life—for example, the importance of African-American leaders such as Martin Luther King—I needed to include as well photographs of people not elected to political office.

The photographers whose work is included here are American unless otherwise indicated. The captions to the photographs are original and appeared with the pictures when they were published, or released. While they reflect the prejudices and biases of their respective cultural, political, and social eras, they have been included in order to present the photographs as accurately as possible.

On behalf of The Museum of Modern Art and its public, I would like to thank Agnes Gund and Daniel Shapiro for their generous support of this publication and exhibition. I am also especially grateful to the lenders to the exhibition, both public and private—including several that opened their archives and lent original photographs for the first time—and to the photographers themselves. They are acknowledged individually at the end of this volume.

Susan Kismaric

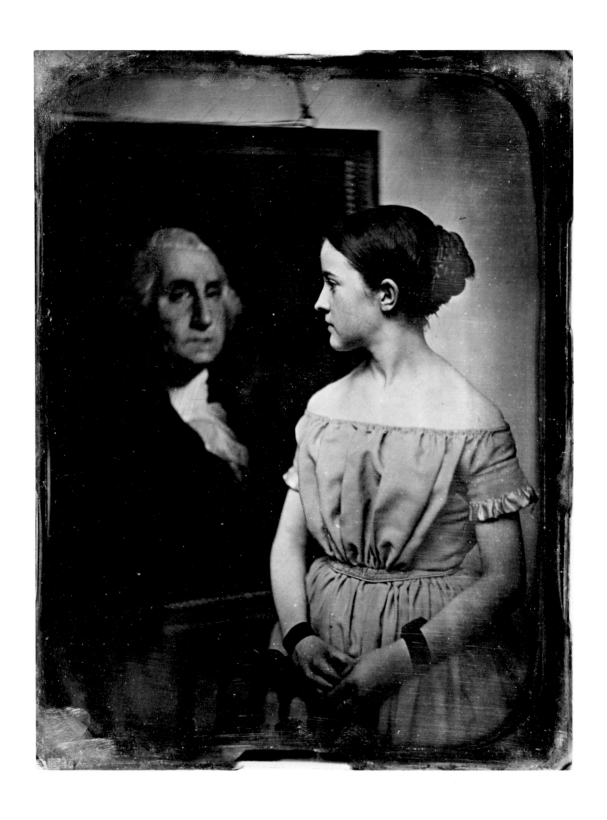

Albert Sands Southworth (1811–1894) and Josiah Johnson Hawes (1808–1908). **Young Girl with Portrait of George Washington**. c. 1850

Whole-plate daguerreotype. 7⁷⁄₈ x 5¹³⁄₁₆" (20 x 14.8 cm). Lent by The Metropolitan Museum of Art, New York. Gift of I. N. Phelps Stokes, Edward S. Hawes, Alice Mary Hawes, and Marion Augusta Hawes, 1937

I

But not alone our near and dear are thus kept with us; the great and the good, the heroes, saints, and sages of all lands and all eras are, by these life-like "presentments," brought within the constant purview of the young, the middle-aged, and the old. The pure, the high, the noble traits beaming from these faces and forms,—who shall measure the greatness of their effect on the impressionable minds of those who catch sight of them at every turn?
—Marcus Aurelius Root, *The Camera and the Pencil*, 1864[1]

In a daguerreotype of about 1850 by the Boston firm of Southworth and Hawes, an unidentified girl seen in profile gazes at George Washington, who is pictured in a background painting that is a copy of the famous "Athenaeum" portrait by Gilbert Stuart. The use of paintings as backgrounds was not unusual in daguerreotypes, but the juxtaposition of the young woman in profile—giving her an anonymous aspect—with the portrait of Washington—who gazes directly at us—suggests a gentle study of filial devotion to the first president of the United States. This photograph quietly symbolizes the link between the American people and the image of the politician, a symbiotic relationship that was already well established before photography was invented in the 1830s.

Today we justifiably regard the politician's image, and politicians themselves, skeptically, if not cynically; our view of those who shape and purvey that image is scarcely better. (In a recent poll, respondents ungenerously considered being a congressman the most despicable profession; journalism was the second most despised.[2]) Our natural suspicions about politicians have been reinforced over the past several decades by the many books and articles about political campaigns and the precisely controlled images of politicians. We have become painfully aware of our vulnerability to manipu-

lation by political leaders and their teams of sophisticated image handlers. Terms like "sound bite" and "photo opportunity" are part of our vocabulary, and we tend to believe that we are, if not the first victims of image-making in our culture, the most seriously wounded.

Of course, control of the politician's image is as old as politics itself. In William Henry Harrison's presidential campaign of 1840, at about the time photography was introduced in the United States, the candidate's image was shaped to an unprecedented extent; this broadly experienced public servant and military man—the son of a prominent Virginia politician—became the "log cabin and hard cider" candidate of the Whig party. Harrison was presented as a kind of backwoodsman and farmer in political songs and lithographs, and even through the generous distribution of miniature log cabins and jugs of hard cider. It is no surprise, then, that since its inception, the photographic image of the politician has been subjected to manipulation and exploitation. During the past 150 years there has, however, been an extraordinary transformation of the means by which this image is created and controlled. Though photographic technology has inexorably advanced, developments like motor-driven film advance and the telephoto lens encourage the making of pictures that are less carefully considered than those made with the relatively unsophisticated technology of photography's early decades. At the same time, the means of manipulating the politician's image grow ever more refined. As a result, the image of the politician no longer resonates as it once did. Photographs of those who lead our country have become superficial, even banal: they don't inspire or provoke us, and they don't describe with vitality our political leaders in action. Nevertheless, despite the reservations we may have about the pictures' veracity, photographs remain fundamental to our political choices.

★

In a continent-sized democracy, the use of the photographic image to represent the politician was inevitable. Louis Daguerre's formula for making photographs was brought to the United States from Paris in early 1839 by Samuel F. B. Morse. In a depressed American economy, the affordable and relatively lucrative new profession of photographer was quickly established, and the desire for precise and lasting images of those around us rapidly made portraits the most popular subject of the new medium. By 1840 A. S. Wolcott and John Johnson had opened the first of the many portrait galleries in New York to which the political and social elite came to be photographed.

Early photographs of American politicians had little influence on political life. Copies could not be produced conveniently, and while a daguerreotype could be daguerreotyped, extensive dissemination of the image was impossible unless someone painstakingly translated it into an engraving, a lithograph, or a woodcut for publication. Many daguerreotypes were published in these mediums, even though their processes compromised fidelity

to the photograph. It was only after the invention of subsequent photographic processes that multiple copies of a daguerreotype could be made easily. Also, unlike the later paper photographs, daguerreotypes are images on metal, unsuitable for mounting in albums. Even now, daguerreotypes are rarely reproduced except in photographic and historical journals for the specialist. Nevertheless, like Gilbert Stuart's painting of Washington, early daguerreotype portraits are indelible images, which, coupled with written history, help us to grasp something of the personalities of their subjects and to imagine or invent the characters of them.

Among the earliest known photographs of American presidents are the daguerreotypes of John Quincy Adams, Andrew Jackson, Martin Van Buren, William Henry Harrison, John Tyler, James Knox Polk, Zachary Taylor, Millard Fillmore, Franklin Pierce, and James Buchanan. Of this group, only Tyler, Polk, Taylor, Fillmore, and Pierce were photographed during their terms in office. It is sometimes difficult to date these daguerreotypes and to distinguish between the work of one photographer and another in this period. It was common in the nineteenth century for photographers and commercial photographic studios to trade or sell pictures for copying purposes, and to refashion photographs by painting or drawing on them. The style of portrait photographs, in particular, quickly became standardized, adding to the difficulty of dating and assigning authorship to them. The daguerreotype of John Quincy Adams reproduced on page 53, apparently made near the time of his death in 1848, was thought to be by Albert Sands Southworth and Josiah Hawes because it was included in a gift to The Metropolitan Museum of Art, New York, of daguerreotypes by them. The silver-coated plate of the daguerreotype bears in its upper right corner the hallmark of its manufacturer, J. M. L. and W. H. Scovill, of Waterbury, Connecticut. This helped to establish its date: the pioneering historian of photography Beaumont Newhall learned that this firm, one of the leading makers of daguerreotype materials, started in 1842 but changed its name to Scovill Manufacturing Company eight years later, making it likely that the picture dates from before 1850. Newhall discovered that the daguerreotype is actually by Philip Haas, of Washington, D.C., when he happened to obtain a daguerreotype by Haas of John Ridgeway, who represented Ohio in Congress from 1837 to 1843, and realized that the setting of the Ridgeway portrait was the same as that of the Adams one.[3]

Another rare and exceptionally beautiful early daguerreotype is that of Harriet Beecher Stowe, reproduced on page 12. It shows Stowe as a young woman, her great book yet to be written, seeming as fragile and tentative as the plant beside her on the table. Stowe of course went on to exert extraordinary influence over how Americans regarded the policies of their government. In the 1850s, having seen slavery in Kentucky and helped fugitive slaves in Ohio, she published her novel *Uncle Tom's Cabin; or, Life among the Lowly*, first as a serial in an abolitionist newspaper, the *National Era*, and then as a book, which eventually became a phenomenal success: in one year,

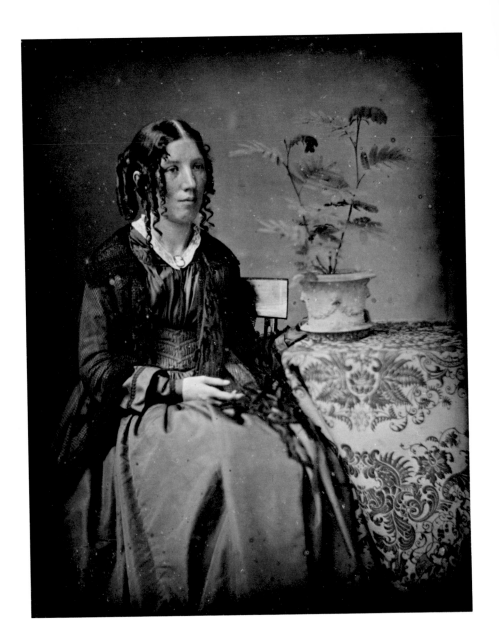

more than three hundred thousand copies were sold. When Abraham Lincoln greeted Stowe at the White House in 1862, he said, "So this is the little lady who wrote the book that made the big war."[4]

★

The daguerreotype, which reigned for close to twenty years, was superseded by the collodion negative and albumen print. In 1850 and 1851 the English sculptor Frederick Scott Archer published a method of making negatives on glass by exposing glass plates coated with collodion (a viscous solution of nitrocellulose in alcohol and ether that quickly dries to form a tough, water-proof film) as a binder for light-sensitive silver salts. It was called the wet-plate system, since it required that the glass plate be coated, sensitized,

exposed, and processed before the colloid began to dry. The collodion negative was soon used to make prints on paper sensitized with either salt or ammonium chloride in an egg-white binder. The resulting albumen print, which has the clarity of the daguerreotype, was the basis for three popular formats: the carte-de-visite, the cabinet card, and the stereograph. Together, these methods of exposing and printing a picture advanced the use of photography for political purposes by making it easier and cheaper. An unlimited number of paper prints could be reproduced from a glass negative, allowing photographers to reach a wide audience. However, the wet-plate process remained cumbersome: because the plate had to be prepared and developed in relative darkness, the photographer had to carry with him a darkroom if he wished to make a picture away from his studio. This limited the circumstances in which a politician could be photographed.

The carte-de-visite was patented in France in 1854 by André-Adolphe-Eugène Disdéri.[5] Its name refers to the common calling card, but instead of the caller's name, the carte bore the caller's image. Cartes became popular in 1859 when Napoléon III stopped in Disdéri's Paris studio to have his portrait taken while en route to Italy with his troops. Disdéri seized the opportunity to make a handsome profit and sold thousands of photographs of the emperor in the carte format, creating an overnight fad. The image size was usually 2⅛ by 3½ inches, and the card on which the photograph was mounted was approximately 2½ by 4 inches. Though easy to handle and carry about, cartes were not used as calling cards in the United States. Instead, they were collected and arranged in albums, becoming a kind of home entertainment for family and friends. The subjects of cartes eventually expanded to include celebrities, political personalities, architecture, paintings, and distant lands and peoples. The larger and grander albumen and salted-paper prints were too expensive for most Americans, but they could afford the mass-produced cartes, which cost $2.00 to $3.00 a dozen, with some photographers charging as little as $1.50; the average price was less than twenty cents per carte. Sold from photographers' studios, bookstores, and magazine shops, cartes provided the political personality with his first good opportunity to connect his image with his political platform.

Cartes were made with a wet-plate negative that had been exposed in a special camera with four lenses and a sliding plate holder. Four exposures were made on each half of the plate, and eight exposures were captured on one negative. A single print from the negative could be cut up into eight separate portraits. The use of unskilled labor to print and mount the pictures made possible tremendous savings in production costs. The prints were widely disseminated: according to Newhall, a thousand prints a day were sold of an image of Major Robert Anderson, the hero of Fort Sumter. Page 70 shows a sheet of small photographs of Ulysses S. Grant, illustrating how the carte pictures looked before they were cut up into individual photographs and mounted.

Technology and the pictorial conventions of portrait painting both

influenced the depiction of nineteenth-century American politicians. Because of long exposures—anywhere from five minutes to over an hour for a daguerreotype, depending on the available light, and from a few to thirty seconds for photographs created with the wet-plate process—sitters had to remain perfectly still, which made them appear composed or aloof. Details in the studio setting were standard props—a fluted column, a book, a table—intended to lend dignity to the sitter. Images of political figures conveyed little psychological insight. Nothing inherent in these photographs identified the sitters as leaders, but the air of dignity and reserve lent by the cumbersome and slow photographic processes could imply qualities of leadership, and many a scurrilous and ill-behaved politician was made to appear statesmanly and honorable. Moreover, in an era when social mores were such that no respectable man would be seen out of doors without a hat, it would never have occurred to a photographer to compromise his subject by allowing a picture to convey a derogatory undercurrent that might suggest the photographer's personal opinion of the sitter.

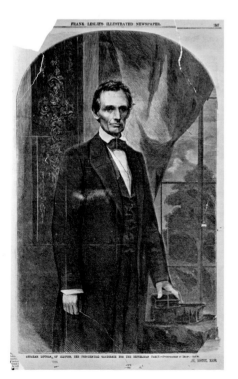

★

It was during Abraham Lincoln's presidential campaign of 1860 that photographs began to exert a far-reaching effect on the careers of political personalities. The story of photography and Lincoln is very rich because of our nation's deep affection for and admiration of Lincoln, his distinguished and somewhat strange physical appearance, and photography's ability to describe that charismatic countenance.[6] The story foretells aspects of contemporary political photography—including the photo opportunity, the physical manipulation of imagery, and the use of an image to sell a candidate.

It is thought that there are 136 photographs of Lincoln, the earliest a daguerreotype portrait in the collection of the Library of Congress.[7] Apparently made in 1846 by H. H. Shepherd of Springfield, Illinois, it is a companion to a daguerreotype of Lincoln's wife, Mary Todd Lincoln. The last portrait of Lincoln, made between early February and mid-April 1865, several weeks before he was assassinated, is probably by Alexander Gardner. He made about 30 photographs of Lincoln, more than any other photographer, which include the four cartes-de-visite seen on page 64, taken at a single sitting and published by the Anthony studio of New York. This gathering is unusual because it is difficult to locate photographs made at one sitting after they have been published and distributed. The reverse of each carte bears the name of the Anthony studio as publisher and indicates that the cartes were made from a photographic negative supplied by Brady's National Portrait Studio (where Gardner worked). The original negatives, according to James Mellon, were made as stereographs (discussed on p. 21), on or about February 24, 1861. The difference between poses is minimal—Lincoln's top hat appears in one, in another it does not—but the pictures still differ from each other and are thus individually salable. Another curious example of the uses

to which the carte-de-visite was put shows Lincoln and his son Tad (Thomas) (p. 15). The photograph is believed to have been part of a multiple-image stereographic plate made by Anthony Berger at Brady's gallery in Washington on February 9, 1864. An enterprising clothier has incorporated the portrait into an advertisement for his firm, exploiting both the powerful position of the president and popular affection for the man and his son.

The most significant photograph of Lincoln's political life was made by Mathew Brady in his New York studio at the corner of Broadway and Bleecker Street on the morning of February 27, 1860 (p. 14, *above*). On that day, just a few hours before Lincoln delivered his famous "right makes might" speech at the Cooper Institute, the fifty-one-year-old Lincoln posed for Brady for the first time. He is seen in a standard setting for such portraits, his hand resting on a book, indicating he is an educated man. In preparing his subject for the "shoot," Brady modified Lincoln's gangling appearance by pulling up the candidate's collar to make his neck look shorter; he also retouched the photograph to remove the harsh lines in Lincoln's face. The photograph was reproduced as a line engraving in *Frank Leslie's Illustrated Newspaper* (p. 14, *below*) and *Harper's Weekly*[8] several weeks after the speech at Cooper. It was also used on campaign posters and buttons and was published as many thousands of cartes-de-visite, reaching the hands of numerous Americans. Lincoln himself attributed his election as president to his Cooper speech and the portrait by Brady. For the first time, citizens had more than the name of a person running for president. They knew what he looked like, which made him more real to them. Lincoln understood the value and meaning of a photograph: to an artist who had not met him and who may have requested that he sit for a portrait, he wrote some years later: "The next best thing . . . would be to carefully study a photograph."

Mathew Brady had begun his photographic career as a manufacturer of cases for daguerreotypes. He opened his own studio in New York in 1844 and quickly became the preeminent portrait photographer in America. Within a year, he realized that the best way to achieve financial success was for him and his roster of more than a dozen "cameramen," eventually including Silas Holmes, William Braithwaite, and Gardner, to photograph famous people, whose portraits would serve as advertisements for the studio's work. In addition to making photographs, running the gallery, and supervising his cameramen, Brady oversaw the style of each photograph and was responsible for advertising and promotion. His first major project was *A Gallery of Illustrious Americans*, a collection of lithographs by Francis D'Avignon based on Brady daguerreotypes of the most famous Americans of the day, among them Henry Clay, Andrew Jackson, and Zachary Taylor. Over the years, Brady moved his studio to several different locations in New York and, after an unsuccessful try in 1850, opened in 1858 a branch run by Gardner in Washington, D.C., where politicians were most readily accessible.

★

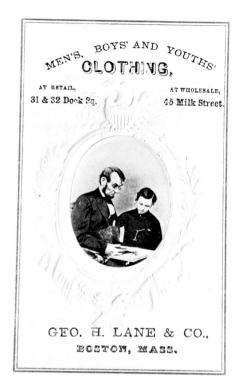

Anthony Berger/Studio of Mathew B. Brady (active 1844–1883). **Abraham Lincoln and His Son, Tad.** February 9, 1864

Albumen-silver print on trade card for Geo. H. Lane & Co., Boston. 1½ x 1⅛" (3.8 x 2.9 cm) oval print on 4 x 2½" (10.2 x 6.4 cm) embossed mount. Society for the Preservation of New England Antiquities, Boston. Gift of L. G. Chace, 1931

Opposite, above: Studio of Mathew B. Brady (active 1844–1883). **Abraham Lincoln.** 1860

Albumen-silver print (carte-de-visite), published by E. Anthony, New York. 3¼ x 2⅛" (8.3 x 5.4 cm). Society for the Preservation of New England Antiquities, Boston. Bequest of Dorothy S. F. M. Codman, 1969; from an album in the Codman Family Manuscripts Collection

Opposite, below: Studio of Mathew B. Brady (active 1844–1883). **Abraham Lincoln, of Illinois, the Presidential Candidate for the Republican Party.** 1860

Wood engraving from *Frank Leslie's Illustrated Newspaper*, October 20, 1860. 14 x 9" (35.6 x 22.9 cm). Central Research Division, The New York Public Library, Astor, Lenox and Tilden Foundations

From a very early point, photographs of American politicians were manipulated, either in response to events or in attempts to shape them. The smaller of the photographs reproduced on page 66 shows an original carte-de-visite of John Cabell Breckinridge, vice president under James Buchanan. Beside it is Breckinridge in the uniform of a brigadier general of the Confederate army. The painting of the uniform on the larger albumen print is obvious and somewhat clumsy, but if it were rephotographed and printed in a smaller size, perhaps as a new carte-de-visite, the deception would be less apparent. The handiwork was undoubtedly done to exploit the commercial value of a picture of Breckinridge in uniform. Most likely, the original portrait was made during his vice presidency (1856–60), and the uniform was painted on after his appointment as a general in 1861.

While the vast majority of cartes-de-visite were portraits, cartes were also made of political cartoons and drawings. The undated composite of albumen prints reproduced on page 72, titled "Radical Members of the South Carolina Legislature," was fabricated by James G. Gibbes, of Columbia, South Carolina, to attack that state's boundlessly corrupt government during the Reconstruction era. In 1868 Gibbes, a former Confederate colonel, set about making a permanent photographic record of the legislative body. He gathered the individual portraits, using a picture of one member to lure another, until he had the complete roster. He then arranged a "lay-out" and had it rephotographed. The inscription beneath the picture makes clear his racist bias. Reproduced as a carte-de-visite, the composite picture was used by Benjamin R. Tillman, a United States Senator from 1894 to 1918, at the state constitutional convention of 1895, which adopted clauses for a new constitution that drastically restricted the suffrage of African Americans in South Carolina. The image was also used as an illustration in several books about Reconstruction, including Henry T. Thompson's *Ousting the Carpetbagger from South Carolina,* published in 1926.

The carte-de-visite gave way in popularity to the cabinet card, a larger photograph (approximately 5½ by 4 inches) that was mounted on a 6½-by-4½-inch card. Like cartes-de-visite, cabinet cards were collected in elaborately bound albums, which were introduced in 1860. Because cabinet card portraits are about three times the size of carte-de-visite portraits, greater facial detail of a sitter is possible. See for example the photograph (p. 76), by the Falk Studio in New York, of Belva Lockwood—the first woman to practice law before the U.S. Supreme Court and the second one to run for president (as the candidate of the Equal Rights party in 1884 and 1888).

Like carte portraits, cabinet card images are rather straightforward and plain, and provide little psychological insight into their subjects. The four cabinet cards of President James Garfield by Napoleon Sarony of New York (p. 73) are an exception. Sarony, whose specialty was the theatrical portrait, thoughtfully posed his sitters and lighted his pictures to bring out dramatic possibilities. These pictures of Garfield bring to mind a passage in "Photography and Electoral Appeal," an essay by the French critic Roland

Barthes, who wrote about the way photographs convey political and social messages through conventionalized signs: "The iconography is meant to signify the exceptional conjunction of thought and will, reflection and action: the slightly narrowed eyes allow a sharp look to filter through, which seems to find its strength in a beautiful inner dream without however ceasing to alight on real obstacles, as if the ideal candidate had in this case magnificently to unite social idealism with bourgeois empiricism."[9]

It was not until the 1870s that it became possible for photographers to depict their subjects as they moved through the world and to respond to them more spontaneously. The wet-plate process had required the photographer to coat a glass plate (negative) with a light-sensitive emulsion, and although B. J. Sayce and W. B. Bolton had invented in 1864 plates that could be used dry, the time needed to expose them averaged three times that of wet plates. In 1871 the British physician Richard Leach Maddox substituted gelatin for the collodion, so that a photograph could be made at snapshot speed (approximately a twenty-fourth of a second). Dry plates could be manufactured, so the photographer no longer had to prepare his own. The speed of the new plates not only freed the photographer from the awkward and restricting procedures required to use wet plates, but made the tripod dispensable in many situations; the camera now could be held in the hand. With dry plates, the politician could be photographed more easily and in a variety of settings, especially outdoors among the people—giving speeches, of course, but also holding and kissing small children, wearing the costumes or sampling the foods of ethnic voters, and reviewing parades; in short, practicing the rituals that every politician went through to convince constituents that he was one of them and represented their interests.

George Eastman improved on the dry-plate process by making the negative material flexible, so that it could be rolled past the focal plane of the camera. By 1884 he had produced a paper film coated with sensitized gelatin, called stripping film; after exposure and processing, the gelatin emulsion was soaked free of the paper and mounted on a glass plate. In 1888 he introduced the Kodak Camera, which came loaded with enough film to make a hundred exposures. After the film was exposed, the entire camera was returned to the Kodak factory, where the film was developed and printed. The resulting photographs and the camera, loaded with fresh film, were then returned to the owner. The Kodak Camera was used mostly by amateurs. For the first time, a politician could be photographed by the very people he represented. His picture was pasted into family albums alongside snapshots of family celebrations. The politician now had to reckon further with his public image and adjust himself to a new level of scrutiny.

The development of this more flexible photographic technology helped to reinforce the politician's association with popular values, a connection that is apparent from the medium's outset and one that continues to some extent to this day. Such values, which may or may not reflect a politician's actual inclinations, are reflected in photographs (excluding formal portraits)

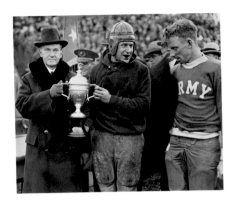

Times Wide World Photos. **The Final Act of the Game.** 1923–29

"President Coolidge presents his cup to Duncan, captain of the Marine Corps eleven, after his team had beat the Army 14-0." Gelatin-silver print. 7⅝ x 9⅜" (19.4 x 23.8 cm). The New York Times

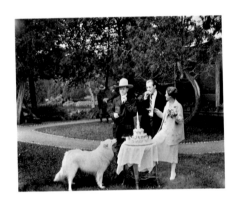

Times Wide World Photos. **Even Rob Roy Wants His Share of President's Birthday Cake.** July 5, 1928

"Brule, Wisc. . . . Photo shows President Calvin Coolidge, John Coolidge, and Mrs. Coolidge, partaking of the splendid birthday cake which a neighbor of the presidential party baked in honor of Mr. Coolidge's 56th birthday which was celebrated yesterday. Even Rob Roy, the favorite dog of the White House is shown waiting for his share of the appetizing looking cake." Gelatin-silver print. 7½ x 9⁹⁄₁₆" (19 x 24.3 cm). The New York Times

of American politicians with their families (pp. 15; 67, *center*; 71; 96; 111–13; 139; and 192), involved in sports (pp. 18, *above*; 105; and 109), engaged in leisure activities (pp. 24 and 41), displaying affection to a family pet (p. 18, *below*), and showing an appreciation of nature (pp. 90, 91, and 147). Theodore Roosevelt, an avid outdoorsman, was often photographed wearing buckskins and camping clothes at natural sites like Yellowstone National Park and Jacob's Ladder, in the Grand Canyon (p. 91). Calvin Coolidge, who was no outdoorsman, also put in an appearance at Yellowstone (p. 90).

Popular values intersect with patriotism to create a folksy mélange: the candidate or officeholder is seen in the obligatory mise-en-scène rife with the symbols of American culture—eating hot dogs, with or near an American flag, greeting Native Americans. Given the number of photographs of American politicians wearing a headdress or smoking a peace pipe, one would think that the Native American population was substantial enough to swing an election (see pp. 104; 109, *below*; 119, *below*; and 188). These symbols are, of course, meant to reinforce our sense that the person pictured is "one of us," a regular fellow who believes in the things we believe in (whether we are Polish or Irish), in addition to being a patriot whose civic duty calls him from on high. These political clichés, which remain in use despite our visual sophistication and political savvy (p. 188), came to determine how our leaders are pictured; photographers' use of them unintentionally helped to undermine formerly respectful attitudes toward the men and women who lead us. The dignity and nobility, the qualities of character implied in the nineteenth-century portrait, which set the politician somewhat apart from and above his constituents, were replaced in photographs by seemingly more accessible values, ones that the majority of voters could (and, it was thought, *should*) identify with, such as dedication to hard work and love of family. When the politician participated in the customs and rituals of one after another ethnic group, class, or stratum of American society, he supposedly demonstrated his abilities as a leader of all Americans. At the least, a photograph of a politician engaged in such an activity demonstrated his willingness to endorse a simplified idea of American democracy—that we are all one indivisible group—an idea which, though naive, is dear to us.

It was by abstracting such values that photographic images themselves came to be political symbols. The still life of political campaign posters and paraphernalia reproduced on page 102 is one of adoring patriotism. It was the custom of nineteenth-century lithographers and engravers to associate the politician with higher ideals by aligning him with his successful predecessors.[10] In this still life, "our governor" (unidentified) is set at the top of a pyramid whose base is created by pictures of Lincoln and Washington, among others. Behind the pyramid is the Stars and Stripes, and at the top of the picture dangles an array of heavenly crepe paper stars.

Patriotic delirium is reached in a wonderfully bizarre photograph of 21,000 soldiers forming the head of Woodrow Wilson, made by the Chicago firm of Mole and Thomas (p. 103). Arthur Mole, a member of the religious

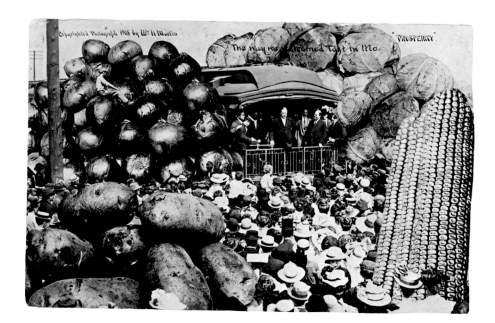

William H. Martin. **"Prosperity": The Way We Welcomed Taft in Mo.** c. 1908

Gelatin-silver print of a rephotographed collage (postcard). 3⅜ x 5⅜" (8.7 x 13.7 cm). Collection Harvey Tulcensky

community of Zion City, Illinois, with the help of church choir director John Thomas, had photographed hundreds of his fellow church members in formations of religious motifs. When America entered World War I, Mole and Thomas were asked to photograph troops at the Great Lakes Naval Training Station. Mole made photographs like *The Living American Flag*, with 10,000 saluting sailors, by positioning his camera on a roof or specially constructed tower. He had drawn the desired formation on his camera's ground glass, so he merely had to shout instructions through a megaphone and use signal flags to direct Thomas and his assistants to form the flag's shape on the ground, in perspective.

★

Tens of thousands of photographs of politicians (among countless other subjects) have been generated since the middle of the last century, and a great many of them have been collected by stock picture agencies, whose business it is to rent images for use in everything from newspapers to annual reports. Each agency owns millions of copies of original photographs of famous people, cultural artifacts, and important news events, as well as photographs of woodcuts, etchings, lithographs, and paintings of such subjects. While thousands of these photographs are found, carefully organized, in agency drawers, it is important to keep in mind that the photographs have, in effect, been edited by the individuals who formed the collections. Moreover, they undergo constant daily editing: photographs that are not requested are "retired," and those that become perennial best-sellers are sent out more and more. Often part or all of an institutional collection of photographs, such as that of the Library of Congress, will be on file in an agency, making available to today's mass media Brady's photographs of Lincoln, for example, or

the Wide World photograph of Democratic presidential nominee Adlai Stevenson on the campaign trail in 1952, revealing a hole in the sole of his shoe (p. 148). There are dozens of stock picture agencies across the United States, each supplying illustrations of historical figures and events to newspapers, magazines, and publishing houses on a daily basis. It is scarcely possible to overestimate the influence of the endlessly repeated stream of pictures of presidents and other political leaders that feeds this river of images. Our ideas about who these people are or were, and the legacy of their actions, are formed to a great extent by such pictures.

The first stock agency in the United States was Underwood and Underwood, founded in the 1880s by the brothers Bert and Elmer Underwood. They were midwestern photographers who realized early on the commercial value of the stereograph as a kind of home entertainment. (A stereograph consists of two photographs of the same subject, photographed from the same vantage point with a camera that has two lenses three inches apart. When viewed using a stereoscope, the stereograph produces a remarkable three-dimensional illusion.) By 1890 the Underwoods and their studio of photographers were producing some twenty thousand stereo views a day. Important people—including political candidates on the stump—news events, natural wonders, and "ethnic types" were all subjects in demand. The Keystone stereograph of President Harding on page 22 (*below*) shows him among the farmers of Hutchinson, Kansas, and their children as he gladly submits to the endlessly photographed ritual of holding babies. Today, the stereo cards of Underwood and Underwood, the Keystone View Company, Langenheim of Philadelphia, Anthony of New York, and hundreds of other photographers and publishers are in stock picture agencies, catalogued and readily available.

The Bettmann Archive, one of the largest stock picture agencies, was founded by Otto Bettmann, who, as a young man, began photographing illustrated books, etchings, and other works of art in libraries and collections in the major cities of Europe. After his arrival in the United States in 1935, he enterprisingly began selling his personal file of pictures to advertising agencies, publishers, and eventually magazines. Bettmann believed that the "country has an appetite for taking in news via the visual media."[11] Over time, the Bettmann Archive, which contains between ten and twenty million images, acquired the picture collections of Underwood and Underwood, United Press International, the New York *Daily Mirror*, International News Photos, Acme News Photos, Reuters, and the British Broadcasting Company.

★

With the perfection of the halftone process by the turn of the century, the technology for reproducing photographs in the mass media was in place. The halftone process creates the illusion of a continuous range of gray tones by modulating the size and distribution of black dots of ink on paper. The process of using a halftone screen to translate a photographic image into dots

had been perfected for relief printing in the 1880s, and by 1890, a monochrome picture, whether in halftone or black on white, could be reproduced in large editions at a low cost. Soon, newspapers and magazines, political brochures, posters, and handbills—all lavishly illustrated with halftone images— destroyed the market for cartes-de-visite, cabinet cards, and stereographs.

Just as Lincoln benefited as a politician from the widespread dissemination of his portraits through cartes-de-visite, Theodore Roosevelt profited from the fact that his career coincided with the introduction of the photographic reproduction of halftone images in magazines and newspapers. Following a term in the New York state legislature in the early 1880s and a failed mayoral campaign in New York City in 1886, Roosevelt became highly visible in a variety of positions to which he was appointed. After preparing the Navy for war with Spain as assistant secretary of the Navy, he formed the "Rough Riders," a regiment of volunteers, to participate in that war. He became a hero when he led the charge up San Juan Hill in Cuba, opening the way for the surrender of Santiago. He then rose rapidly through elective offices as governor of New York, vice president of the United States, and finally president, after succeeding the assassinated McKinley in 1901. He was elected president in 1904.

A picture of Roosevelt reproduced on page 94 provides a fine example of how his image was projected. He is seen at the Panama Canal, one of the great successes of his presidency. The inevitable photograph, showing him dressed in a white suit, confidently operating a steam shovel, was released as both an 8-by-10–inch print and as a stereograph. Such photographs reveal how thoroughly Roosevelt appreciated the opportunity to be photographed, and how photographs became integral to the creation of his political persona. He wore a somewhat theatrical cowboy uniform as a Rough Rider (p. 95), and he always cut an outstanding figure in the halls of government, with his wire glasses dangling on a silk cord. Roosevelt was the first president to give Washington correspondents a press room in the White House, he had telephones installed to help them get the news out more quickly, and he held occasional news conferences in the Oval Office. He frequently leaked items to his favorite reporters, and he was the first president to provide a campaign press schedule.

A politician during Roosevelt's era gave speeches without a microphone. He had to project his voice and gesticulate with force and drama if he wanted to hold the attention of his audience for very long (see pp. 22, *above*; 23; and 92). Photographs of Roosevelt show him using his entire body to get his message across; clearly, he was a master at playing to the cameras. Even in formal portraits (pp. 95–97), he met the camera like a "bull moose," the symbol of his independent political party—fearless and aggressive, asserting a persuasive persona of leadership.

The power of Roosevelt's captivating photographic presence was conveyed to the public in illustrations that appeared in books and periodicals. During 1895 and 1896, as president of the Board of Police Commissioners for

the City of New York, Roosevelt had befriended Jacob Riis, the newspaper reporter and photographer whose 1890 book, *How the Other Half Lives*, with halftones and line engravings made from his startling photographs of slum life, had awakened Roosevelt to New York City's tenement problem. Riis wrote a 1903 biography of Roosevelt, *Theodore Roosevelt, the Citizen*, illustrated with photographs by noted New York portrait studio photographers Arthur Hewitt, the Pach Brothers, and others. A sophisticated and imaginative early example of a magazine layout with halftone images, from *Harper's Weekly*, shows Governor Roosevelt campaigning in Indianapolis (p. 23); its graphic design focuses attention on the confident candidate in a forceful, dynamic way. One image shows a large crowd listening to Roosevelt speak, while others picture the candidate with attentive members of the crowd, with local politicians, and speaking and shaking hands.

Fiorello La Guardia, the mayor of New York from 1934 to 1945, was another master at projecting a political persona. In newspaper pictures, La Guardia is shown as the consummate politician, ever ready to enter the fray—fight fires (p. 125), burn books, smash slot machines, hold babies (p. 124), drive subway cars, cut ribbons (p. 123, *below*), lay cornerstones

Underwood and Underwood. **President Roosevelt Speaking at Grand Island, Nebraska**. 1903

Albumen-silver print (stereograph). 3³⁄₁₆ x 6³⁄₁₆" (8.1 x 15.7 cm). Prints and Photographs Division, The Library of Congress, Washington, D.C.

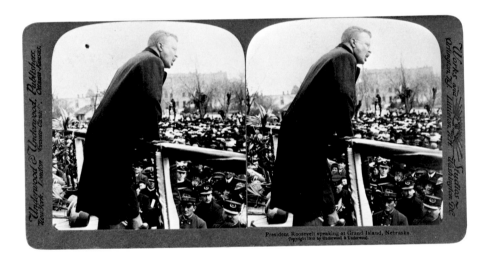

Keystone View Company. **Pres. Harding Holds the Baby and Talks to the Farmers, Hutchinson, Kans**. 1923

Gelatin-silver print (stereograph). 3¹⁄₁₆ x 6" (7.8 x 15.3 cm). Prints and Photographs Division, The Library of Congress, Washington, D.C.

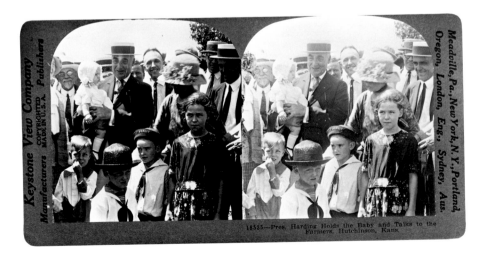

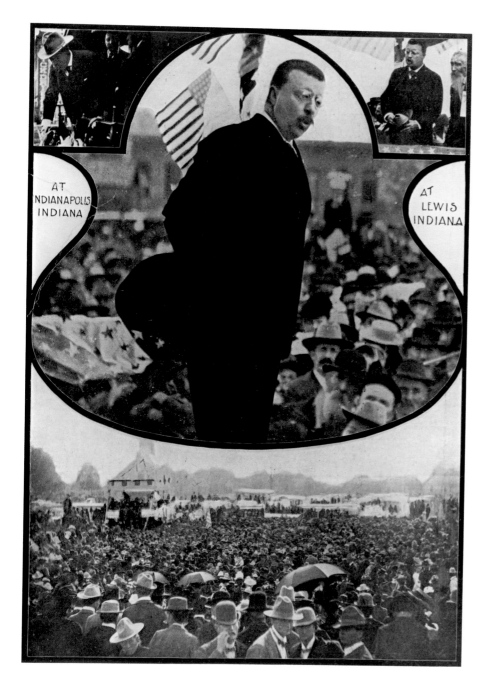

Photographer unknown. **Governor Roosevelt On the Stump**. 1900

Rotogravure published in *Harper's Weekly*, October 27, 1900. 9 x 6⁷⁄₁₆" (22.9 x 16.4 cm). Collection of The New-York Historical Society

(p. 123, *above*)—and generally to be available to entertain, greet, and, above all, be photographed with a great variety of famous and not-so-famous people. What comes through in these pictures of the city's beloved mayor is La Guardia's love of being a politician. One photograph, reproduced on page 121, was taken by the newspaper photographer Arthur Fellig (Weegee), famous as a chronicler of New York City and for getting a picture of the scene of a crime moments after it occurred.

Just as a politician could transform his image through canny manipulation of his appearance in a photograph, a photographer could transfigure a

United Press International/Bettmann. **Mayor La Guardia Reading the Comics.** 1945

"Reading the comics over New York's municipal radio station during newspaper strike in 1945, La Guardia provides some of the best mugging ever recorded by a candid camera. He was much funnier than the cartoons." Four gelatin-silver prints mounted together. Overall 7½ x 9¹⁄₁₆" (19.1 x 23.1 cm). Lent by the Time Inc. Picture Collection

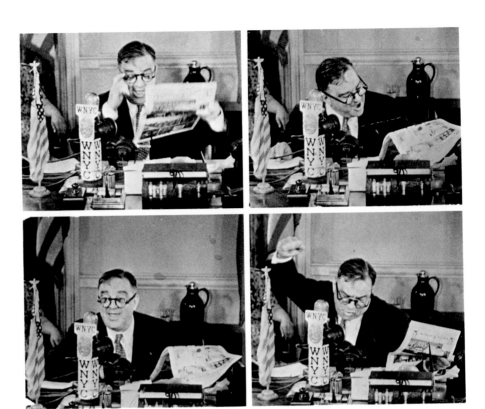

politician merely by being present at an event. In 1910, New York *World* photographer William Warnecke made one of the first photographs of a political assassination (p. 26). Warnecke had gone on a routine assignment to cover the departure of New York Mayor William J. Gaynor, who was embarking for a vacation in Europe. Seconds after an assassin stepped forward and shot the mayor twice, Warnecke photographed the wounded man stumbling into the arms of a companion.

As the media came to form a ubiquitous aura around political candidates, photographers were often on hand when assassinations and near-assassinations took place (p. 27), though the century's most notorious photographs of an assassination were made with a home-movie camera by an amateur, Abraham Zapruder, who happened to be filming President Kennedy's motorcade in Dallas on November 22, 1963. A photograph of an assassination documents the historic event and also helps create a special place in history for the murdered subject. The hideousness of a violent death is made more real by the camera's record, and we identify with the subject's vulnerability. Such photographs allow us vicariously and repeatedly to experience the assassination so that these images momentarily supersede all others of the person and remain in our memories. Despite the countless photographs and endless film footage of John and Robert Kennedy working, sailing, or relaxing with their families, the loop we review in our minds when we think of them is either completed or interrupted by the photographs of their deaths.

In addition to staff photographers, wire services, and stock picture

agencies, newspapers and magazines rely on photo agencies for pictures of current events. More than twenty-five agencies presently serve the press. The prominent ones in the United States include Magnum, a cooperative that began in Paris in 1947, Gamma-Liaison, Sygma, Black Star, Contact, and Impact Visuals. The photo agency sells the work of its photographers, who are sent to cover news events and personalities, often providing the only photographs to be had of them. Agency photographers travel to such hot spots as Iran or South Africa to cover a specific meeting or event, but also often photograph a story in depth over an extended period of time. For example, Gilles Peress, a member of Magnum Photos, recently went to Bosnia to depict the effect of the war there on daily life. In-depth coverage of such an event helps to balance the sometimes superficial coverage that may result when a photographer is simply dropped into an event for a brief time.

With the founding between 1921 and 1933 of several news magazines in Germany, including the *Münchner Illustrierte Presse*, *Berliner Illustrierte Zeitung*, *Die Woche*, and *AIZ* (*Arbeiter Illustrierte Zeitung*), the photo essay and the photo agency came into existence, creating an exciting new opportunity for photographers to work as freelance photojournalists. As a freelancer, a photographer could shoot what he found interesting and, to a certain extent, could choose where his work would be published. The photo agency was created to act as middleman between the photographer and the print media. Dephot (Deutscher Photodienst), established in Berlin by former Bauhaus student Otto Umbehr (Umbo), was one of the most prominent agencies, employing such photographers as Felix H. Man, Lux Feininger, and Andrei Friedmann (Robert Capa), as well as Tim Gidal, who described the mood of the new movement: "Down with tradition! Photograph living things and people as they really are!"[12]

The advent of the photo essay was made possible to a great extent by the development of the small-format camera. Both the Leica and the Ermanox, marketed in Germany in 1924, had faster lenses, meaning the maximum aperture of the lens was larger, allowing more light to expose the film. This permitted the photographer to make pictures at greater speeds and in less light. These cameras also used roll film, which could be advanced quickly. These improvements enabled photographers to make pictures more spontaneously and attempt many new subjects. Since only natural light was necessary, the atmosphere of the occasion might remain undisturbed. In 1928, Erich Salomon, widely recognized as the author of some of the first "candid" views of European politicians, began his career as a photojournalist on assignment for the *Berliner Illustrierte Zeitung*. Although picture-taking was forbidden in German courtrooms, Salomon, hiding his camera in his hat, secretly photographed the trial of a man accused of murdering a policeman. The magazine had a major scoop, and Salomon's career was launched. Over the years, he went on to photograph heads of state during a variety of formal and informal conferences, providing views of important people at work that could not have been obtained with previous technology.

William Warnecke (1881–1939). **Shooting of Mayor William J. Gaynor of New York**. 1910

Gelatin-silver print, printed later. 8½ x 6½" (21.6 x 16.5 cm). The Museum of Modern Art, New York. Courtesy Brown Brothers

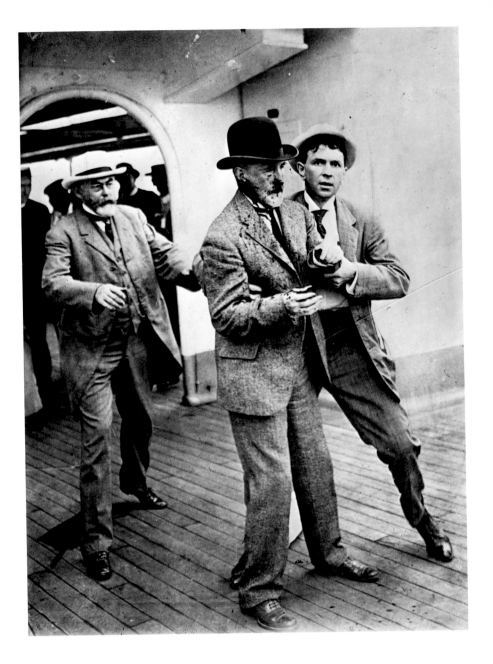

The success of the photo essay in European magazines, and the photographic advances provided by the smaller, faster cameras, were not lost on one influential American. In 1936 Henry Luce launched *Life* magazine, one of several picture magazines to emerge in the United States before World War II that enjoyed great success and helped shape the opinions of the American public. *Life* appeared in millions of American homes every week, filled with photographs of catastrophes, celebrations, famous people, average citizens, news events, wars, murders, show business, and anything else deemed entertaining and informative by its editors. America's sense of itself and the people who ran our country were mythologized in the pages of *Life*.

The magazine's coverage of the American politician during its period

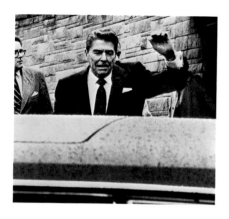
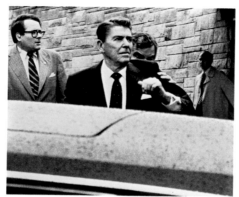
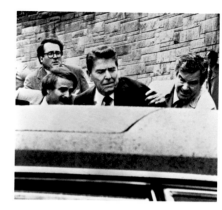

of weekly publication (1936–70) included news pictures and photo essays that brought to life the day-to-day activities of presidents, governors, senators, mayors, and other politicians. Races for nominations, campaigns, ceremonies, political rituals, state visits, funerals, and the political personality "at home" were all considered engaging subjects. The first issue of *Life* (November 23, 1936) featured a photo essay called "The President's Album," a two-page spread mimicking the format of a family album. The photo story documented the activities and events of one week in President Franklin D. Roosevelt's life. He is pictured with his granddaughter and visiting dignitaries, there is a picture of the turkeys given to the White House at Thanksgiving, and there is one of the floor of the New York Stock Exchange, which was enjoying a "Roosevelt Boom." From the outset, the magazine seemed to aspire to make folk heroes out of politicians. It ran photo stories of them participating in significant news events, but it also effectively "humanized" them, making them accessible to millions of readers.

"The Nixons in Their Backyard," a standard *Life* photo essay of 1956, features color photographs of the then vice president, his wife, Pat, and their daughters relaxing at home. The two-paragraph text describes how Nixon helped his daughters build a tree house and put up a trampoline for them. We see the girls bouncing on the trampoline and playing in the tree house, Nixon reading, and the family romping with their pet cats and the infamous cocker spaniel, Checkers. The story conveys the popular values long associated with pictures of the politician—love of family, children, and pets, and enjoyment of the pleasures of domestic life. The photogenic Kennedy family enjoyed considerable coverage in the magazine, especially during John F. Kennedy's term as president. "A Week in the Life of JFK's Wife," "The First Lady—She Tells Her Plans for the White House," "The Jackie Look—How to Get It," and "Caroline Becomes a Celebrity at Age 4" all ran in addition to hard news stories about the president's activities in office.

The technology that radically expanded the dissemination of photographs of politicians was the transmission of photographs by wire, a process regularly in use by 1935.[13] The first organized wire service for newspapers, the

Above (l. to r.): Ron Edmonds (born 1946)/ Associated Press

Reagan Shot. March 30, 1981

"President Reagan waves and then looks up before being shoved into the President's limousine by secret service agents after being shot outside a Washington hotel Monday."

President Hit. March 30, 1981

"President Reagan looks to his left and holds up his left arm as a secret service agent places a hand on his shoulder and pushes the president into his limousine after he was shot leaving a Washington hotel Monday."

President Hit. March 30, 1981

"President Reagan is shoved into the President's limousine by secret service agents after he was shot by an assailant as he left a Washington hotel Monday after making a speech to a labor group. The president was shot in the upper left side."

Three gelatin-silver prints, printed later. Each 7½ x 9½" (19.1 x 24.2 cm). Courtesy Associated Press Photo Library

Associated Press, was founded to expedite the coverage and distribution of news by six New York newspapers, which had created a cooperative in 1848 to share stories, cut costs of coverage, and sell their product to other newspapers via telegraph. Wire transmission of photographs had become possible just after the turn of the century, when a professor at the University of Munich, Alfred Korn, invented a system by which a positive transparency placed on a drum was spirally scanned by a light beam focused on a selenium cell. The light varied in brightness according to the density of tone in the area of the photograph scanned, transmitting more or less electric current to the distant receiver. There, photographic paper revolving on a drum at the same speed as the transmitter was gradually exposed to a light beam that varied in brightness according to the current received.

As early as 1907, *Scientific American* printed a photograph of the German crown prince that had been sent by telegraph using Korn's method. The image was readable but unclear, and it was not until the 1920s that the transmission of photographs by wire became practical. Types of wire transmission introduced during the decade included the British Bartlane system and others developed by Siemens-Karolus-Telefunken and the American Telephone and Telegraph Company. The photograph reproduced on page 29 shows an image of Calvin Coolidge transmitted by radio as it is being recorded on a cylinder. Besides documenting the occasion, the picture is a wonderfully surreal image that conveys the strangeness of an image being produced as if by magic.

In 1935 the Associated Press Wirephoto network was founded, originating in New York and with members in Boston, Chicago, Dallas, Miami, St. Louis, Washington, and eighteen other cities. Its success quickly spawned competitors. William Randolph Hearst bought Soundphoto that year and began transmitting halftones by ordinary telephone lines. The following year, Wide World Photos, then a service of the *New York Times*, began Wired Photos, and NEA–Acme Telephoto was begun by Scripps-Howard. Today, Associated Press employs a staff of 110 photographers and many stringers (photographers who work for the service on an assignment-by-assignment basis). Subscribing newspapers in each state wire out hundreds of photographs daily, via satellite. The photographer usually edits the film and writes the captions for his or her pictures. When there is a big news event requiring massive coverage, such as a political convention, editors are at the scene to edit film and captions before the pictures are "wired." The captions supplied with the photographs are then rewritten to suit their needs by the newspaper and magazine editors who receive them. The original captions for older wire-service photographs, a number of which are reproduced as part of the captions in this book, reveal the cultural and historical biases of the periods in which they were written (see, for example, the lower caption, p. 119).

When a photograph is reproduced in a newspaper, it is also generally "edited" to some extent, a process that can result in a fascinating picture, such as the International Newsreel photo of Chicago's Mayor William

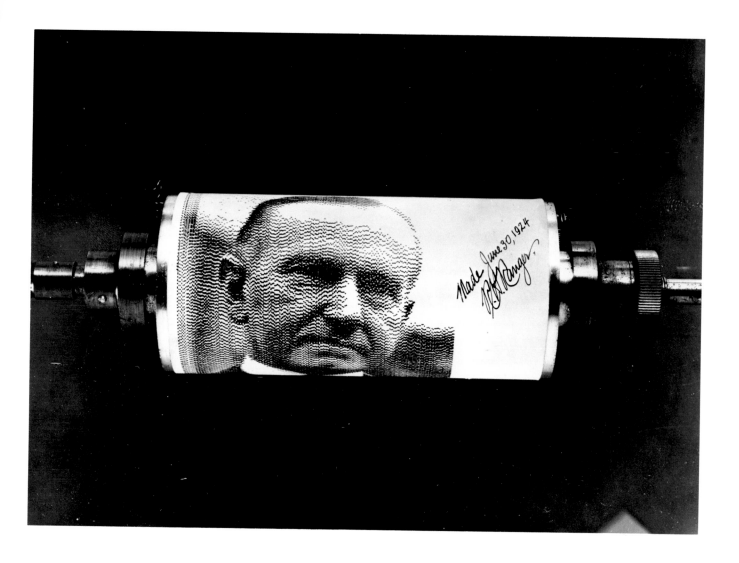

Emmett Dever in 1924 (p. 117). A newspaper picture editor has excised one man from the original photograph by painting a frame around the key characters, in effect creating a new photograph to be reproduced in the newspaper. It is difficult to determine whether the picture was edited in the interest of isolating the newsworthy figures or fitting the picture to available space, or whether it was manipulated for the purpose of distorting the meaning of the event. Regardless, it is a fine example of early cropping that has rendered the original photographic print an object worthy of delectation.

Today, technological advances have increased the speed and efficiency of transmitting images to a mind-boggling extent. Picture editors at the *New York Times* receive photographs by satellite transmission via three services—Associated Press, Agence France-Presse, and Reuters—or directly from its photographers on assignment. A portable instrument called a compander is used on location by the photographer or wire service to begin immediate transmission of a picture. (A compander works something like a photocopier in that either a negative or a photographic print is placed on glass and scanned.) The photograph is digitized, transmitted by satellite, and received

Photographer unknown. **President Coolidge**. June 30, 1924

"Radio transmission by R.H. Ranger." Gelatin-silver print. 6 7/16 x 9 3/16" (16.4 x 23.3 cm). Museum of the City of New York Archives

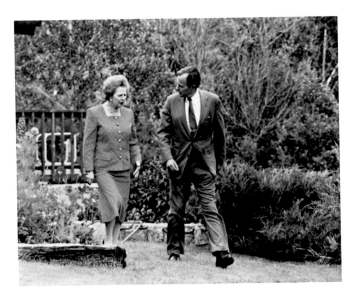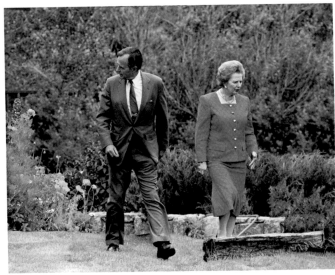

Above left: Dennis Cook/Associated Press.
Bush/Thatcher Meeting. August 1990

"British Prime Minister Margaret Thatcher and President George Bush walk through the garden at the estate of Ambassador Henry Catto, US Ambassador to Britain, prior to their talks Thursday, near Aspen." Chromogenic color print. 7⁹/₁₆ x 9⁵/₈" (19.2 x 24.5 cm). Courtesy Associated Press Photo Library

Above right: Computer-manipulated image by Paul Higdon/*The New York Times* of photograph at left. Courtesy of Jack Harris/Visual Logic, Hockessin, Del.

in computers at the newspaper. On an ordinary weekday, the wire services and photographers on special assignment for the *Times* may "move" to the picture editor more than five hundred photographs. These pictures are categorized as International, National, Financial, and Specials (events assigned by the *Times*), allowing the editor to call up photographs of specific individuals and subjects based on the information in the captions that are transmitted along with the pictures. Once a photograph is brought up on a computer screen, the editor can use a computer application like Adobe Photoshop to manipulate the photograph in many ways, including changing its contrast, adjusting tonal range, or cropping it to seamlessly edit out or rearrange elements or to blend several different pictures. (The policy of the *New York Times* is to do nothing but crop pictures or adjust their tonal range in order to guarantee the best possible reproduction.) The picture is then printed out on a laser printer, which yields a high-quality image that becomes "hard copy." From it, or an actual photographic print when it is available, a print called a velox is made and used for reproduction in the newspaper.

Computer alteration of photographs, illustrated here by a fabricated picture of George Bush and Margaret Thatcher (*above right*), has aroused consternation over the future of photography as a purveyor of "facts." Journalists, writers, and social critics have noted that assembling a photographic reproduction with the aid of a computer opens the door to serious misrepresentation. Undoubtedly, there is a difference between a completely fabricated photograph, bringing together people who were not in the same place at the same time, and a photo of an actual scene that has subsequently been manipulated by cropping or retouching. The computer-generated image results in a seamless physical object, while a photograph that has been altered by hand will bear the signs of manipulation—areas painted out or in, glued-on additions, or evidence that two (or more) negatives had been combined in printing (as in the somewhat clumsy example reproduced on page 83 of

Massachusetts Governor Greenhalge and his council). Once a picture has been altered by computer, however, the evidence of its being changed no longer exists. Characters from disparate negatives can be brought together and the only thing that exists is the altered picture.

The potential for manipulating news photographs is now boundless and raises innumerable ethical and moral questions. For example: Who is responsible for decisions regarding manipulation, and should the responsibility be left, as it usually is, to a very few people? *Newsday*, a daily New York paper printed on Long Island, recently violated journalistic ethics by creating a photograph on a computer for its front page that showed the notorious ice skater Tonya Harding beside her rival, Nancy Kerrigan. While the caption for the photograph stated that the photograph had been fabricated, a person walking by a newsstand, and glancing at the photograph, would not have known this. The photograph created such a flap that the editors of *Newsday* printed an apology to their readers.

Enhanced technologies for the electronic dissemination and manipulation of still pictures are of course only part of the revolution in communications that radically altered the politician's relationship to his or her constituents. The advent of radio in the 1920s and of television in the 1940s exerted a profound and irreversible effect on the practice of politics.[14] A politician could not tailor a broadcast speech to suit an audience in one part of the country, as he might on the campaign trail. For the first time, people in country and city, in North and South, the farmer and the office worker, heard on the radio and saw on television one message from a politician.

In 1924 there were three million radios in the United States. By 1935, during the presidency of Franklin Roosevelt, there were thirty million, enabling him to reach perhaps sixty million people during one of his famous fireside chats. Radio transmission encouraged an easy conversational tone, giving politicians an opportunity to subtly shade their personae. The public's reaction to radio and television speeches was gauged by candidates through polls, which began to have a tremendous influence on political campaigns.

In 1940 a political convention was covered by television for the first time. In 1948 Harry Truman delivered his convention speech wearing a white suit and dark tie, which a *New York Times* reporter termed "the best masculine garb for video cameras." The campaign of that year was the first in which a presidential candidate purchased time on television to influence voters. Once a mass TV audience was established, media consultants came into existence. Today, media advisers themselves hold press conferences to introduce candidates' television ads. Jacques Lowe, whose photographs helped define the Kennedy presidency, has suggested that television is now ninety percent of any candidate's budget, photography two percent.

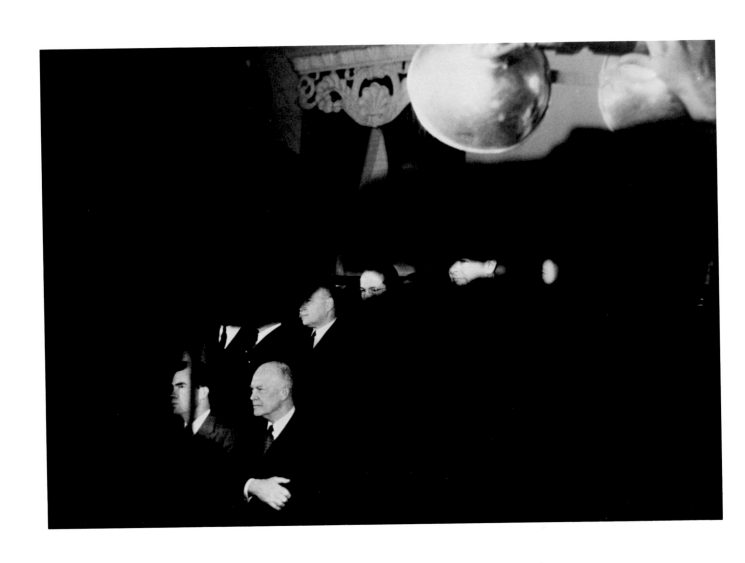

Garry Winogrand (1928–1984). **Eisenhower-Nixon Press Conference**. c. 1955

Gelatin-silver print. 9 1/16 x 13 1/2" (23 x 34.2 cm). Lent by The Metropolitan Museum of Art, New York. Purchase, Nancy and Edwin Marks Gift, 1988

II

*Valid photography, like humor, seems to be too serious a matter to talk about
seriously. If, in a note, it can't be defined weightily, what it is not can be stated
with the utmost finality. It is not the image of Secretary Dulles descending from
a plane. It is not cute cats, nor touchdowns, nor nudes; motherhood; arrange-
ments of manufacturers' products. Under no circumstances is it anything ever
anywhere near a beach. In short it is not a lie, a cliché—somebody else's idea.
It is prime vision combined with quality of feeling, no less.*
—Walker Evans, text for the exhibition *Diogenes III*,
The Museum of Modern Art, New York, 1956

The world's second global war and its upbeat aftermath released a flood of
positive images of American politicians, from a smiling Franklin Roosevelt
(who was never photographed with his leg braces visible) to the gleeful Harry
Truman after his defeat of Thomas Dewey. The image of a prosperous post-
war America and its homogenous, happy families was propagated through
many mediums, including the relatively new, and soon to be ubiquitous, tele-
vision. Political and historical events, along with an evolution in media cul-
ture and technological changes within photography itself, helped precipitate
a profound change in how America was pictured. By the early 1960s the image
of the American politician had shifted from an essentially reverent and often
ennobling portrait to a critical and persistently undermining one. This shift
occurred within two arenas of photographic practice: it was deliberately fos-
tered by photographers working outside the photographic establishment,
and, in a fractured and indirect way, it was apparent in the work of "estab-
lishment" photographers, who were influenced by the same complex inter-
mingling of social, economic, and political forces that affected their
independent colleagues.

For the most part, magazine photographers in the 1950s illustrated the brightness of America's prospects, and, within the constraints of the magazines, many were able to develop a refined photographic style. Among them were George Zimbel, Dan Weiner, and Elliott Erwitt. Zimbel, a stringer with the Pix Inc. photo agency, had studied in the 1930s at the Photo League, an association of photographers specifically concerned with the social and economic plight of people. One of his primary interests was politics, and he has described his experience of photographing politicians in the 1950s and 1960s:

> I usually got credentials from the national committees and would go on my own behalf (and expense). That way I was free to shoot what I saw as important and also to have time to think about the pictures before showing them. I was very interested in political relationships and kept tabs on who was important to whom, who hated whom etc. I believe that in the fifties the older politicians were not intimidated by the photographer who was carrying a couple of 35mm cameras. They probably thought the pictures wouldn't come out . . . no flash. They certainly were not self-conscious. Nixon hated the press and showed it; Kennedy knew how to use us, and his poses appeared and reappeared in different circumstances. Harry Truman, who was my longest running political subject, was a real mensch, a comfortable public man . . . or maybe I should say a real straight-forward public man. Bess Truman once told the secret service to leave us alone so we could do our work! I think Ike hated the public part of being a politician, but he was decent to work with."[15]

(Truman's ease with the media is confirmed by the assistant to the president of Associated Press, Hal Buell, who mentioned an occasion when Harry Truman came up to the offices of AP in New York to chat with the reporters while out on one of his famous walks.) The photograph by Zimbel on page 160 of President and Mrs. Kennedy riding in a motorcade through the streets of New York celebrates their youth and vitality in an energized moment of the campaign, and exemplifies the professional discipline of magazine work.

Dan Weiner had studied painting and, like Zimbel, became a member of the Photo League. His belief in the power of documentary photography led him to a career as a photojournalist after the war, primarily with *Fortune* magazine, which was in the 1950s a beautifully produced periodical designed for a new breed of American capitalist. It enlisted artists like Max Ernst and Edward Hopper to illustrate its pages, and it featured an extraordinary range of photographic styles and interests, reflected in photographs by Berenice Abbott, Paul Strand, André Kertész, and Walker Evans. Weiner's assignments, such as photographing a corporate merger—not exactly a visually compelling event—often may have seemed impossible, but his deep interest in and respect for people, an attitude fostered by his experience in the Photo League, always helped inspire him. His photograph of Martin Luther King, Jr. (p. 156), made during the 1956 bus boycott in Montgomery, Alabama, and published in *Collier's*, shows a relatively young King, poised at the outset of his great career as a leader of the civil rights movement. The boycott had dramatic moments, but, as with many historic events, its participants spent

much time in meetings or simply waiting, and it is this experience that Weiner has described with such vitality.

Elliott Erwitt, a member of the Magnum photographic agency since 1953, worked as a freelance photographer for *Collier's*, *Look*, and *Life*, as well as other national magazines. Many of Erwitt's photographs are enlivened by his sense of humor. In a 1962 triptych, Nelson Rockefeller, then governor of New York, holds court on an Albany street corner (p. 159). In each frame of the triptych, there is a dog, who first appears to watch the governor speak, then turns aside, then relieves himself.

Several news photographs Erwitt made on assignment have become famous, symbolizing an event and its era. In 1959 Richard Nixon visited the Soviet Union to preside at the opening ceremonies of the first exhibition of American products and culture in Moscow. Erwitt had been sent by Westinghouse to photograph the event. He followed Vice President Richard Nixon and his entourage when they arrived at the exhibition, where Nixon met Soviet premier Nikita Khrushchev. As they talked in front of a model American kitchen set up by Macy's department store, the photographers crowded around. Erwitt stepped behind a barrier and into the kitchen so he could have a better view. His picture and another, taken by an Associated Press photographer, are reproduced here on pages 36 and 37.

The story of the "kitchen debate" photographs is related by Vicki Goldberg in her book *The Power of Photography*.[16] An amusing and surprising detail is that the AP picture was actually taken by William Safire, later a Nixon speechwriter and columnist for the *New York Times*, who was at the exposition as the press agent for the builder of the model American house that had been put up by Macy's. She reports that the Associated Press photographer found himself standing behind the gathering, so he tossed his camera to Safire, who had a good view. Erwitt wonders about this version of the event, since the AP photographer used a Speed Graphic, a heavy and cumbersome camera not easily tossed over someone's head. The AP photograph and the one Erwitt made, showing Nixon and Khrushchev face to face, with Nixon's pointed finger touching Khrushchev's chest, became icons of the Cold War competition between the United States and Russia. Erwitt, who speaks Russian, thought the puerile "debate" was ridiculous. Khrushchev said "We will catch up" in response to Nixon's "We are richer than you are." The day after the argument, the AP photograph was reproduced on front pages of newspapers across the United States. That picture, Erwitt's "pointing finger" photograph, and others of the debate by Erwitt and *Life* photographer Howard Sochurek were reproduced in *Life*, *Newsweek*, and *Time*. These photographs projected Nixon as a fearless and competent leader, an image he was intent upon creating for the cameras. Nixon was evidently so pleased with Erwitt's picture that it was used, without his permission and much to his dismay, as a poster during Nixon's 1960 campaign for president.

For the independent photographer, whose impulse was to make pictures that directly responded to his or her experience of an event, the choice

Associated Press. **The Great Debate.** July 24, 1959

"U.S. Vice President Richard Nixon, in dark suit, gestures as he talks with Soviet Premier Khrushchev, left, during their tour of American Exhibition in Moscow this summer. As pair stood in front of kitchen display July 24, their famous running debate of merits of Russian and U.S. ways of life reached one of its dramatic moments. Both kept up the dramatic, tense debate during Khrushchev's visit to the exhibit." Gelatin-silver print. 6⅝ x 8½" (16.9 x 21.7 cm). Lent by the Time Inc. Picture Collection

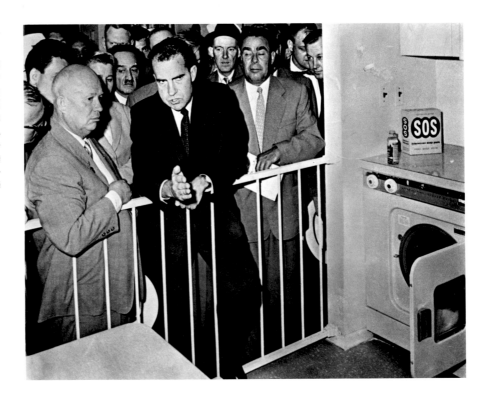

to turn away from an upbeat perspective on America was in part an artistic one; it was a revolt against the constraints imposed by magazine editors who wanted formulaic pictures. But it also arose from the broader cultural condition in which postwar euphoria and an economic upswing were accompanied by an undercurrent of suspicion and dissatisfaction that was manifested, for example, in the work of the Beat writers. The photographs of the Swiss-born photographer Robert Frank became the model that succeeding generations of independent American (and European) photographers would follow in their efforts to reveal the underbelly of American politics. Frank's photographs of American politicians made in the mid-1950s, including those attending the Democratic National Convention in 1956 (p. 153) and President Dwight D. Eisenhower, who is seen on posters in store windows at the time of his second inauguration as president in 1957 (pp. 154 and 155), crystallized the disillusionment and bitterness that some photographers in the 1950s felt toward the leaders and lifestyle of America.

Frank had worked as a freelance photojournalist in the United States after his arrival in 1947, covering a variety of events for popular magazines of the time, from *Harper's Bazaar* to *Pageant*. In 1955 he became the first foreign-born American to receive a Guggenheim Foundation grant in photography, which he used over the next year to finance a trip by car across the United States. The photographs he made while traveling were first published in Paris in 1958 in the book *Les Americains*, and in 1959 *The Americans* appeared in the United States with an introductory essay by the Beat writer Jack Kerouac. By the end of the 1960s it had become a kind of textbook for

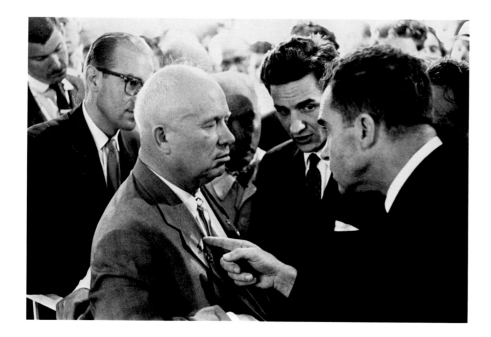

Elliott Erwitt (born 1928). **Vice President Nixon and Soviet Premier Khrushchev during the "Kitchen Debate" at the U.S. Exhibition in Moscow.** July 24, 1959

Gelatin-silver print, printed later. 10⅝ x 15¾" (27.1 x 40.1 cm). The Museum of Modern Art, New York. Joel and Anne Ehrenkranz Fund

young, alienated, and artistically inclined photographers.

Without a doubt, Frank's insight into American culture was aided by his foreignness. He himself was in rebellion against his middle-class Swiss family, and, as a European, he had grown up in a culture that did not idealize political subjects. *City Fathers—Hoboken, New Jersey* (p. 152) shows five cartoonish politicians ranging in character from the ruthless to the ineffective and effete, all of them pompous and clearly "above the people"—a frieze of vacuous corruption. Four wear top hats and appear as "official" city fathers; the fifth wears a regular hat and seems to represent the civilian—perhaps a member of the plumbers' union who has just been paid off.

★

Profound changes in American journalism during the 1960s and early 1970s directly affected photography and the American politician. From the political campaigns of Theodore Roosevelt at the turn of the century until the early seventies, political reporting at a national level was essentially dictated by the candidate. But a major shift in political journalism toward investigative reporting began in 1961, with the publication of Theodore White's book *The Making of the President 1960*, a behind-the-scenes report of the presidential contest between Nixon and John F. Kennedy.[17] White's book became number one on the best-seller lists soon after publication and stayed there for a year. As Timothy Crouse observed in *The Boys on the Bus*, "The most devastating comment on the political coverage of the time was the reception that greeted Theodore White's book, [which] struck most readers as a revelation—it was as if they had never before read anything, anywhere, that told them what a political campaign was about. They had some idea that a political campaign

consisted of a series of arcane deals and dull speeches, and suddenly White came along with a book that laid out the campaign as a wide-screen thriller with full-blooded heroes and white-knuckle suspense on every page."[18]

The book's success generated a stream of behind-the-scenes campaign reporting. "By 1968," Crouse observed,

> White was competing against seventeen other campaign books. . . . Most books adopted White's magic formula: present politics in novelistic terms, as the struggle of great personalities, with generous helpings of colorful detail to sugar the political analysis. . . . The book competition was bad enough, but White also had to contend with the newspapers . . . In 1972 AP told its men, . . . "When Teddy White's book comes out, there shouldn't be one single story in that book that we haven't reported ourselves." Abe Rosenthal, the managing editor of the *New York Times*, told his reporters and editors: "We aren't going to wait until a year after the election to read in Teddy White's book what we should have reported ourselves." By 1972 most editors were sending off their men with rabid pep talks about the importance of sniffing out what makes the campaign tick, and generally going beyond the old style of campaign reporting.

Crouse continues his discussion of the effects of White's book:

> [White] sometimes felt that the methods he had pioneered had gotten out of control, had turned into Frankenstein's monster. Thinking back to the early spring of 1960, he remembered watching a relaxed John Kennedy receiving the Wisconsin primary returns in a Milwaukee hotel room. White had been the only journalist present, except for a young filmmaker working on a documentary. . . . Then he recalled the July night . . . when George McGovern had won the Democratic nomination in Miami. White had been in McGovern's suite at the Doral Hotel: "It's appalling what we've done to these guys, McGovern was like a fish in a goldfish bowl. . . . There were three different network crews at different times. The still photographers kept coming in in groups of five. And there were at least six writers sitting in the corner . . . and all of us are observing him, taking notes like mad, getting all the little details."

In his book, Crouse elaborates on the power acquired by the press through this kind of reporting and suggests that reporters, because of their detailed coverage of Republican and Democratic primary campaigns, now determine the candidates. This close scrutiny helped create the kind of political personality that carefully cultivates and then guards his or her image with the help of "spin doctors," make-up artists, advertising agencies, campaign managers, and image consultants. The press covering the president gained more and more power as the presidency itself grew more visible.

★

In the contemporary history of the photograph of the politician, John F. Kennedy's brief presidential term was a watershed for two reasons. First, his keen awareness of his image and his ability to exploit its power through the media deeply influenced subsequent generations of politicians. The colum-

nist Russell Baker regards the televised Kennedy press conferences as the point in American history when the attention of the American public irrevocably shifted away from local politicians to the office of the president, focusing our political awareness on one person. Second, as a result of the assassination of Kennedy, followed by those of Martin Luther King, Jr., Malcolm X, and Robert Kennedy, access to politicians was limited for security reasons. These developments irrevocably changed the face that the American politician presented to the world. The combination of control and limited access would help generate thousands and thousands of innocuous photographs in the decades to come.

The photographs of Kennedy and his family have consistently been linked to the creation of the Kennedy "myth," and with good reason. It's undoubtedly true that photographs exist of John or Jacqueline Kennedy looking foolish or unattractive, but it is difficult to recall where such a picture may have been published. Jacques Lowe, a German-born photojournalist who came to the United States as a young man in 1949, was Kennedy's personal and "official" photographer from 1958 through 1963 and was in a unique position to understand something about the creation of the Kennedy myth.

In 1956 Lowe was simultaneously given three magazine assignments to photograph the young Bobby Kennedy, who was then a member of the Senate's McClellan Committee investigating racketeering. Lowe and Kennedy became friends, and Lowe was invited to Bobby and Ethel Kennedy's home in McLean, Virginia, where he photographed the senator and his large, rambunctious family. Joseph Kennedy was so impressed with Lowe's work that he asked him to photograph his other son, John. Lowe went on to photograph John Kennedy and his family from the time of his 1958 campaign for senator through the end of his presidency in 1963 (see pp. 162–65).

During Kennedy's campaign against Nixon, Lowe was given the status of "official" photographer. In his book *JFK Remembered*, Lowe writes that his job "was to feed TV stations, small dailies, and rural weeklies with pictures of the candidate and the campaign as frequently as possible. I was also to supply state chairmen and party organizations with photographs of the campaign. And finally, I was to work with the publications staff to supply special images, Kennedy with the elderly, with the young, with labor, with management, Kennedy and the minorities, etc. Most of these pamphlets were in English but some were in foreign languages, from Spanish to Chinese. A New Frontier internal paper was published at regular intervals. And then there were the buttons—'J'Aime Jack' and 'Viva Kennedy'—and the fliers and the stickers, all carrying pictures of the candidate. And of course there were posters." Lowe continues, "Not once during the campaign did anyone, let alone the candidate, ask me what I was sending out or why I was choosing certain images."[19]

The Kennedy family had found in Lowe a photographer of talent and a believer in the Kennedy mission. Based on the photographs he had made of the family, the campaign staffers and Jack himself were confident that Lowe

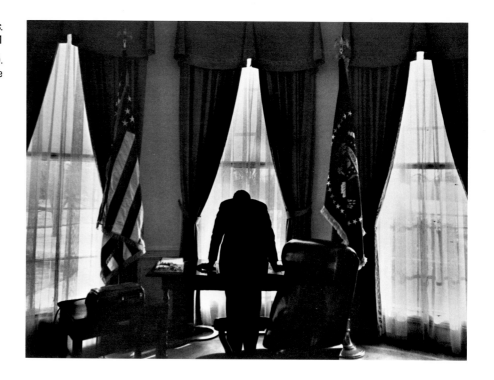

George Tames (1919–1994)/*The New York Times.*
The Loneliest Job in the World. February 1961

Gelatin-silver print. 10 x 13½" (25.3 x 34.3 cm).
The Museum of Modern Art, New York. Gift of The
New York Times

could project an unsullied image of Kennedy. The photographs of the Kennedys by Lowe are terrifically sensitive to the psychological moment. His subjects also are always dignified—and in control. They reveal J.F.K. to be serious (but not without a sense of humor), thoughtful, and, most important, active and alive in some fundamental way.

Two other anecdotes in Lowe's book illustrate Kennedy's sophisticated understanding of image-making. Jacqueline Kennedy wanted privacy for herself and her children and did not want them to be subjected to the constant surveillance of a photographer. Kennedy, however, knew how his children could enhance his public image and insisted that Lowe make photographs of them. Again, when the president was given a choice between releasing photographs to *Vogue* or the less tasteful *Modern Screen*, whose circulation was a hundred times greater than that of *Vogue*, Kennedy chose without hesitation *Modern Screen*, a movie fan magazine that catered to the fantasies of a mass audience.

Until Lyndon Johnson's presidency, the actual official White House photographer was on assignment from the U.S. Navy. Johnson was the first president to choose his official photographer, Yoichi Okamoto. Subsequent presidents have all named their official photographer. But Lowe, as Kennedy's personal and chosen photographer, had unprecedented access to the president and recorded most key meetings during the early days of Kennedy's term. (He was the only other person present when Kennedy offered Johnson the office of vice president.) Nevertheless, Lowe was not the only photographer to have intimate access to Kennedy and his immediate family. Mark Shaw, whose pictures of Kennedy were published in 1964 in *The*

Mark Shaw (1922–1969). **This Was the President's Favorite Photograph**. 1959

"He loved to walk on the dunes near Hyannis Port." Gelatin-silver print. 9 x 13⅛" (23 x 33.4 cm). Lent by the Time Inc. Picture Collection

John F. Kennedys: A Family Album,[20] first photographed Kennedy on assignment for *Life* magazine. Shaw's book concentrates on the family at leisure, often in Hyannis Port (*above*). His vision of Kennedy is romantic, his photographs idyllic snippets of Camelot. Shaw's photographs, like Lowe's, help fill the pantheon of Kennedy imagery that promoted him during his life and helps to sustain his memory.

In addition to providing the media with a seemingly endless supply of flattering photographs for reproduction, Kennedy was also the first president whose press conferences were broadcast live on television. The story of the Nixon-Kennedy debates during the 1960 campaign has been written many times, by both sides, and its lessons have been well studied. The general consensus is that if you had listened to the first debate on radio, Nixon clearly won, but if you had watched the debate on television, Kennedy did. History has it that the composed Kennedy outshone the sweating Nixon. But to a viewer accustomed to the polished television performances of a contemporary politician, viewing a tape of that debate today may be a startling experience. Neither candidate knew exactly how to act for the cameras, and both seem stiff and nervous. Even the cameraman apparently did not always know what to do. In effect there are three camera views: a long one showing the candidates and the moderator between them, a sort of half-length shot of each candidate at his podium, and a closer head shot. Unlike more recent televised political debates, which are broadcast from cheery, tasteful sets with bright colors, the setting for the Nixon-Kennedy debates evokes the gloomy and slightly sinister atmosphere of film noir.

★

Like Robert Frank, Garry Winogrand had been making his living through the 1950s by working for a variety of popular magazines such as *Harper's Bazaar*, *Collier's*, *Redbook*, and *Pageant*. He was also under contract to two agencies, Pix Inc. and Henrietta Brackman Associates. Winogrand's perception of the magazine photographer's task is revealed in his statement that in order to work for the magazines, "You have to be able to make a head shot and a picture of a guy walking down a beach."

Despite the fact that he never voted in a political election and refused to join an organization of any kind (except for a brief stint as a young member of the American Society of Magazine Photographers), Winogrand kept close watch on the American political and cultural scene. His pictures are filled with humor, irony, and the sense that we serve ourselves badly. His unpublished photograph of a press conference from around 1955 (p. 32) conveys the festering bitterness that preluded the despair and pessimism so keenly expressed in the Guggenheim Fellowship application quoted below. In the picture, President Eisenhower, Vice President Nixon, and Henry Cabot Lodge are framed by the crooked elbow and raised arm of a photographer, also shooting the scene, who is standing between Winogrand and the politicians. The politicians' expressions are stern, with beady eyes and tight mouths; the usually smiling Eisenhower looks positively hateful. Cut off from a direct view by the media itself, Winogrand made a picture implying an outsider's perspective that presages the mediated image of the politician that would evolve subsequently in his work and in that of others.

The antiestablishment position of the independent photographer responding to the political and cultural climate of the United States after World War II was eloquently, if pessimistically, stated by Winogrand in his application for a Guggenheim Fellowship in 1963:

> I look at the pictures I have done up to now, and they make me feel that who we are and what we feel and what is to become of us just doesn't matter. Our aspirations and successes have been cheap and petty. I read the newspapers, the columnists, some books, I look at the magazines (our press). They all deal in illusions and fantasies. I can only conclude that we have lost ourselves, and that the bomb may finish the job permanently, and it just doesn't matter, we have not loved life.
>
> I cannot accept my conclusions, and so I must continue this photographic investigation further and deeper. This is my project.[21]

In 1964 Winogrand received the fellowship to make "photographic studies of American life," and the same year he made his second trip across the United States (the first was in 1955), spending five months photographing as he traveled.

The majority of Winogrand's later pictures of politicians were made with the aid of another Guggenheim Foundation grant, which he received in 1969 to photograph the "effect of the media on events." The photographs he made are gathered in *Public Relations*, the catalogue accompanying a 1977

exhibition of the work at The Museum of Modern Art. (Winogrand's photographs of politicians from the 1970s were not published in the popular press of the day. He had stopped working for the magazines years before and earned his living as a teacher.) Winogrand photographed pro– and anti–Vietnam War demonstrations, feminist marches, presidential candidates' press conferences, museum openings, "be-ins," and a variety of other public events. As Tod Papageorge wrote of the work in his introductory essay for the catalogue, Winogrand "has given us in these photographs . . . a unilateral report of how we behaved under pressure during a time of costumes and causes, and of how extravagantly, outrageously, and continuously we displayed what we wanted."[22] A photograph of John Lindsay made in Central Park in 1969 exemplifies the narcissism of that era (p. 186). The handsome and charismatic mayor of New York City appears literally to be basking in the admiration of his constituents, an odd grab bag of teenagers, photographers, and others. The purpose of the mayoral visit to the people is obvious: Lindsay is there to be photographed. While his admirers regard him with delight, one feels that their only purpose there is to provide the mayor an audience with which he can be photographed. When viewed as a whole, the work in *Public Relations* describes a culture and its leaders operating at a level of public performance that is near hysteria and seemingly devoid of purpose. Winogrand, in response, has apparently distanced himself psychologically from the goings-on and seems to be acting as a witness to folly.

Other photographers who came of age in the 1950s, and who likewise did not continue to work for magazines, except on a rare assignment, include Lee Friedlander (pp. 170–72) and Jerome Liebling (pp. 158 and 176). These photographers developed bodies of work whose style and content were independent of the magazines. Often, their photographs would have been unsuitable for such publications because the pictures are filled with a range of experiences for the viewer, and they are visually complex and do not have the immediate impact required by commercial graphic design.

★

The quality of the photographs of politicians that appear in newspapers and magazines today has been seriously compromised as our culture has given itself over to the cult of personality. The increased security surrounding political figures over the past twenty years has made it very difficult for photographers to gain access to them except in highly controlled situations. No longer can a photographer move in close to capture an intimate, off-guard moment. For the most part, hordes of photographers with the same assignment to "get the pic" are kept behind barricades and controlled by police or hired security personnel as they wait for an event to be manufactured. The numbing effect of the stream of images of politicians on television, especially on news channels such as CNN and C-Span, has made them a banal, tired subject. Most significantly, it is politicians' keen awareness of the importance

Bill Owens (born 1938). **Ronald Reagan**. 1972
Gelatin-silver print. 8 x 10" (20.3 x 25.4 cm). The
Museum of Modern Art, New York. Purchase

of controlling their photographic image—everything from making sure they are expressing an emotion that will convey their position on a particular issue to monitoring how they show their profile—that affects the photographs of them. The contemporary "official" portrait handed out by the White House, for example, is a bland item meant to avoid any response or analysis on the part of the viewer. We have come a long way from the fierce images of Teddy Roosevelt: in the portraits of today, the personalities seem interchangeable, nothing more than figures going through predictable paces.

Faster film and cameras, the motor drive that automatically advances film without effort on the part of the photographer, a demand for immediately "readable" pictures, and the use of color photography for reproduction all have lessened the impact of today's photographs of politicians. The increased speed with which photographers are able to make photographs has allowed them to capture images in more candid circumstances, but it has also led them to make less carefully considered pictures. The demand for simple, graphically immediate, but less-than-subtle pictures has engendered a mass of boring head shots. The distortion that occurs when color pictures are reproduced in magazines reduces their believability and clarity. In sum, many different kinds of information about who our leaders really are and how they really behave have been filtered out.

In the mid-1980s a decision was made at *Time* magazine to run all of its photographs in color to attract the color-television-viewing American public (and possibly to justify raising rates for advertisers, since color pages in a magazine are more costly to produce). In 1993, however, *Time* resumed run-

ning a handful of black-and-white photographs in each issue. As with the small number of feature films and television commercials that began to be produced in black and white at about this time, the intention was to get attention—but also to convey "seriousness," relying on the popular belief that black-and-white photographs convey the "truth" about a subject.

The photo opportunity, wherein the participants arrange themselves to be recorded by cameras, is a self-conscious, staged activity that may have little to do with anything of substance that transpired. Commissioned photographers encounter numerous and immense difficulties in their attempts to make meaningful photographs of politicians within this ritualized setting. In a conversation with the author, *Time* picture editor Michelle Stephenson described how a typical photo shoot at the White House can include so many news media crews that they are referred to as "waves." The first wave to come in might be the television crew, which is allowed perhaps one and a half minutes to photograph the president with the leader of a foreign country. Then the wave of wire service photographers is allowed in for the same amount of time, perhaps followed by the wave of magazine photographers, and so on, until all the components of the visual news media have had controlled access to the event.

How do contemporary photographers try to recapture their freedom to photograph an event as it unfolds and as they wish? Occasionally, being associated with an agency may give them an opportunity to cover a newsworthy event in greater depth or from an unconventional perspective. The photograph reproduced on page 195 by Gilles Peress was made at the 1976 Republican convention in Kansas City. Peress was not there on assignment from a publication, and when the mobs of photographers and television crews and the remoteness of the candidates made access to scheduled events difficult, Peress was driven to photograph the people and events on the periphery of the convention. The mordant picture of a delegate symbolically demolishing candidate Schweicker demonstrates how the sheer inhospitality of political events toward photographers can foster a productive adversarial relationship.

Creating a picture different than those usually reproduced in magazines can require months of planning and solicitation. Stephenson related that the editors of *Time*—knowing that Oliver North's swearing-in before the Senate committee investigating the Iran-Contra affair had potential as a great photo opportunity—had to cut through layers of bureaucratic red tape in order to arrange for their photographer, Terry Ashe, to use an 8-by-10–inch camera on a tripod to record the moment when North stood before the committee, his hand raised, surrounded by a vast array of political observers, aides, lawyers, and the press (p. 46). In the end, Ashe was able to make one exposure of the seven-second swearing-in, and the magazine had to agree to "pool" the resulting photograph, making it immediately available to other newspapers and magazines for reproduction.

Since Kennedy's death, photographers' access to the president and other top political leaders has depended very much on how the politician

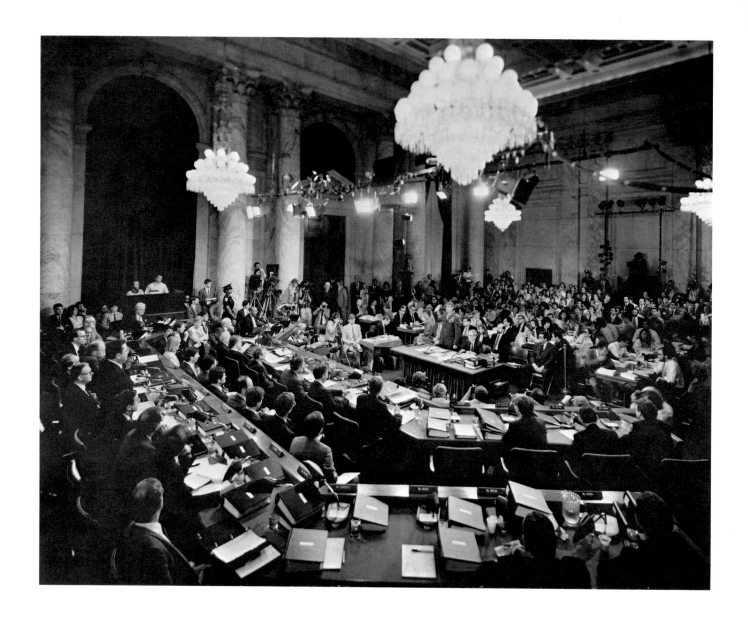

Terry Ashe (born 1942)/*Time* Magazine.
Swearing-in of Oliver North at Iran-Contra Hearings, Washington. July 7, 1987

Chromogenic color print, printed later. 10⁹⁄₁₆ x 13³⁄₈" (26.9 x 34 cm). Courtesy Time Picture Syndication, New York

wants to use the media. During his primary campaign for president, Bill Clinton fell out of favor in the polls after having been accused of an adulterous affair and draft dodging. *Time* contract photographer P. F. Bentley persuaded the picture editors at the magazine that Clinton, despite his difficulties, would be the Democratic candidate, and that it would be a scoop for Bentley to get behind the scenes to reveal the inner workings of the campaign. Bentley himself approached the candidate and his wife, both of whom readily agreed to be photographed for the duration of the campaign. Bentley was successful because Bill and Hillary Rodham Clinton were eager to get more coverage and to project themselves into the public consciousness as a happily married couple (p. 192). *Time* subsequently ran three photo essays (in black and white) of Bentley's photographs.

Today's "bread and butter" photographs of politicians, the pictures made for the daily newspapers and wire services, fall into three categories of

picture-making. The first is straightforward documentation of a significant historic moment, which, more often than not, does not have much inherent photographic interest. Occasionally pictures transcend the facts of an event and project their subjects in a way that is visually compelling. An example of such pictures, which constitute a second category, is Teresa Zabala's 1977 photograph of President Carter and congressional leaders at a press conference (p. 198). Her photograph achieves a high level of quality through metaphor: she has captured the president and the legislators in a Mount Rushmore–like configuration whose characters bear the terrible weight of responsibilty for the state of the nation.

The third category of "bread and butter" photographs is a direct result of the often unnerving lack of visual potential in some events. The Associated Press photograph of Vice President Al Gore and President Clinton reproduced on page 191 is a humorous example of such a picture. The photographer, Greg Gibson, undoubtedly knew when he took the picture that it would appear as though Gore and Clinton were talking to each other by telephone while seated a mere four feet apart. The presidential tenure of Gerald Ford provided ample opportunity for this kind of photograph. The generally tedious rituals of "deplaning" and glad-handing were enlivened by Ford's clumsiness, and photographers took full advantage. The picture on page 48 is but one of six made by Associated Press photographer Peter Bregg that document Ford's fall down the steps of Air Force I. This series of photographs, made with the aid of a motor drive on the camera, and other records of Ford's mishaps may have created an image of an ideal post-Watergate president—one who could be laughed at, who did not have to, or couldn't, be taken seriously. For the most part, the public remembers Gerald Ford for his clumsiness, not for the fact that he pardoned Richard Nixon.

The most innocuous photo opportunity can turn into a devastating political mistake, affirming the power of a photograph to make or break a candidate. The incongruity of the helmeted presidential hopeful Michael Dukakis riding in a new tank (p. 189) was enough to damage his image and his chances for election. Though plenty of presidents have been photographed in some kind of military setting to enhance their images as strong leaders and to align themselves with the armed forces, Dukakis looked like a fish out of water. The photograph precipitated an idea about him that had been hovering in the public consciousness: he was, somehow, a *nerd*. There was no reason for him to be in the tank; the photograph illustrates perfectly the lengths to which politicians and their handlers will go to invent a situation that is "photographable."

★

In 1970 Lee Friedlander published *Self Portrait*,[25] a book of photographs made during the middle and late 1960s in which the photographer, represented by his shadow or reflection, is seen as a physical part of the American land-

Peter Bregg (Canadian, born 1948)/Associated Press. **Lands on His Hands.** 1975

"President Gerald Ford lands on his hands after slipping and falling on a wet ramp while deplaning Air Force One in Salzburg, Austria, Sunday. A military aide, with an umbrella in hand, reaches to help the President break his fall." Gelatin-silver print, third in a series of six, printed later. 9⁷⁄₁₆ x 6¹¹⁄₁₆" (24 x 17 cm). Courtesy Associated Press Photo Library

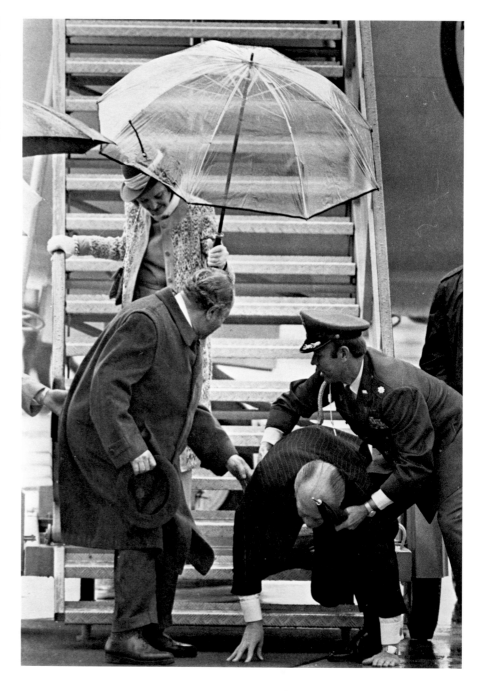

scape. The book conveys something of the interior life of a photographer as he wanders through America, and it records a society that was then undergoing a period of social and political disruption. Friedlander is a *flâneur*, a contemporary nomad, collaging himself onto the cultural iconography of late 1960s America—Pepsi bottles, cigarette machines, plastic flowers, and window displays. The Americanness of his pictures is underscored by familiar messages (a "God Bless America" sign at a kind of roadside chapel) and advertisements ("American Temporaries—Male Division"), or by a majorette in a glittering, spangled outfit strutting down a small-town American street.

Friedlander is also drawn to reproductions of photographs, for example on posters, and to photographs in store windows. In *Colorado* (1967; p. 171), he is reflected at full length in a window, except for his head, which is replaced by a blank white rectangle that is affixed to the window. Above the rectangle, and slightly to its left, is a photograph of the late John Kennedy, probably an official White House picture, placed there by the building's proprietors. The self-portrait is a blatant act of identification with the young president: the photographer shows himself with his head obliterated, metaphorically blown away. It is also a plaintive lament for the lost hero who had been assassinated four years earlier. The presence of the Kennedy picture in the window and Friedlander's choice to make it an essential part of his picture reflect the profound impact on the photographer and the American people of Kennedy's presidency and death, and the power of Kennedy's image. By the time Friedlander was making such photographs, political figures existed only as images; Friedlander's relationship to the leaders of his country was distant and estranged. We had progressed from the photographs in Robert Frank's *The Americans*, in which living political figures actually appear, to those of Friedlander, in which his shadow or reflection is juxtaposed with a politician's image.

In 1984 Frank was commissioned by *California* magazine to photograph the Democratic National Convention in San Francisco. In comparing the photographs he made there to his 1956 pictures of politicians, he said: "In 1956, it was much more open. You could see things happening and you could see and photograph people in corridors and in the lobbies. But in San Francisco [in 1984], it was totally controlled. Everybody was aware of having a camera around him. The security was everywhere. You couldn't move. I would see something or someone that would interest me and I would find myself in a crowd of five, twenty, a hundred people. That drove me out into the streets."[24] The photographs Frank made in 1984 are of people outside the convention—religious fanatics engaged in mini-demonstrations, gays protesting, and the gang-media photographing.

Nowadays it is rare for a photographer to get close enough to make pictures that critique the political establishment and its processes. When her husband was appointed by President Carter to direct the government's General Services Administration in 1977, the photographer Rosalind Solomon gained a degree of access to the president and a world of Washington politics that few photographers could hope to attain. Even though she was not an official photographer, Solomon made pictures at state dinners, political gatherings, and at least one meeting at the White House. Before moving to Washington, she had been making photographs for more than twenty years and had developed a sophisticated aesthetic grounded in the teachings of Lisette Model, with whom she had studied from 1974 to 1976. Solomon's view of political life is tinged with a streak of suspicion that accentuates awareness of the self-serving aspects of the politician's most routine activities.

In 1986 and 1987, the portrait photographer Judith Joy Ross embarked

on a personal mission to photograph the members of Congress whose decisions determine the quality of her life. In an interview with the author, Ross explained that at the time, the American government seemed to her to be doing not much more than "bombing people." She felt that the images of leaders on television and in newspapers had rendered political figures "unrecognizable as human beings." The question she kept asking herself was, Who *are* these people? To confront her question head-on, she consulted the annual *Almanac of American Politics*, published by the *National Journal*, a compendium that includes every member of Congress and a brief description of his or her voting record, a short biography, political affiliations, and a small head shot. Through an extraordinarily aggressive and extended campaign of letter writing and telephone calls, she petitioned for personal meetings with members of Congress, and she was able to photograph fifty-two representatives in their offices. For each sitting, Ross set up her 8-by-10–inch camera, took the photograph, dismantled the camera, and departed in about fifteen minutes.

Ross had gone to Washington with a mix of emotions—hoping that the camera would objectify her subjects and in turn identify some truths about them, and simultaneously wishing that her previously held ideas about who was "good" and who was "evil" would be confirmed. To her surprise, instead of an either/or record of good and evil, she came away with a series of portraits of very human beings. The political figures Ross photographed are essentially unavailable to most photojournalists. It was only through her persistence that she was able to photograph these men and women.

It should also be said that Ross's anonymity served her well. If she had been affiliated with a major newspaper or photo agency, her chances of photographing these people in the intimate settings she demanded would have been slim. Also, power recognizes power, and had Ross been a magazine or newspaper photographer, the tendency of her subjects to perform for the camera would have intensified. While her portraits are not always flattering or ennobling, they are sympathetic. Her subjects appear to suffer the same complicated lives we all do. Like Robert Frank, Garry Winogrand, and others, including many of the photographers who work on assignment, Ross is interested in photographing without a plan or preconceived notion of what her photographs should look like. The medium, for these photographers, is a way to discover and know the world; it is not a means of visual codification, of illustrating, in Walker Evans's words, "somebody else's idea."

★

The moral and philosophical circumstances of photographing politicians today are radically different from what they were when photography was introduced in the United States. While the photo opportunity has been a fixture for at least a century, and the desire to modify one's image to fit the needs of the electorate has always existed, cultural mores and societal factors

have shifted. The relationship between the photographer and the politician, once one of cooperation and mutual benefit, has become adversarial. An open tug-of-war exists between the politician who wants to project a carefully calculated image and the photographer who is in pursuit of "truth."

Over time, politicians wisely, then perhaps cynically, learned to protect themselves from the camera and use it to their own advantage. They have achieved an unprecedented degree of control over their images, casting photographers in an increasingly difficult moral position. Gilles Peress has recalled in conversation that when he was photographing Gary Hart's campaign for the presidential nomination in 1988, he at one point found himself seated across a desk from the politician. Hart threw his feet onto the desk, revealing a hole in the sole of one shoe. Peress instantly knew that Hart was tempting him to make a photograph that would recall the famous one of Adlai Stevenson in 1952, mentioned above. Hart undoubtedly hoped that if such a photo were published, it would stir memories of Stevenson, grafting onto Hart Stevenson's reputation for intelligence and probity. Peress did make the picture but never made it available for reproduction.

Despite continuing advances in photographic and visual technology, which simultaneously aid and hinder photographers, and despite the increasing sophistication of political strategists, photographers will continue, in the near future anyway, to make meaningful and important photographs of politicians. It is their job as journalists and artists to report and comment on what interests the public that consumes images. And as a public, our desire for photographs of our leaders has not abated. The people we select to represent us symbolize what we hope for. As a group, photographers remain profoundly important in telling us how successful we are in our choices. They will make photographs that describe campaigns, influence elections, document terms of office, and portray the man or woman behind the image. They will make photographs that will help create and then confirm our image of ourselves through our politicians, the photographs that will exist in our museums and in newspaper and magazine archives as history.

1. Marcus Aurelius Root, *The Camera and the Pencil* (1864; reprint, Pawlet, Vt.: Helios, 1971), p. 27.

2. *The New York Times Magazine*, 5 December 1993, p. 29.

3. Beaumont Newhall, "A Daguerreotype of John Quincy Adams by Philip Haas," *Metropolitan Museum Journal* 12 (1977), pp. 151–54.

4. Clifton Fadiman, ed., *The Little, Brown Book of Anecdotes* (Boston and Toronto: Little, Brown and Company, 1985), p. 526.

5. For a history of cartes-de-visite, see William C. Darrah, *Cartes de Visite In Nineteenth Century Photography* (Gettysburg, Pa.: W. C. Darrah, 1981).

6. Three scholarly publications have been devoted to the subject: Charles Hamilton and Lloyd Ostendorf, *Lincoln in Photographs* (Norman, Okla.: University of Oklahoma Press, 1963); Stefan Lorant, *Lincoln: A Picture Story of His Life* (New York: W. W. Norton & Company, 1969); and James Mellon, ed., *The Face of Lincoln* (New York: The Viking Press, 1979).

7. Mellon, *The Face of Lincoln*, p. 12.

8. Vicki Goldberg, *The Power of Photography: How Photographs Changed Our Lives* (New York: Abbeville Press, 1991), p. 78.

9. Roland Barthes, "Photography and Electoral Appeal." In *Mythologies*, trans. Annette Lavers (1957; reprint, New York: Noonday Press, Farrar, Straus & Giroux, 1992), p. 92.

10. The subject is discussed at length in Harold Holzer, *Washington and Lincoln Portrayed: National Icons in Popular Prints* (Jefferson, N.C., and London: McFarland & Company, Inc., 1993).

11. Otto L. Bettman, *Bettmann: The Picture Man* (Gainesville: The University Press of Florida, 1992), p. 58.

12. Tim N. Gidal, *Modern Photojournalism: Origin and Evolution 1910–1933* (New York: Collier Books, 1973), p. 12.

13. On the development of the wire services, see Marianne Fulton, *The Eyes of Time: Photojournalism in America* (Boston: New York Graphic Society, Little, Brown and Company, 1988), pp. 108–14.

14. See chapter 1, "Broadsides to Broadcasts," in Kathleen Hall Jamieson, *Packaging the Presidency* (New York: Oxford University Press, 1984).

15. George Zimbel, letter to the author, May 9, 1994.

16. Goldberg, *The Power of Photography*, pp. 82–86.

17. Theodore H. White, *The Making of the President 1960* (1961; reprint, New York: The American Past Book-of-the-Month Club, 1988).

18. Timothy Crouse, *The Boys on the Bus* (1972; reprint, New York: Ballantine Books, 1992), pp. 33–38.

19. Jacques Lowe, *JFK Remembered* (New York: Random House, 1993).

20. Mark Shaw, *The John F. Kennedys: A Family Album* (New York: Noonday Press, 1966).

21. John Szarkowski, *Winogrand: Figments from the Real World* (New York: The Museum of Modern Art, 1988), p. 34.

22. Garry Winogrand. *Public Relations*, introduction by Tod Papageorge (New York: The Museum of Modern Art, 1977), p. 15.

23. Lee Friedlander, *Self Portrait* (New City, N.Y.: Haywire Press, 1970).

24. David B. Cooper, *Robert Frank and American Politics* (Akron: Akron Art Museum, 1985), pp. 6–7.

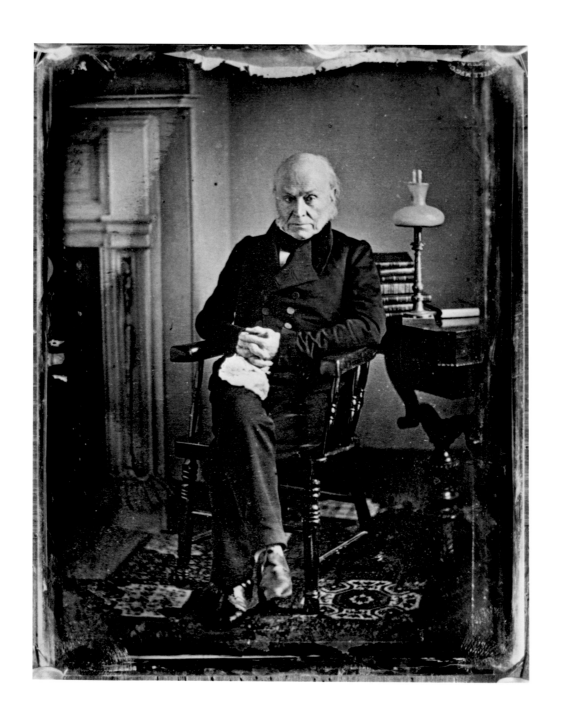

Philip Haas (active 1837–1857). **John Quincy Adams**. 1843

Half-plate daguerreotype, copy of Haas's original by Southworth and Hawes, after 1850. 4¹¹⁄₁₆ x 3½" (12 x 9 cm). Lent by The Metropolitan Museum of Art, New York. Gift of I. N. Phelps Stokes, Edward S. Hawes, Alice Mary Hawes, and Marion Augusta Hawes, 1937

Photographer unknown. **John Brown**. c. 1856

Sixth-plate daguerreotype. 3¼ x 2⅝" (8.3 x 6.7 cm). Boston Athenaeum. Gift of Miss Sally Fairchild, 1942

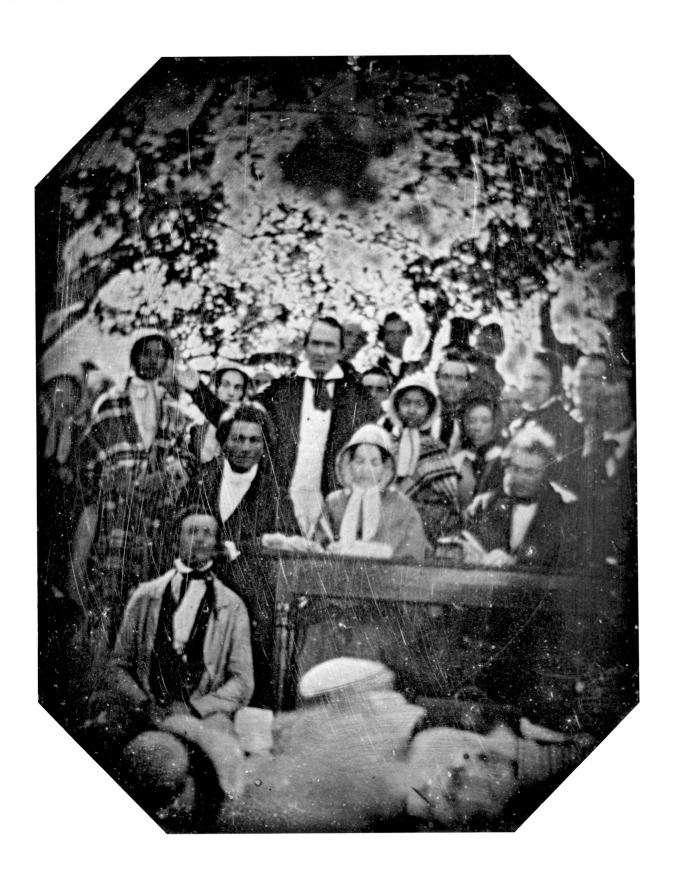

Photographer unknown. **Scene of Abolitionist Meeting with Frederick Douglass**. c. 1850

Sixth-plate daguerreotype. 3⅛ x 2⅝" (8 x 6.7 cm). Collection of the J. Paul Getty Museum, Malibu, California

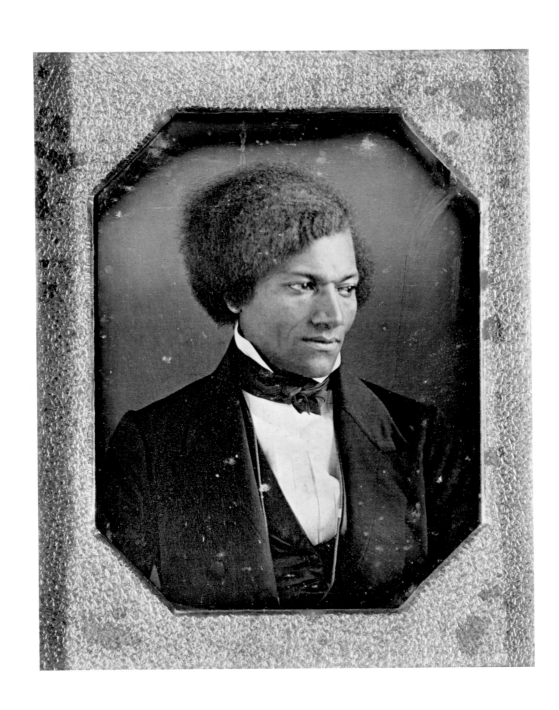

Photographer unknown. **Frederick A. Douglass**. 1847–48

Quarter-plate daguerreotype. 3⁵⁄₁₆ x 2¾" (8.4 x 7 cm). Chester County Historical Society, West Chester, Pennsylvania.
Gift of Albert Cook Myers

Photographer unknown. **Sam Houston**. 1850

Sixth-plate daguerreotype. 3⅛ x 2⅝" (8 x 6.7 cm). George Eastman House, Rochester, New York. Gift of Alden Scott Boyer

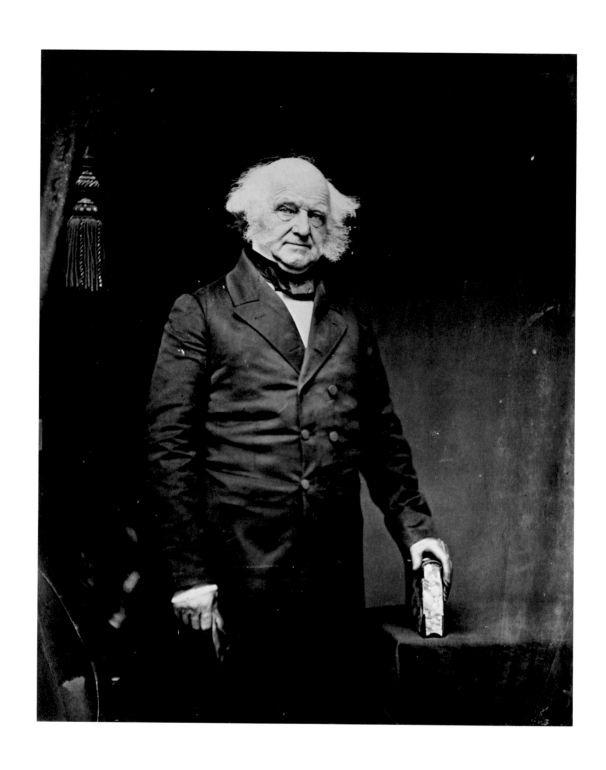

Attributed to Alexander Gardner (American, born Scotland, 1821–1882). **Martin Van Buren**. 1850s

Salted paper print from a glass negative. 19 x 15⅝" (48.3 x 39.7 cm). Lent by The Metropolitan Museum of Art, New York. David Hunter McAlpin Fund, 1956

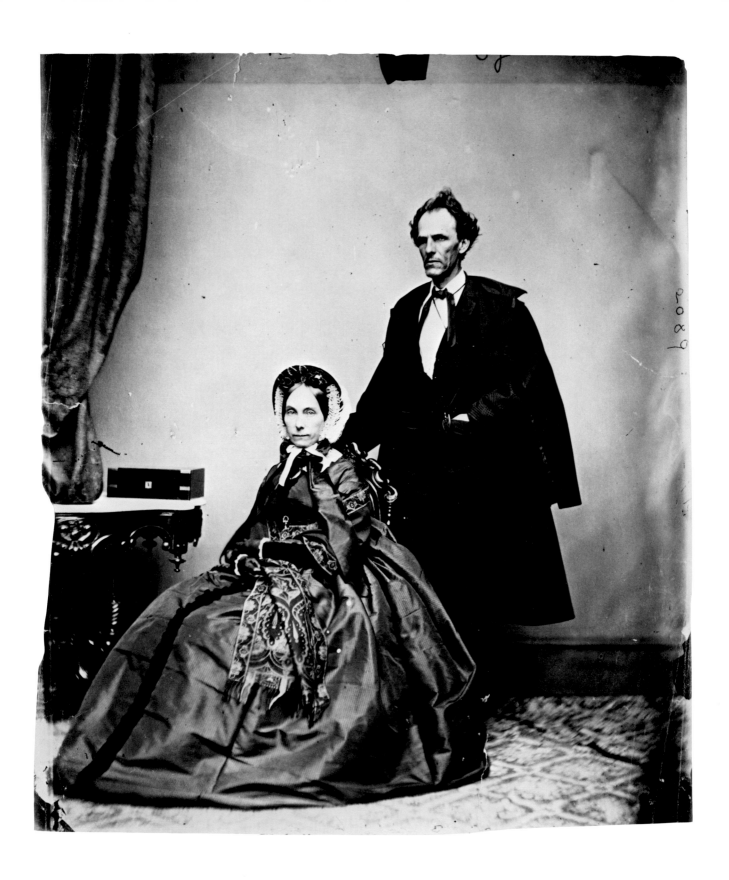

Studio of Mathew B. Brady (active 1844–1883). **Senator and Mrs. James Henry Lane**. 1861–66
Albumen-silver print from a wet collodion-on-glass negative. 8⅞ x 7¾" (22.4 x 19.7 cm). Collection Gilman Paper Company, New York

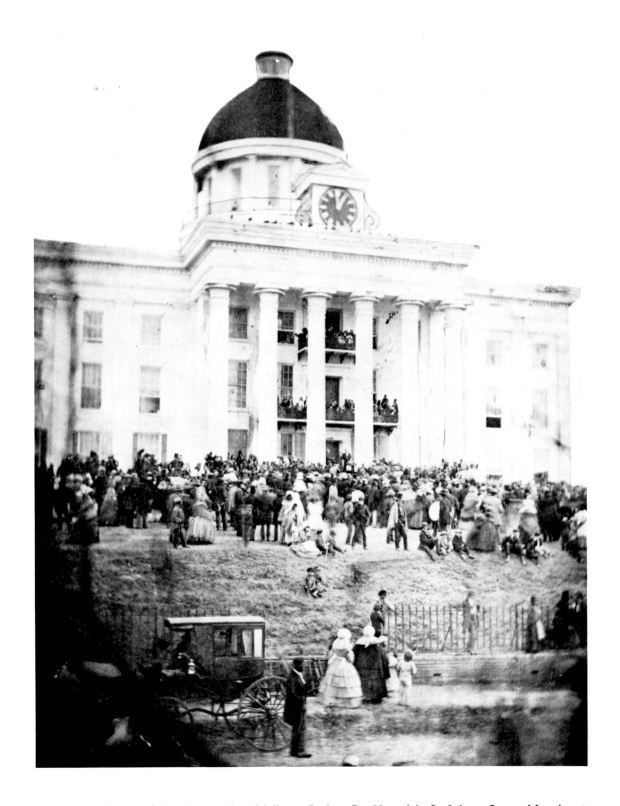

A. C. McIntyre (died 1891). **First Inauguration of Jefferson Davis as President of the Confederate States of America at Montgomery, Alabama**. February 18, 1861

Salt print. 7¹³⁄₁₆ x 5¾" (19.9 x 14.7 cm) print on 12¹⁵⁄₁₆ x 10" (32.9 x 25.4 cm) mount. Boston Athenaeum

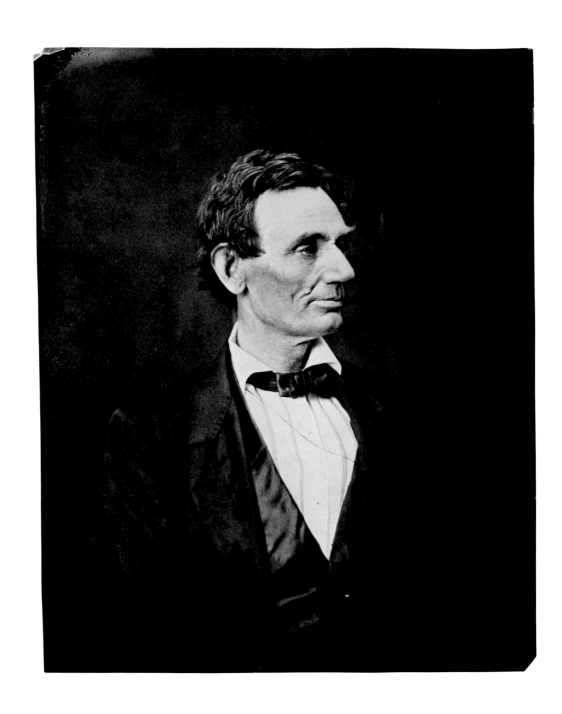

Alexander Hesler (American, born Canada, 1823–1895). **Abraham Lincoln**. 1860

Albumen-silver print by George B. Ayres from a glass negative, c. 1881. 8¹¹⁄₁₆ x 6¹¹⁄₁₆" (22.1 x 17 cm). Lent by The Metropolitan Museum of Art, New York. Gift of Mrs. Claire K. Feins, in memory of Daniel M. Feins and Linda S. Silverman, 1992

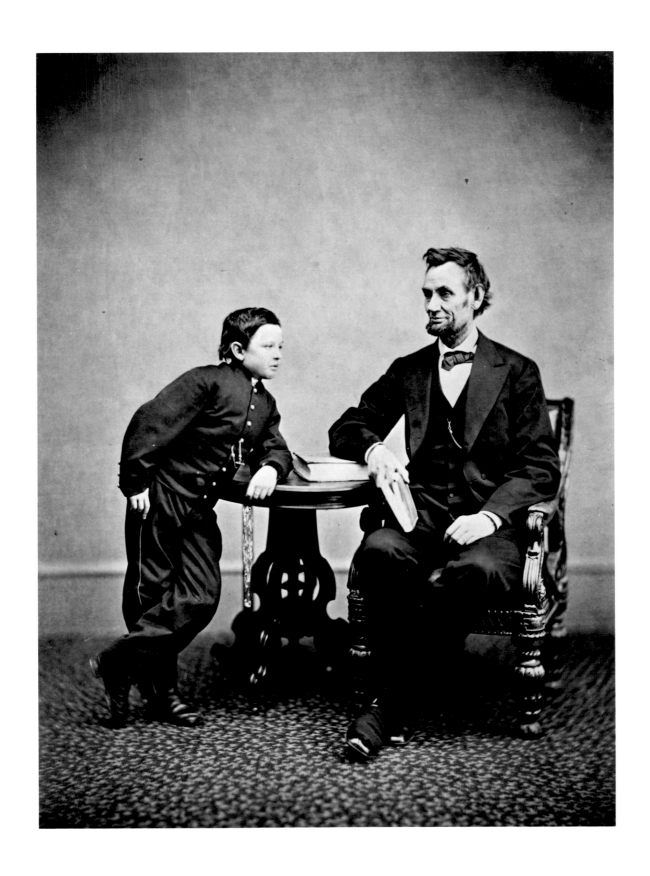

Alexander Gardner (American, born Scotland, 1821–1882). **Abraham Lincoln and His Son, Thomas (Tad)**. 1865
Albumen-silver print. 17¹⁄₁₆ x 13¹⁄₁₆" (43.3 x 33.2 cm). Collection of the J. Paul Getty Museum, Malibu, California

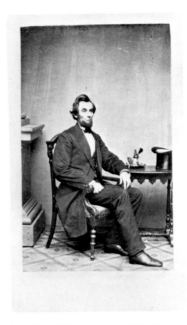
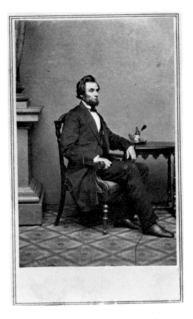
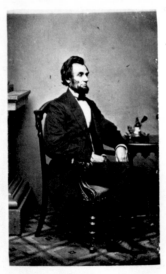
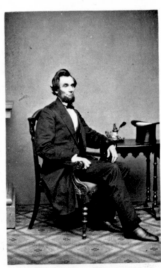

Alexander Gardner (American, born Scotland, 1821–1882)/Studio of Mathew B. Brady. **Abraham Lincoln**. c. February 24, 1861

Four albumen-silver prints (cartes-de-visite), published by E. Anthony, New York. Each approx. 3⅜ x 2¹⁄₁₆" (8.6 x 5.2 cm). George R. Rinhart Collection

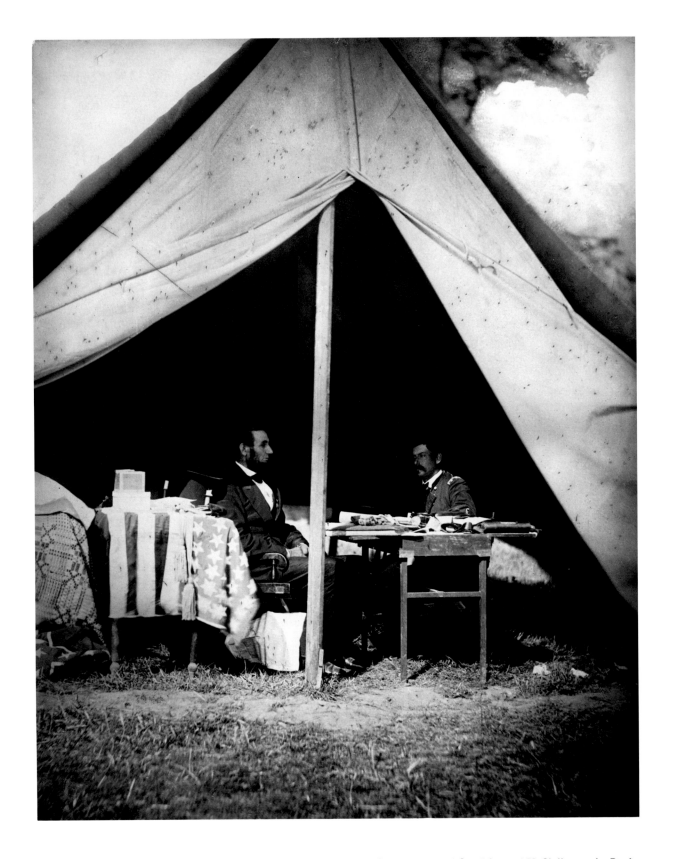

Alexander Gardner (American, born Scotland, 1821–1882). **The President [Abraham Lincoln] and General McClellan on the Battlefield of Antietam**. 1862

Albumen-silver print. 19½ x 15¾" (49.5 x 40 cm). The Museum of Modern Art, New York. Gift of Carl Sandburg and Edward Steichen

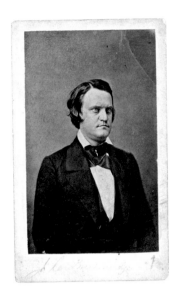

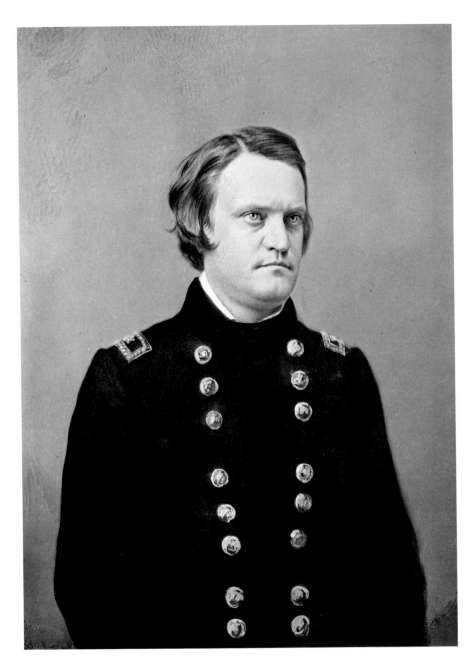

Above: Studio of Mathew B. Brady (active 1844–1883). **Gen. John Cabell Breckinridge**. 1861

Hand-painted albumen-silver print. 8⅞ x 5¾" (22.6 x 14.7 cm). George R. Rinhart Collection

Above left: Studio of Mathew B. Brady (active 1844–1883). **John Cabell Breckinridge**. 1860

Albumen-silver print (carte-de-visite), from Richards' Photograph and Fine Art Gallery, Philadelphia. 3⅜ x 2¹⁄₁₆" (8.7 x 5.3 cm). George R. Rinhart Collection

Opposite: top row (l. to r.)—**Gov. Andrew of Massachusetts,*** 1860s; **Maj. Gen. N. P. Banks,*** 1861–65; **Gen. James Shields,*** 1861–63; middle row—**Gen. James H. Lane,*** 1861–65; **Maj. Gen. George Brinton McClellan and Mrs. McClellan,**** c. 1861; **Maj. Gen. George Brinton McClellan,**** c. 1861; bottow row—**Lt. Gen. Winfield Scott, West Point, New York,**** June 10, 1862; **Benjamin F. Butler, Maj. Gen. of Volunteers,*** c. 1862; **Maj. Gen. John A. Logan,** 1862–65, published by J. Gurney & Son

Nine albumen-silver prints (cartes-de-visite). 3⁵⁄₁₆–3⁹⁄₁₆ x 2⅛" (8.4–9.1 x 5.4 cm). George R. Rinhart Collection
*Studio of Mathew B. Brady (active 1844–1883); published by E. Anthony, New York
**Photographer unknown, published by Chas. D. Fredericks & Co., New York

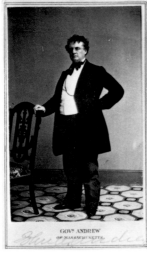

GOV^R ANDREW
OF MASSACHUSETTS.

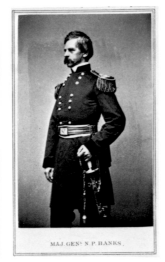

MAJ. GEN^L N. P. BANKS.

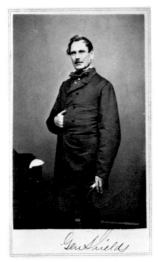

Gen Shields

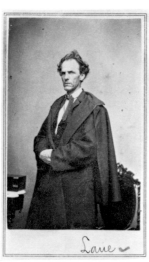

Lane

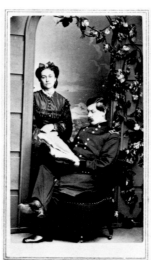

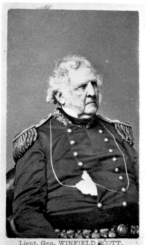

Lieut. Gen. WINFIELD SCOTT.
Entered, according to Act of Congress, in the year 1862, by Chas.
D. Fredricks & Co., in the Clerk's Office of the District Court of the
United States for the Southern District of New York.

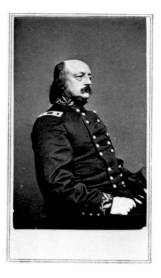

Attributed to Huston and Kurtz. **Ulysses S. Grant**. 1864–65

Printing-out-paper print. 3⅝ x 2⅝" (9.3 x 6.8 cm). George Eastman House, Rochester, New York. Gift of Alden Scott Boyer

Attributed to Huston and Kurtz. **Ulysses S. Grant**. 1864–65

Printing-out-paper print. 3⅜ x 2⁹⁄₁₆" (9.8 x 6.6 cm). George Eastman House, Rochester, New York. Gift of Alden Scott Boyer

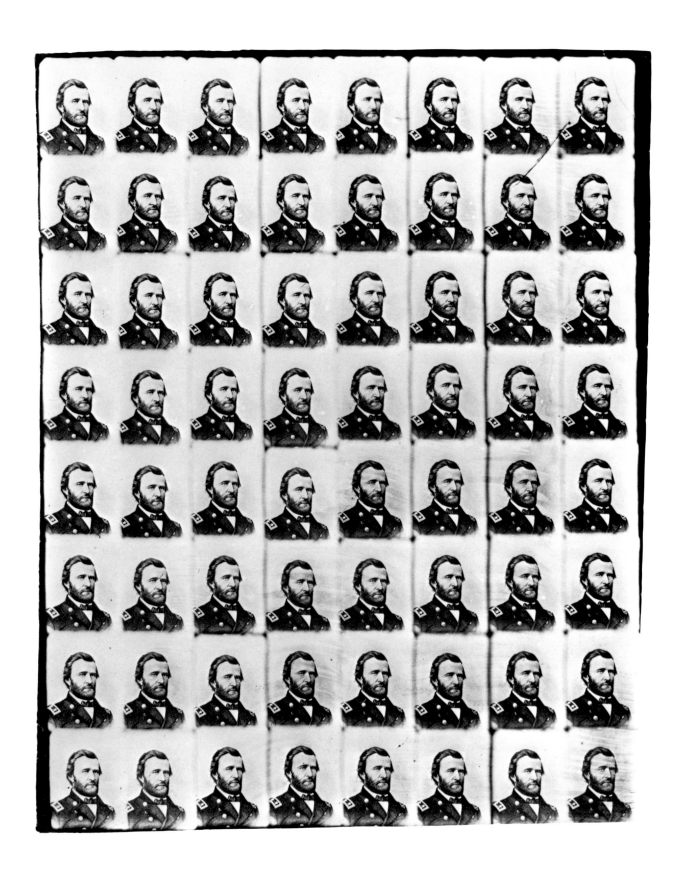

Photographer unknown. **Gen. Ulysses S. Grant**. 1863–65

Albumen-silver print, uncut sheet of stamp photographs. 7$^{15}/_{16}$ x 6$^{5}/_{8}$" (20.2 x 16.8 cm). George Eastman House, Rochester, New York

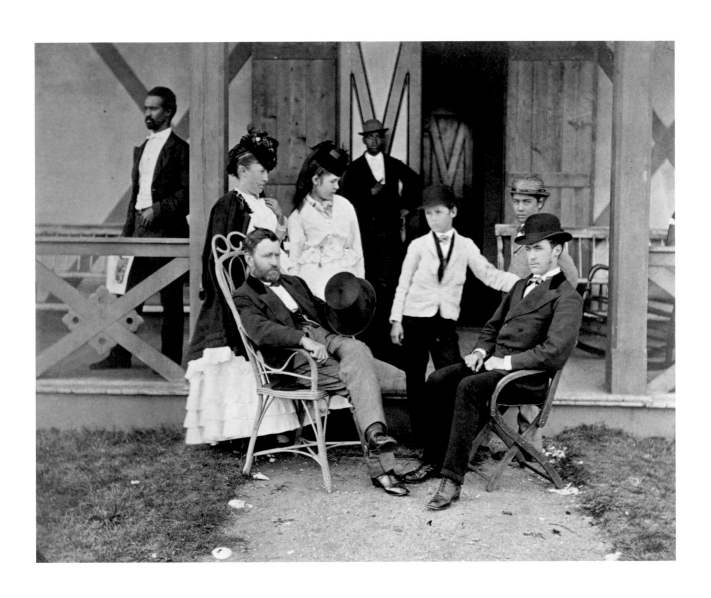

J. Evoli. **Ulysses S. Grant with His Children, Long Branch, New Jersey**. 1868–70
Albumen-silver print. 11 x 14" (28 x 35.6 cm). Chicago Historical Society. Negative no. ICHi-24120

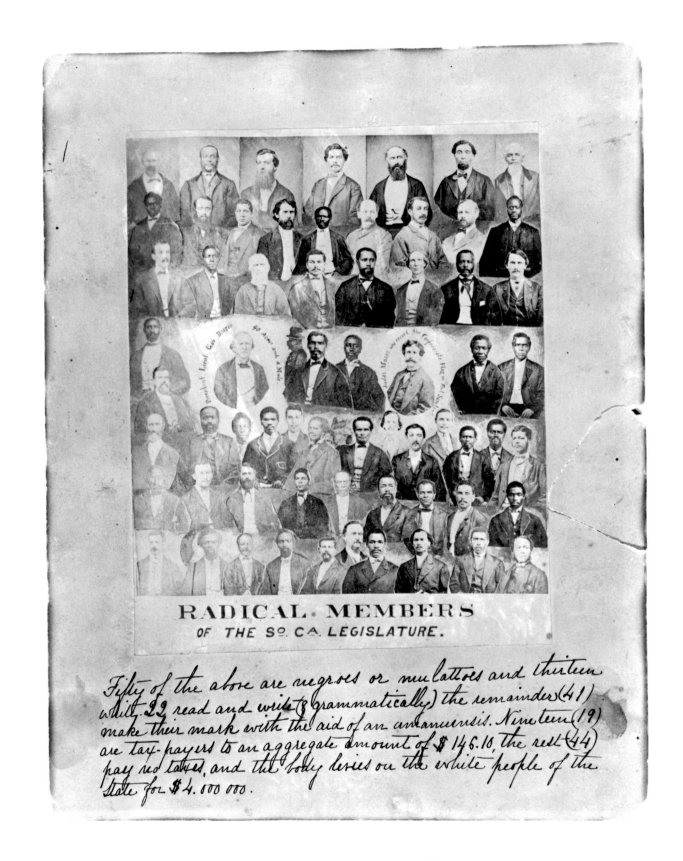

Photographer unknown. **Radical Members of the South Carolina Legislature**. c. 1868

Albumen-silver print, rephotographed collage of albumen-silver prints. 5⅝ x 6¹¹/₁₆" (14.3 x 17 cm) print on 8 x 9¹⁵/₁₆" (20.3 x 25.3 cm) mount.
Eleanor S. Brockenbrough Library, The Museum of the Confederacy, Richmond, Virginia

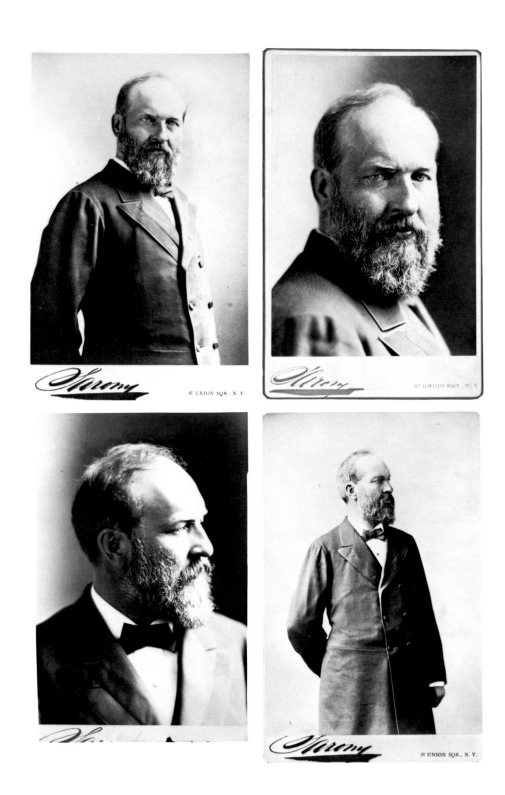

Napoleon Sarony (American, born Canada, 1821–1896). **Hon. James A. Garfield**. 1880

Four albumen-silver prints (cabinet cards). Each approx. 5¹¹⁄₁₆ x 4⅛" (14.5 x 10.5 cm). George R. Rinhart Collection

Frederick Gutekunst (1831–1917). **Lucretia Mott**. 1870–75
Albumen-silver print (carte-de-visite). 3¹¹⁄₁₆ x 2³⁄₈" (9.4 x 6 cm). Boston Athenaeum

George K. Warren (1834—1884). **Charles Sumner**. 1870—74

Albumen-silver print (cabinet card). 5¹³⁄₁₆ x 3¹⁵⁄₁₆" (14.8 x 10.1 cm). Boston Athenaeum

Falk Studio. **Mrs. Belva A. Lockwood**. c. 1880

Albumen-silver print (cabinet card). 5¾ x 3¹⁵⁄₁₆" (14.6 x 10 cm).
George R. Rinhart Collection

Charles M. Bell (c. 1848–1893). **Native American Delegation, Washington, D.C.** 1880–81 (?)
Albumen-silver print. 13⅛ x 16⅝" (33.3 x 42.2 cm). The Museum of Modern Art, New York. Joseph G. Mayer Fund

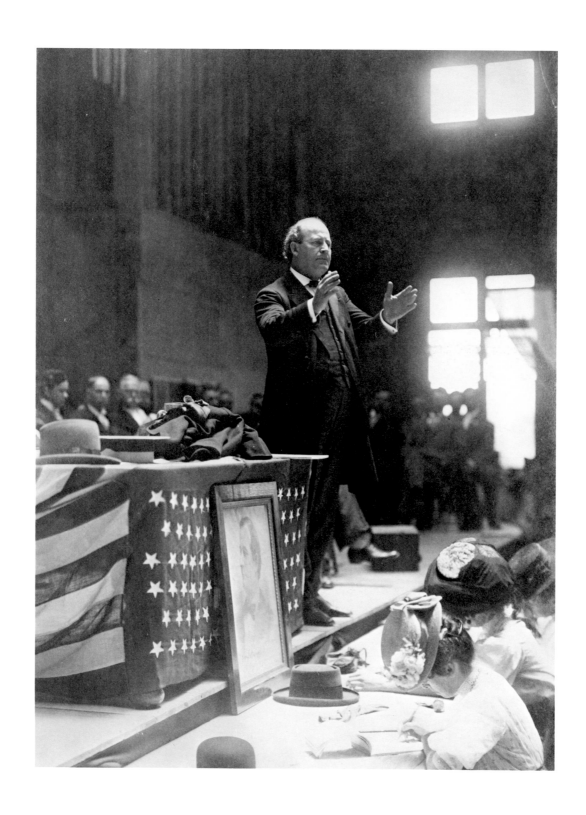

Underwood and Underwood. **William Jennings Bryan Speaking at the Jamestown Exposition**. 1908

Gelatin-silver print from a copy negative, 1993. 9⅜ x 7" (23.8 x 17.8 cm). Prints and Photographs Division, The Library of Congress, Washington, D.C.

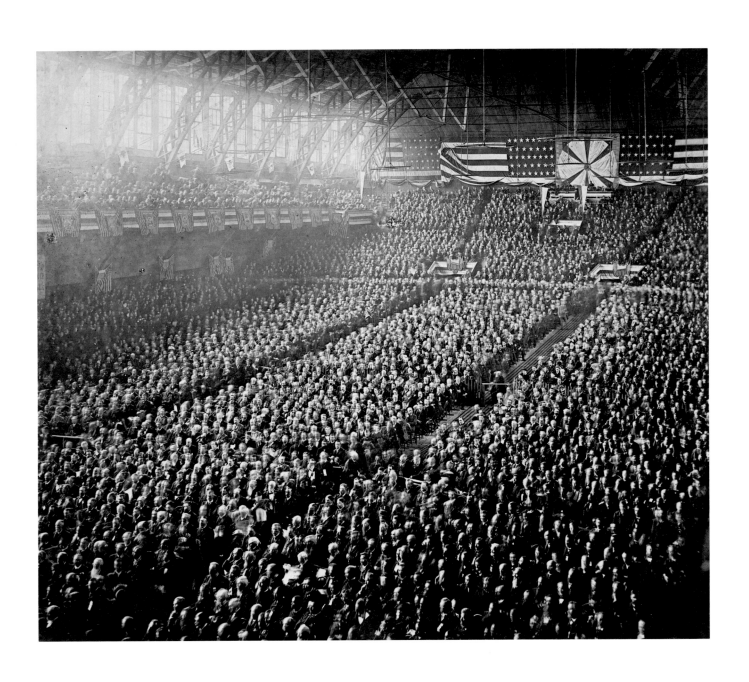

J. M. Wright. **Chicago Republican Convention**. 1888

Albumen-silver print. 9³⁄₈ x 11¹⁄₈" (23.8 x 28.3 cm). George R. Rinhart Collection

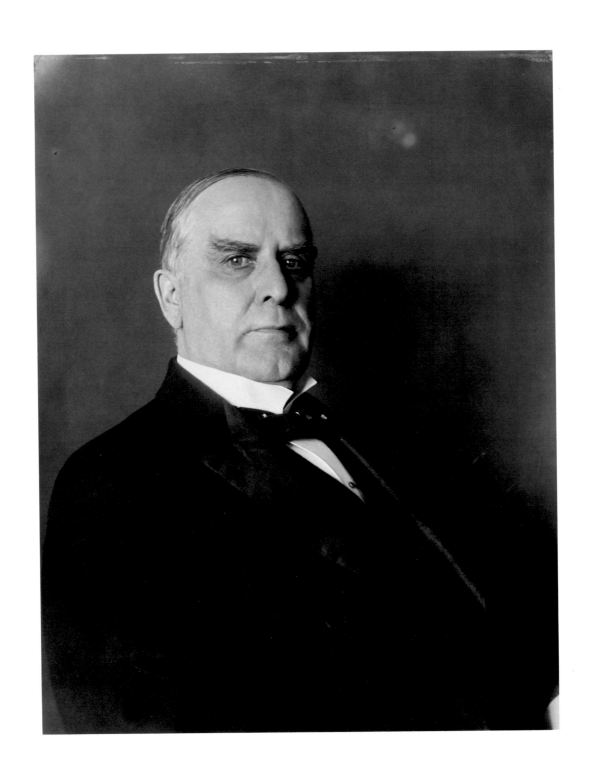

Frances Benjamin Johnston (1864–1952). **President William McKinley Taken at White House**. c. 1900
Platinum print. 9½ x 7½" (22.7 x 17.2 cm). The Museum of Modern Art, New York

DR. SAMUEL A. GREEN,

Citizens' Candidate

For

MAYOR OF BOSTON.

HELIOTYPE PRINTING CO., 211 TREMONT ST., BOSTON.

Photographer unknown. **Dr. Samuel A. Green, Citizens' Candidate for Mayor of Boston**. c. 1882

Heliotype, published by the Heliotype Printing Co., Boston. 11⅜ x 9" (28.9 x 22.9 cm) image on 18 x 14¹⁄₁₆" (45.8 x 35.7 cm) sheet. Boston Athenaeum

Le Rue Lemer. **House of Representatives of Pennsylvania**. 1899–1900

Gelatin-silver composite print. 23¼ x 19½" (59.1 x 49.5 cm). Chester County Historical Society, West Chester, Pennsylvania.
Gift of Jerome Bethel Gray

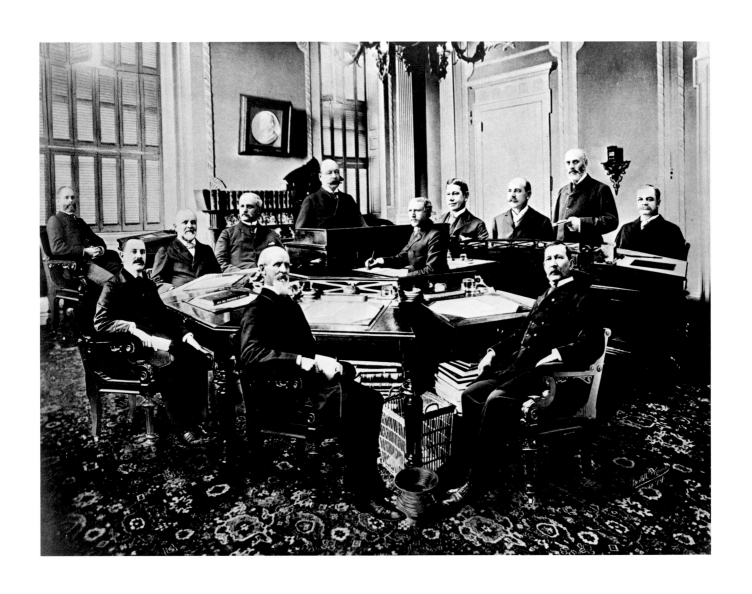

Bartlett F. Kenney. **Massachusetts Governor Frederick T. Greenhalge and Council**. 1894

Platinum composite print. 12¼ x 15½" (31.1 x 38.1 cm) print on 12⅝ x 15¾" (32.1 x 40 cm) mount. Society for the Preservation of New England Antiquities, Boston. Gift of Roger Wolcott, 1934

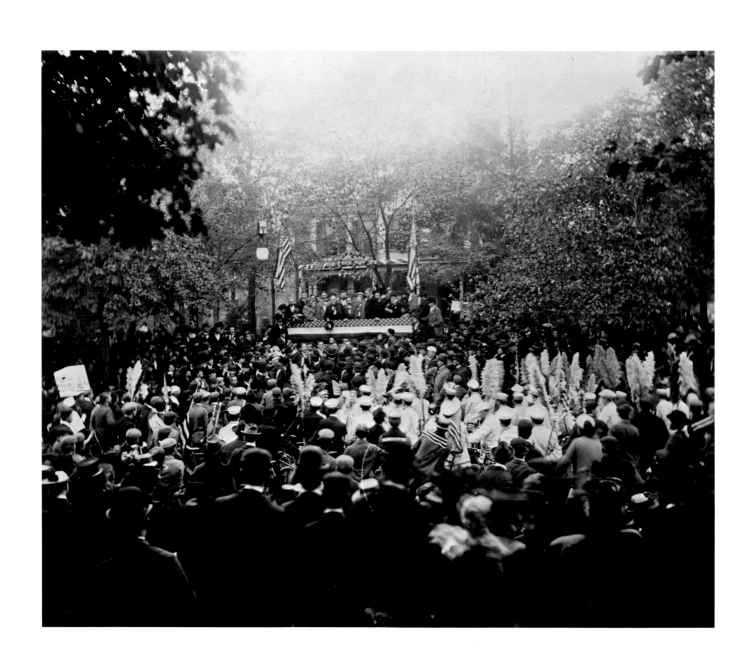

J. L. Brouse. **Hon. William McKinley and Chicago Wheelmen at Canton, Ohio**. 1901

Tinted gelatin-silver printing-out-paper print. 7⅜ x 9" (18.8 x 22.9 cm). Prints and Photographs Division, The Library of Congress, Washington, D.C.

Thomas Smith. **President McKinley at the International Hotel on the Day of His Assassination, Three Hours Before**.
September 6, 1901

Gelatin-silver print. 4⅝ x 3⅝" (11.8 x 9.3 cm). George Eastman House, Rochester, New York. Gift of the Rochester Public Library

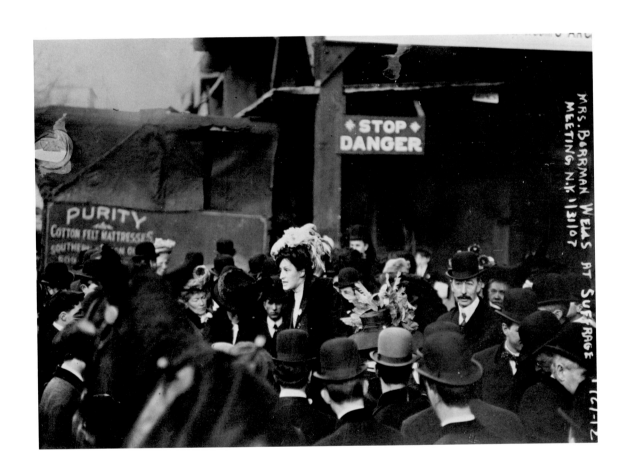

George Grantham Bain. **Mrs. Borrman Wells at Suffrage Meeting, New York**. January 31, 1907

Gelatin-silver print. 4¼ x 6½" (10.9 x 16.6 cm). Museum of the City of New York Archives

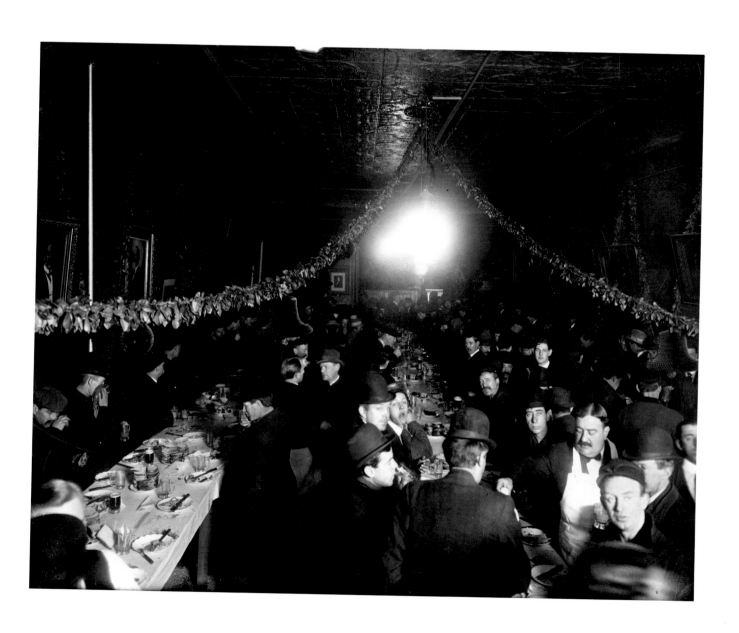

Brown Brothers. **Christmas Party Given by Jim Sullivan's Political Club**. c. 1900

Gelatin-silver print, printed later. 6⅝ x 8⁷⁄₁₆" (16.9 x 21.5 cm). The New York Times

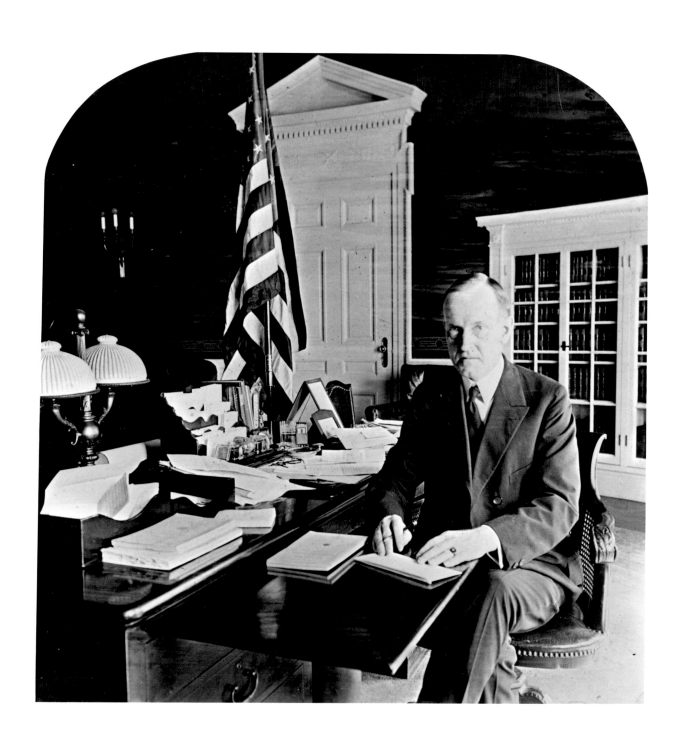

Photographer unknown. **Calvin Coolidge, 30th President of the United States, in His Office in the White House, Washington, D.C.** 1923

Gelatin-silver print (one-half stereograph). 3⅛ x 3" (8 x 7.7 cm). Prints and Photographs Division, The Library of Congress, Washington, D.C.

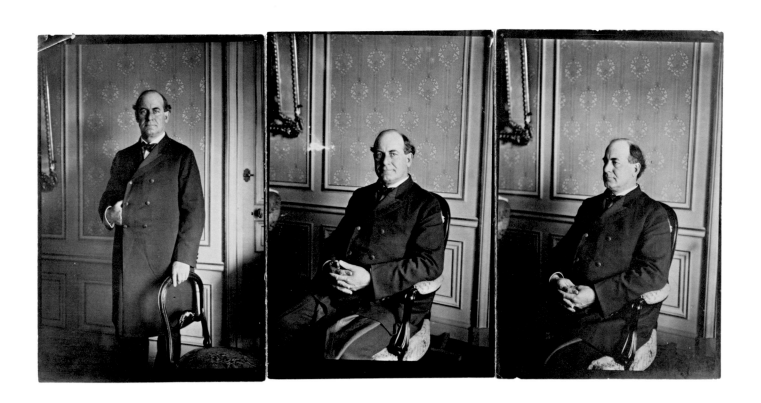

Frances Benjamin Johnston (1864–1952). **William Jennings Bryan, Grand Hotel, Paris**. 1905
Three gelatin-silver prints. Each 7 x 4¾" (17.8 x 12.1 cm). Prints and Photographs Division, The Library of Congress, Washington, D.C.

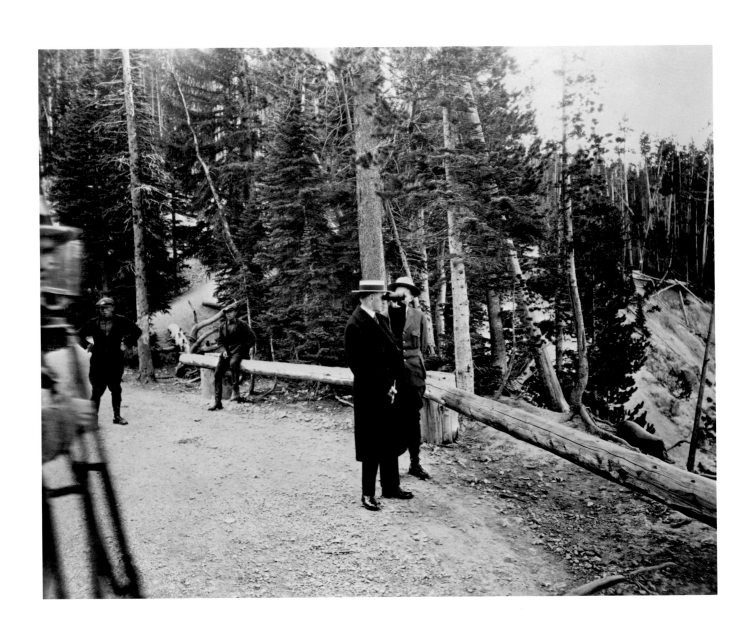

Jack Ellis Haynes (1884–1962). **President Coolidge and Mrs. Albright at Artist Point, Yellowstone National Park**. 1927

Gelatin-silver print. 7¹⁵⁄₁₆ x 10" (20.2 x 25.4 cm). Prints and Photographs Division, The Library of Congress, Washington, D.C.

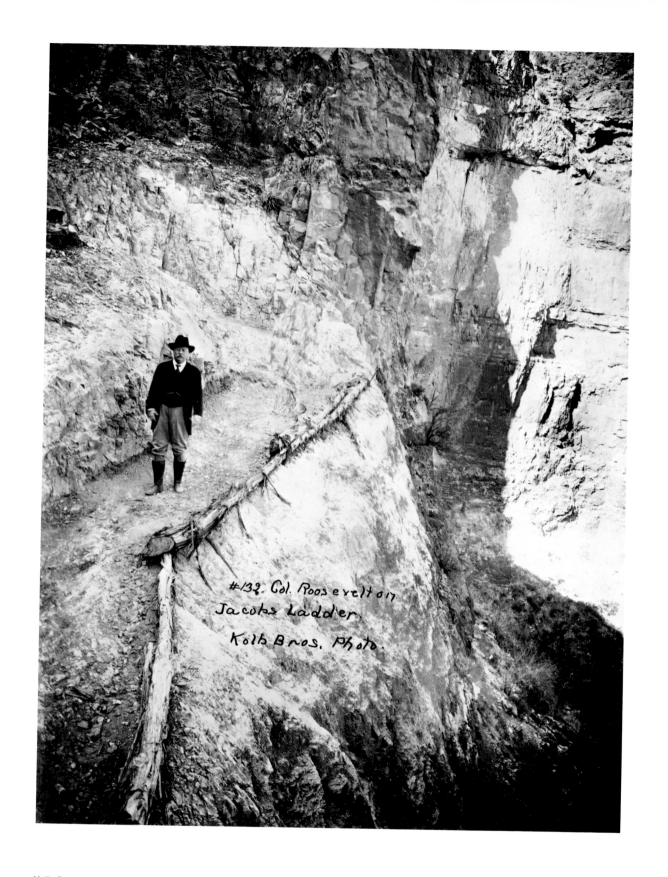

Kolb Brothers. **Colonel Roosevelt on Jacob's Ladder**. 1911

Gelatin-silver print. 9⁹⁄₁₆ x 7⁹⁄₁₆" (24.3 x 19.3 cm). Prints and Photographs Division, The Library of Congress, Washington, D.C.

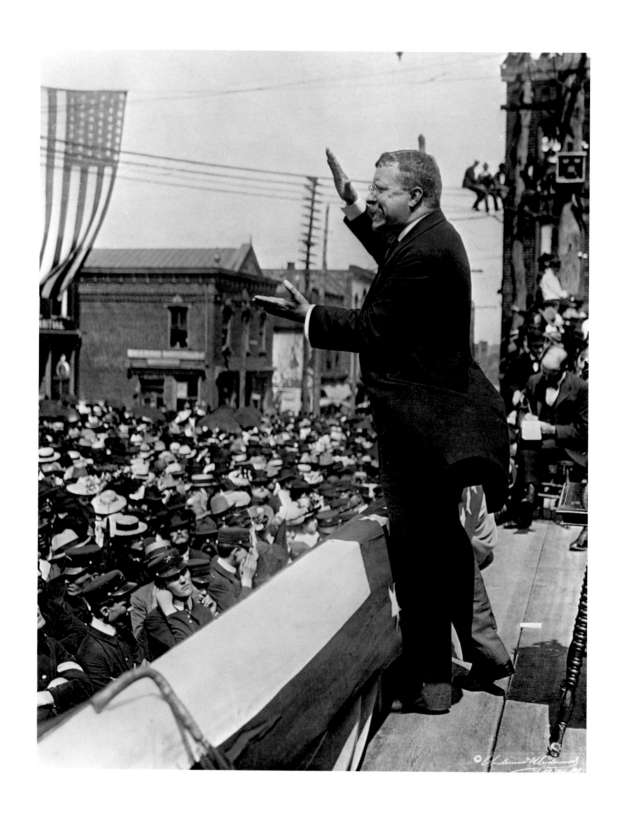

Underwood and Underwood. **President Theodore Roosevelt Speaking with Hands Raised.** 1901–09

Gelatin-silver print. 9³⁄₁₆ x 7⁵⁄₁₆" (23.4 x 18.6 cm). Collection of The New-York Historical Society

Underwood and Underwood. **President Theodore Roosevelt Visiting Hospital**. 1901–09

Gelatin-silver print. 9³⁄₁₆ x 7³⁄₁₆" (23.4 x 18.3 cm). Collection of The New-York Historical Society

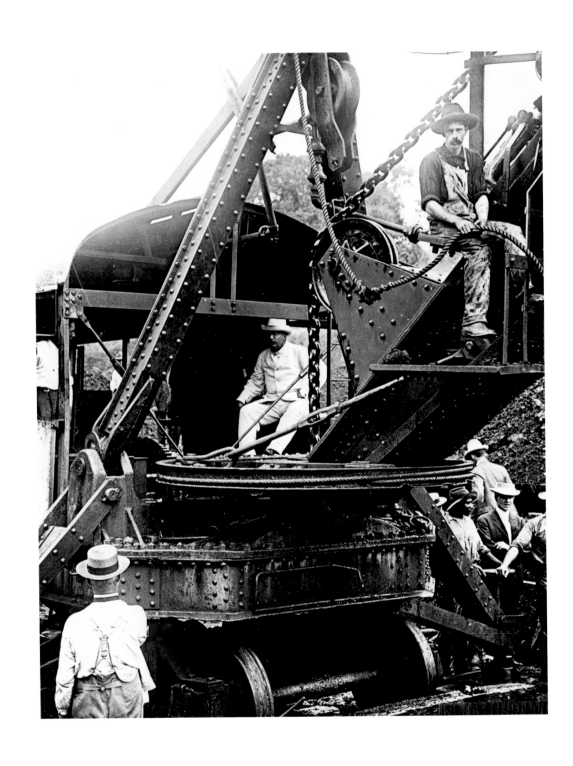

Underwood and Underwood. **President T. Roosevelt Running an American Steam-Shovel at Culebra Cut, Panama Canal**. November 1906

Gelatin-silver print. 9³⁄₁₆ x 7³⁄₁₆" (23.4 x 18.3 cm). Collection of The New-York Historical Society

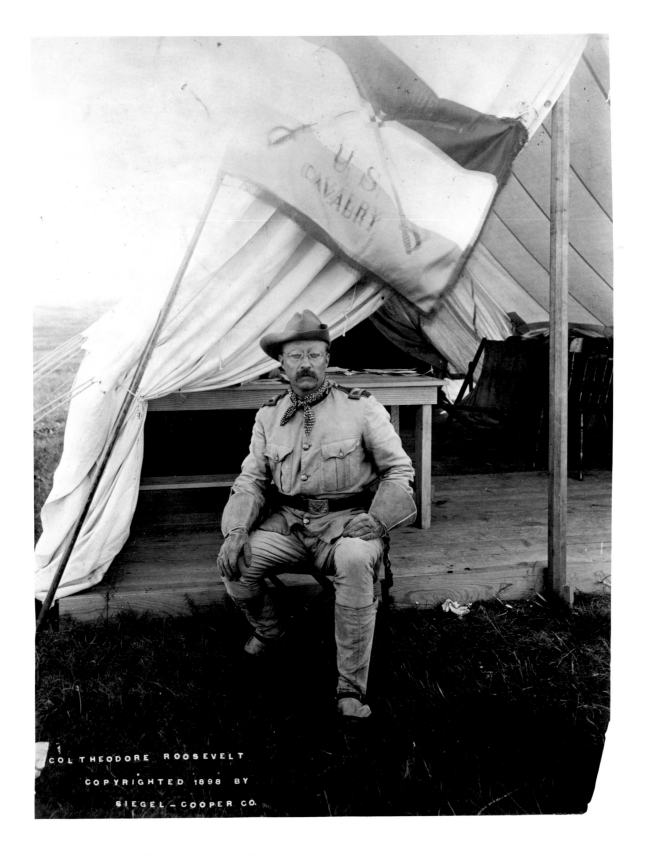

Siegel-Cooper Co. **Col. Theodore Roosevelt**. 1898

Gelatin-silver printing-out-paper print. 8½ x 6⁹⁄₁₆" (21.6 x 16.7 cm). Prints and Photographs Division, The Library of Congress, Washington, D.C.

Harris and Ewing Studio (active 1905–1977). **The Theodore Roosevelt Family at the White House**. c. 1908

Brown-toned gelatin-silver print. 9^{15}/$_{16}$ x 12^{13}/$_{16}$" (25.1 x 32.5 cm). National Portrait Gallery, Smithsonian Institution, Washington, D.C. Gift of Joanna Sturm

Edward Steichen (American, born Luxembourg, 1879–1973). **Theodore Roosevelt**. 1908
Carbon print. 20 1/16 x 15 1/16" (51 x 38.2 cm). Lent by The Metropolitan Museum of Art, New York. Alfred Stieglitz Collection, 1933

United Press International/Bettmann. **Congresswoman Presented with Flag Flown on House During Passage of Suffrage Amendment**. January 21, 1918.

"Left to right: J. J. Shinnott, doorkeeper of the House of Rep., J. Connelly, secretary to Rep. Carter of Mass., Rep. Jeannette Rankin of Montana, and Rep. Carter of Mass." Gelatin-silver print, printed later. 5⁹⁄₁₆ x 7⅛" (14.1 x 18.1 cm). The Bettmann Archive

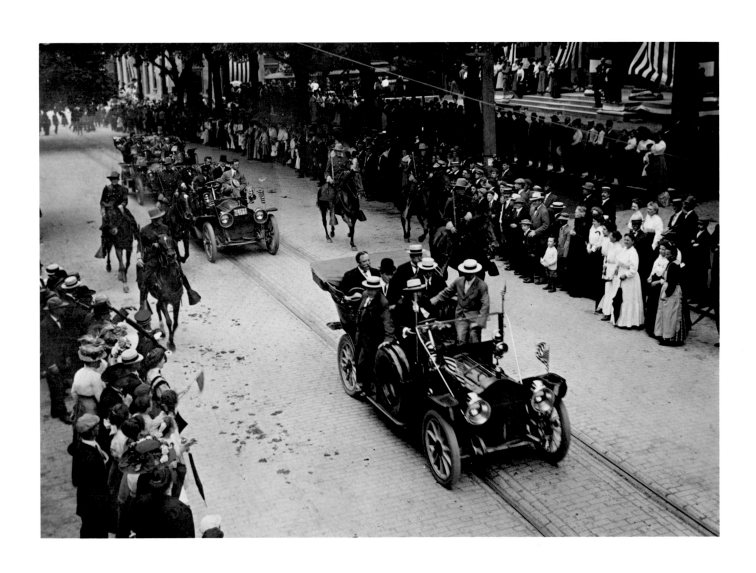

Joseph W. Belt (1874–1950). **President Taft on Parade up High Street, West Chester, Pennsylvania**. June 25, 1910
Gelatin-silver print. 13¾ x 19¹¹/₁₆" (35 x 50 cm). Chester County Historical Society, West Chester, Pennsylvania

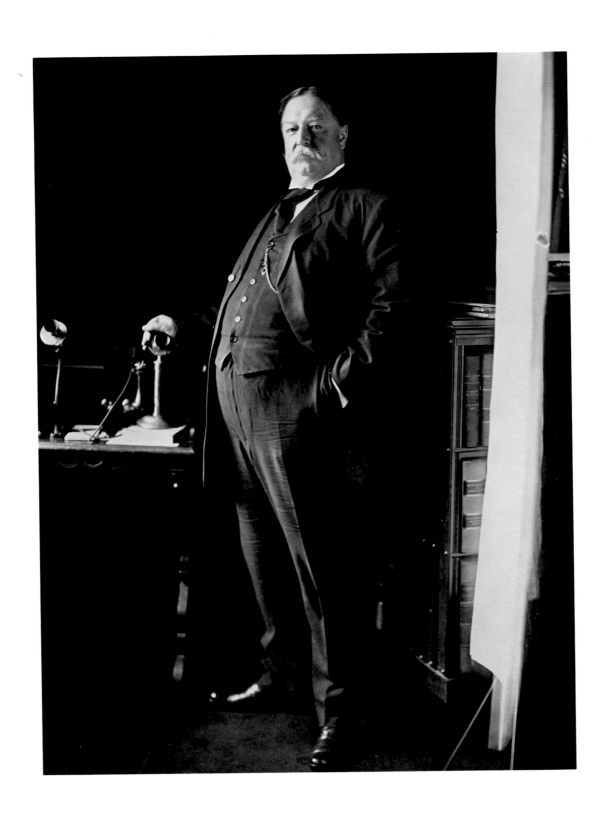

Photographer unknown. **President William Howard Taft**. 1909–13

Gelatin-silver print. 8⅞ x 6⅞" (22.5 x 17.5 cm). Prints and Photographs Division, The Library of Congress, Washington, D.C.

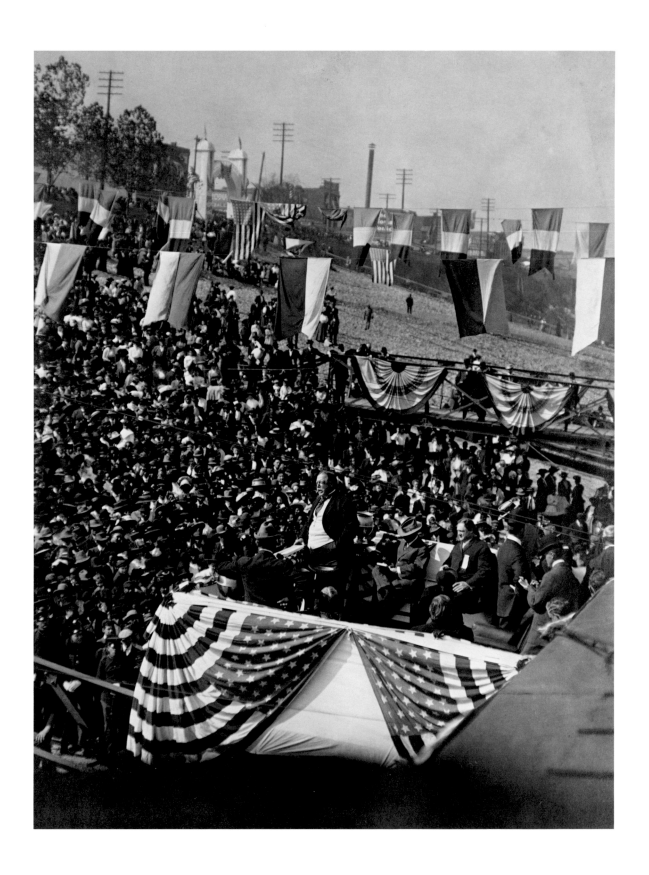

Photographer unknown. **President Taft Speaking**. 1909

Gelatin-silver print. 9⅞ x 7⅞" (25.1 x 20 cm). Prints and Photographs Division, The Library of Congress, Washington, D.C.

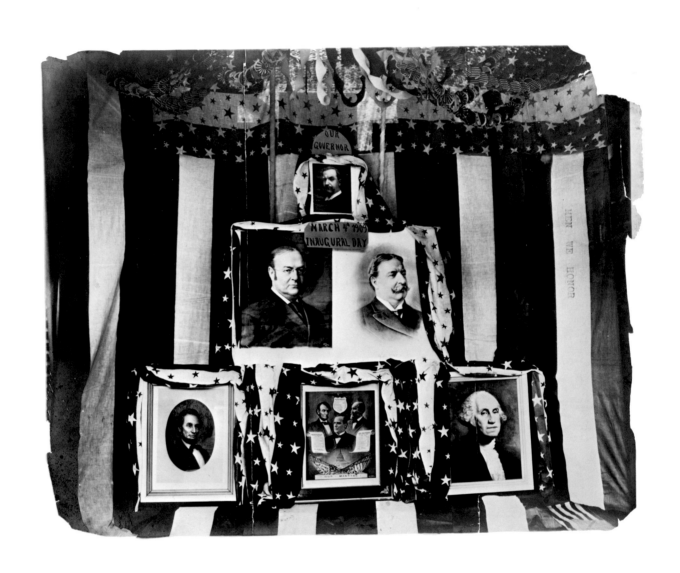

F. E. Dewey. **Men We Honor**. March 4, 1909

Gelatin-silver print. 7¹⁵⁄₁₆ x 10¹³⁄₁₆" (20.2 x 27.4 cm). Prints and Photographs Division, The Library of Congress, Washington, D.C.

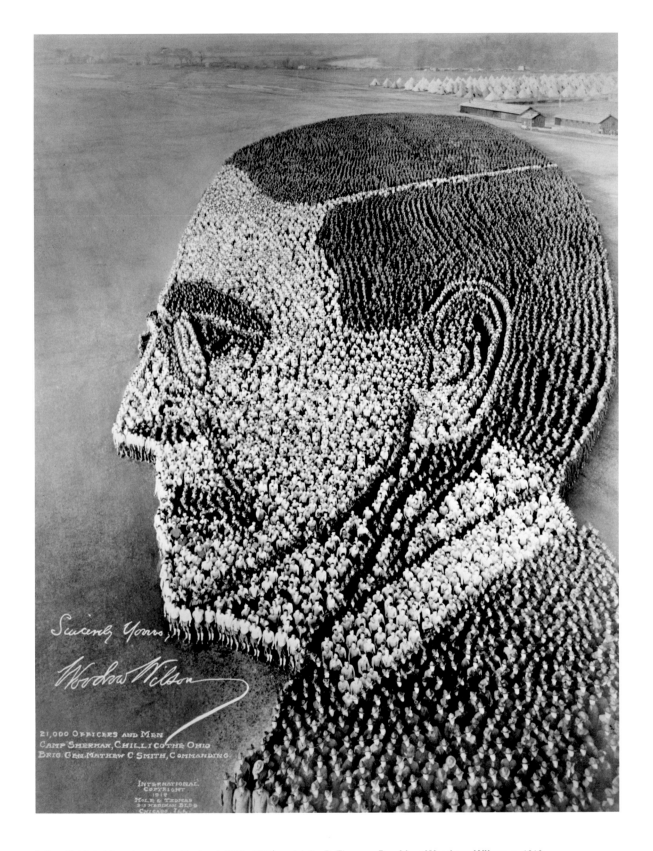

Arthur S. Mole (American, born England, 1889–1983) and John D. Thomas. **President Woodrow Wilson**. c. 1919

"Image of head formed by 21,000 men at Camp Sherman, Chillicothe, Ohio." Gelatin-silver print. 14 x 11" (35.6 x 28 cm). Chicago Historical Society. Negative no. ICHi-16304

Photographer unknown. **President Calvin Coolidge**. 1923–29

Gelatin-silver print. 14 x 11⅝" (35.6 x 29.5 cm). Collection Dimitri Levas

Times Wide World Photos. **President Coolidge Opens the Baseball Season in Washington**. April 20, 1924
"Tossing out the first ball in the game between the Senators and the Athletics." Gelatin-silver print. 8 x 10" (20.4 x 25.4 cm). The New York Times

Schutz Studio. **President Coolidge at a White House Reception, National Society Daughters of the American Revolution, 36th Continental Congress, Washington, D.C.** April 2, 1927

Gelatin-silver print. 9¹⁵⁄₁₆ x 40⁵⁄₁₆" (25.2 x 102.4 cm). NSDAR Archives, National Society Daughters of the American Revolution. Accession no. 89-102(j)

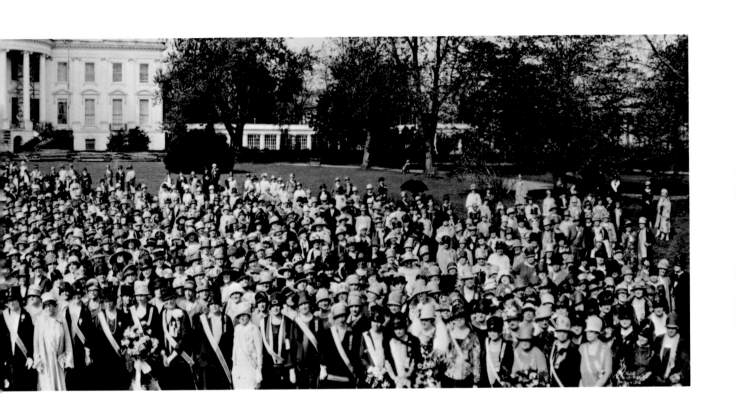

Underwood and Underwood. **The Human Touch.** c. 1935

"New York—Photo shows: Helen Keller, remarkable and world-famous blind deaf-mute, 'seeing' and 'hearing' former Gov. Alfred E. Smith, who is greeting her with his famous smile and a word of cheer at the annual Christmas sale for the benefit of the New York State Commission for the Blind. Witnesses at the meeting of the famous people state that Miss Keller's words could be understood." Gelatin-silver print. 9⅜ x 7½" (23.9 x 19.1 cm). George R. Rinhart Collection

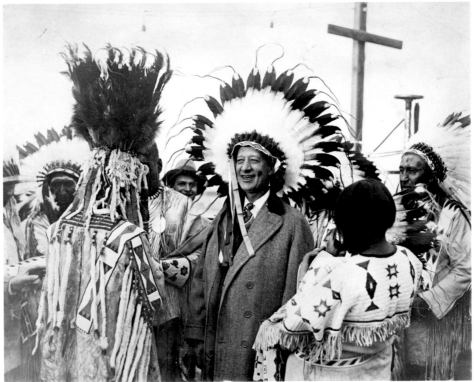

Top: Times Wide World Photos. **Al Smith at Game**. October 18, 1931. Gelatin-silver print. 7½ x 9⅞" (19.1 x 25.2 cm). The New York Times

Above: Pacific and Atlantic Photos. **Governor Smith Becomes Chief "Leading Star."** 1928. "The Democratic presidential candidate is adopted by the Indians at the state fair in Helena, Mont., and henceforth holds high rank among the Blackfoot and Flathead tribes." Gelatin-silver print. 7⅝ x 9½" (19.4 x 24.2 cm). The New York Times

The New York Times. **The Brown Derby That Weathered Many a Campaign.** January 16, 1945

"On display at Alfred E. Smith memorial exhibition: The brown derby that weathered many a campaign." Gelatin-silver print. 9³⁄₈ x 7¹¹⁄₁₆" (23.9 x 19.6 cm). The New York Times

United Press International/Bettmann. **Another Little Democrat in the Party.** May 1930

"Alfred E. Smith with his latest granddaughter, the second daughter of Major John A. Warner and Mrs. Warner, born on May 11 in Albany." Gelatin-silver print. 10¹⁄₁₆ x 8" (25.6 x 20.4 cm). The New York Times

Automatic camera/Photomaton. **Governor Smith and His Wife at Atlantic City Yesterday**. c. 1928

Gelatin-silver print of two rephotographed photo booth strips. Each strip 8¼ x 1½" (21 x 3.9 cm). The New York Times

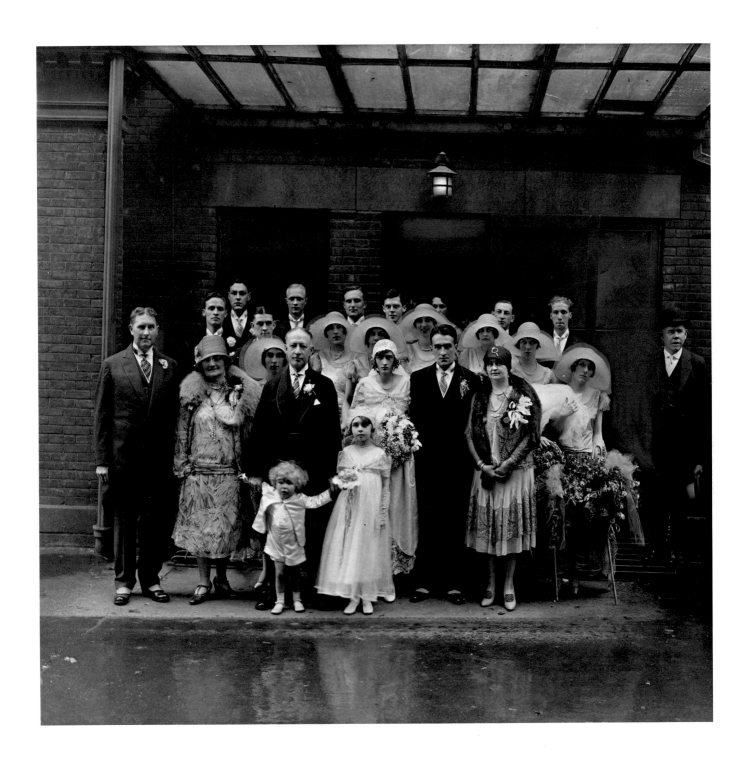

Times Wide World Photos. **After the Wedding in Albany**. June 1928

"Governor and Mrs. Smith, with their daughter, Mrs. Francis J. Quillinan, and her husband, and the bridal party at the Executive Mansion after the wedding in Albany." Gelatin-silver print. 8 x 8¼" (20.4 x 21.1 cm). The New York Times

James Van Der Zee (1886–1983). **Democratic Club Gathering**. c. 1935

Gelatin-silver print. 7⁹⁄₁₆ x 9⁵⁄₈" (19.3 x 24.5 cm). Courtesy Howard Greenberg Gallery, New York

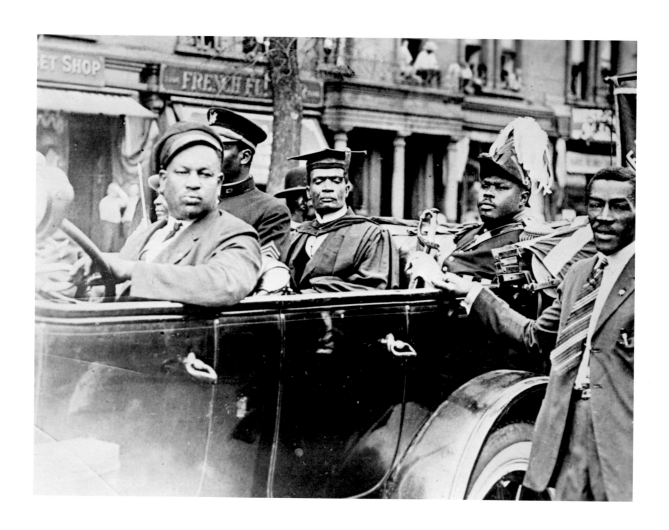

James Van Der Zee (1886–1983). **Marcus Garvey in UNIA (Universal Negro Improvement Association) Parade, New York City**. 1924

Gelatin-silver print. 4⅞ x 5⅞" (12.4 x 14.8 cm). Photographs and Prints Division, Schomburg Center for Research in Black Culture, The New York Public Library

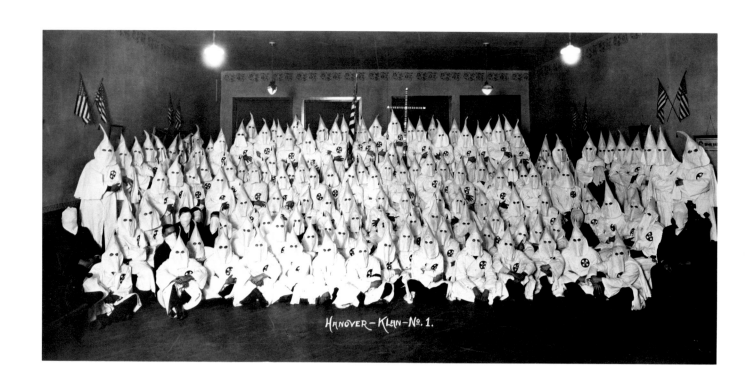

Photographer unknown. **Hanover—Klan—No. 1**. 1920s
Gelatin-silver print. 8½ x 17¹⁵⁄₁₆" (21.6 x 45.7 cm). Collection Dancing Bear

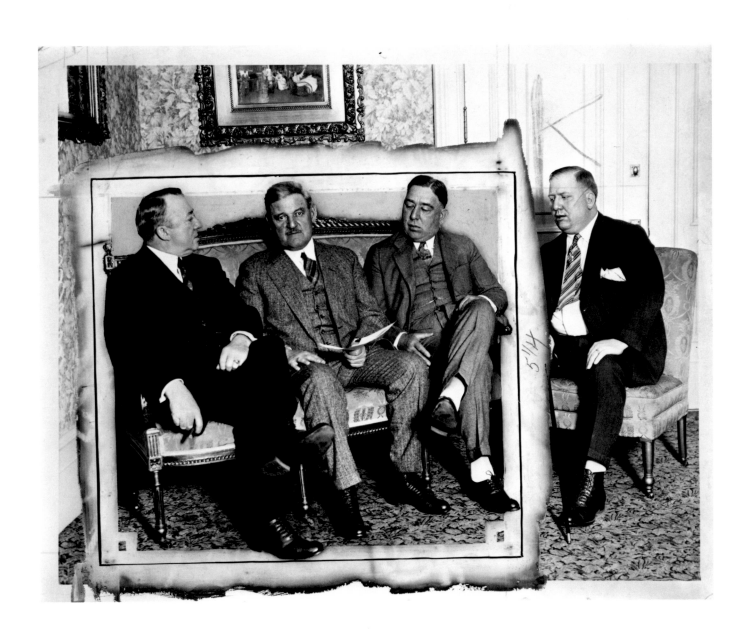

International Newsreel Photo. **Three Illinois Leaders Meet in Their New York Hotel.** June 22, 1924

"Three Illinois leaders meet in their New York hotel to discuss ways and means for the coming battle on the convention floor in Madison Square Garden. Here, from left to right, are Congressman James R. Buckley, Mayor Dever and Comptroller Martin J. O'Brien of the Chicago delegation." Gelatin-silver print. 8 x 10¼" (20.4 x 26.1 cm). Chicago Historical Society. Negative no. ICHi-24163

Bettmann. **Jewish Stage Guild Honors Mayor Walker.** April 12, 1931

"Banquet to Mayor James Walker, was tendered April 12, by the Jewish Theatrical Guild, at Hotel Commodore, New York City. Here's the Chief Executive, in front of the huge floral horseshoe, at the dinner." Gelatin-silver print. 9⅝ x 7⁹⁄₁₆" (24.5 x 19.3 cm). The Bettmann Archive

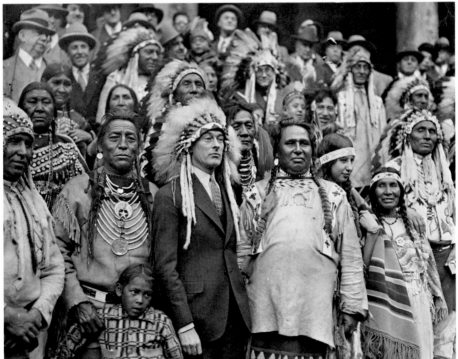

Top: Times Wide World Photos. **The Passing of a Hat.** October 1927. "Mayor Walker deposits the top-per worn by Oscar Hammerstein in the days of his career as an opera manager in the cornerstone of the new Hammerstein Theatre." Gelatin-silver print. 7½ x 9⅝" (19.1 x 24 cm). The New York Times

Above: Times Wide World Photos. **Heap Big Injun.** December 10, 1933. "Mayor James J. Walker of New York City on the steps of the City Hall, where he was christened Chief A-Ka-Ki-To-P (Many Rider) by Blackfeet Indians. Headed by Chief Two Guns White Calf (on Mayor's left) and Chief Owen Heavy Breast at the Executive's right. The Red Men were in the city to take part in the Military Tournament at Madison Square Garden." Gelatin-silver print. 7¹³⁄₁₆ x 9¹³⁄₁₆" (19.9 x 25 cm). The New York Times

Alexander Archer. **Mayor La Guardia and Commissioners**. 1934–45

Gelatin-silver print. 9 x 12¾" (23 x 32.5 cm). Museum of the City of New York Archives

Weegee (Arthur Fellig) (American, born Austria, 1899–1968). **Mayor La Guardia.** 1943

"Mayor La Guardia braces himself around one rail at the West 123rd street Police station in conference with officials of the Fire Department on the night of the Harlem race riots." Gelatin-silver print, printed later. 9½ x 7½" (24.2 x 19.1 cm). Weegee Archive and Collection at the International Center of Photography, New York. Bequest of Wilma Wilcox

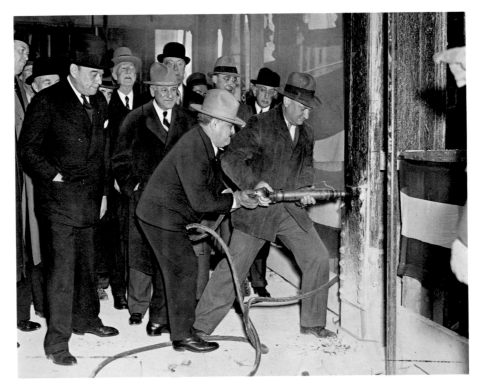

Top: Times Wide World Photos. **The Mayor's Day.** April 10, 1940. "[Mayor La Guardia] gets a letter, drives a rivet. Completing the steel work on the new Criminal Courts Building." Gelatin-silver print. 6¾ x 8⁹⁄₁₆" (17.2 x 21.8 cm). The New York Times

Above: *The New York Times*. **Mayor La Guardia Takes Lessons in Civilian Defense**. April 6, 1942. "At City Hall yesterday. Mr. La Guardia holding a copy of the 'Handbook of Civilian Protection' while he watches a demonstration of the workings of an incendiary bomb. In the center is Dr. Harry N. Wright, president of City College, and at the right, Professor David Lewis of the Chemistry Department." Gelatin-silver print. 7⁹⁄₁₆ x 9³⁄₈" (19.3 x 24 cm). The New York Times

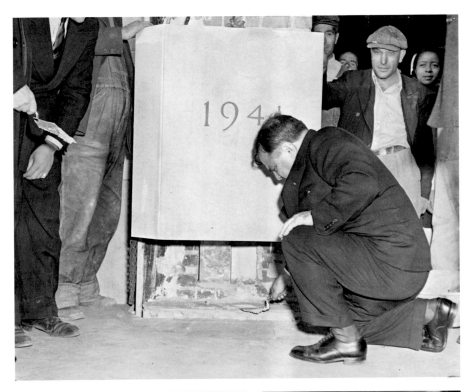

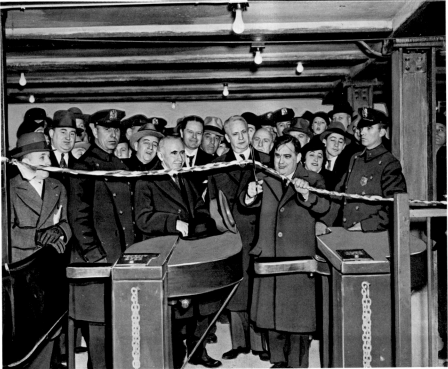

Top: *The New York Times*. **Mayor La Guardia Lays Cornerstone on North Brothers Island**. October 21, 1941. Gelatin-silver print. 7½ x 9½" (19.1 x 24.2 cm). The New York Times

Above: Times Wide World Photos. **Mayor La Guardia Cutting the Ribbon.** 1936. "Mr. La Guardia cutting the ribbon at the entrance to the East Broadway station of the new Houston–Essex Street line. Watching the Mayor are John H. Delaney, chairman of the Board of Transportation, left, and Borough President Samuel Levy." Gelatin-silver print. 6¹¹⁄₁₆ x 8⁷⁄₁₆" (17.1 x 21.5 cm). The New York Times

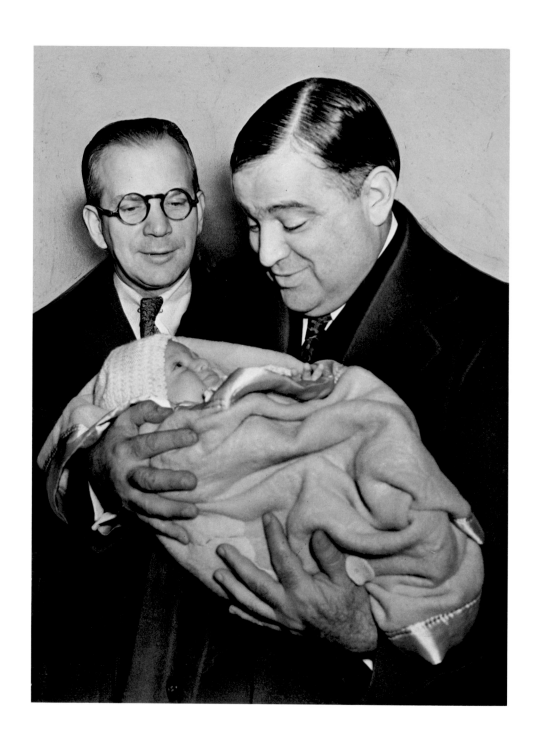

Times Wide World Photos. **The Mayor and a Baby Exchange Smiles.** December 8, 1938

"Mr. La Guardia at dedication of a child health station in Brooklyn." Gelatin-silver print. 7⅝ x 5⅝" (19.4 x 14.4 cm).
The New York Times

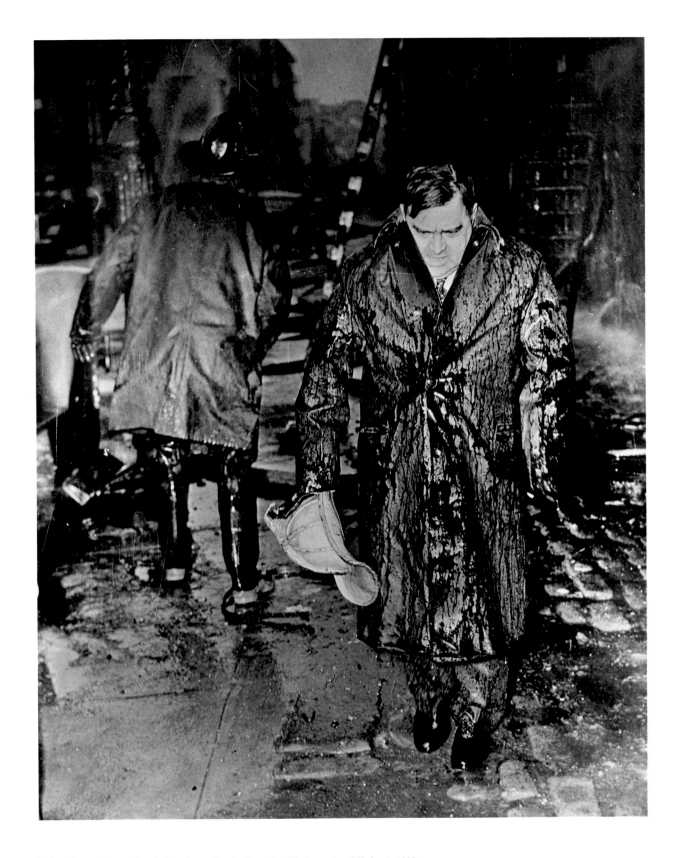

United Press International. **Leaving a Fire in Drenched Raincoat and Helmet.** 1939

"Fire Buff La Guardia appears in his favorite role. In this case he had entered a burning building at considerable risk, to make sure of rescue of a fireman pinned by a fallen beam." Gelatin-silver print. 9⁹/₁₆ x 7¹¹/₁₆" (24.3 x 19.6 cm). The New York Times

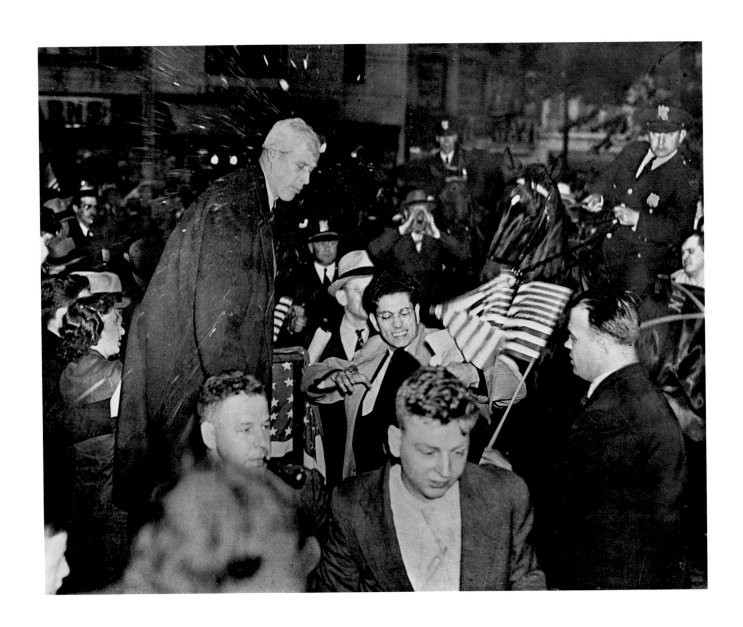

Ralph Morgan/United Press International. **Norman Thomas Attacked by Demonstrators**. 1938

"[One of the] Most Important News Pictures of '38: Rotten eggs and ripe tomatoes break against the face and body of Norman Thomas, Socialist leader, as hostile demonstrators break up a meeting he was attempting to address in Newark, N.J. The demonstrators, many wearing veterans' caps and carrying such banners as 'Reds Keep Out,' marched into Military Park with a band which drowned out Thomas' voice." Gelatin-silver print. 7⁹⁄₁₆ x 9½" (19.3 x 24.3 cm). Lent by the Time Inc. Picture Collection

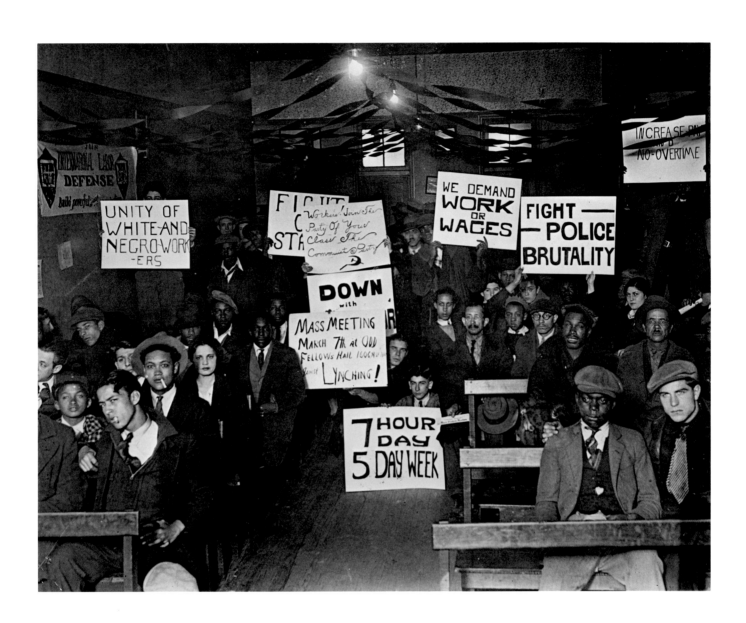

Underwood and Underwood. **Capital Communists Plan Demonstration.** March 6, 1930

"First photo of members of the Washington Communism society, taken at their headquarters in the Capital while plans for a demonstration in front of the White House were being discussed early today." Gelatin-silver print. 7 3/8 x 9 5/16" (18.8 x 23.7 cm). George R. Rinhart Collection

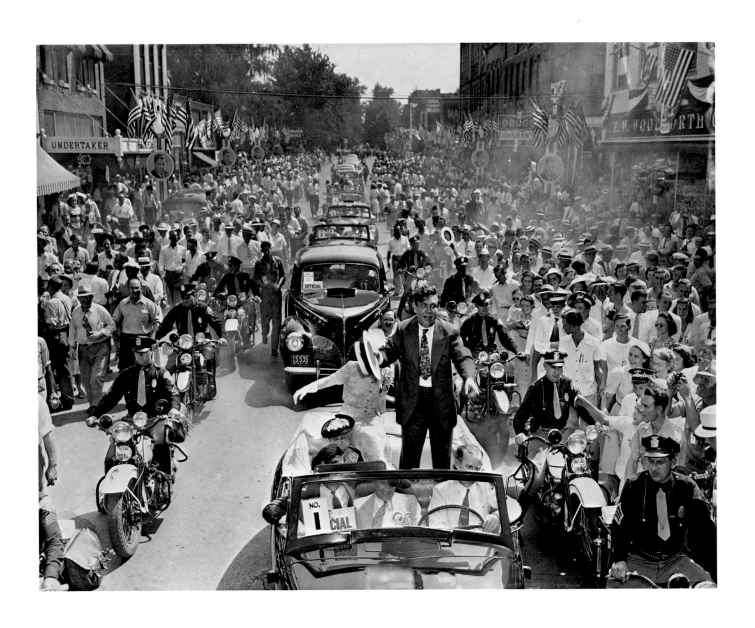

John D. Collins (1908–1963)/Wide World Photos. **Down the Dusty Street of Elwood, Ind. Rides Wendell Willkie Waging the Decade's Greatest Political Campaign**. August 1940

Gelatin-silver print. 10¾ x 13¾" (27.4 x 35 cm). The Museum of Modern Art, New York. Purchase

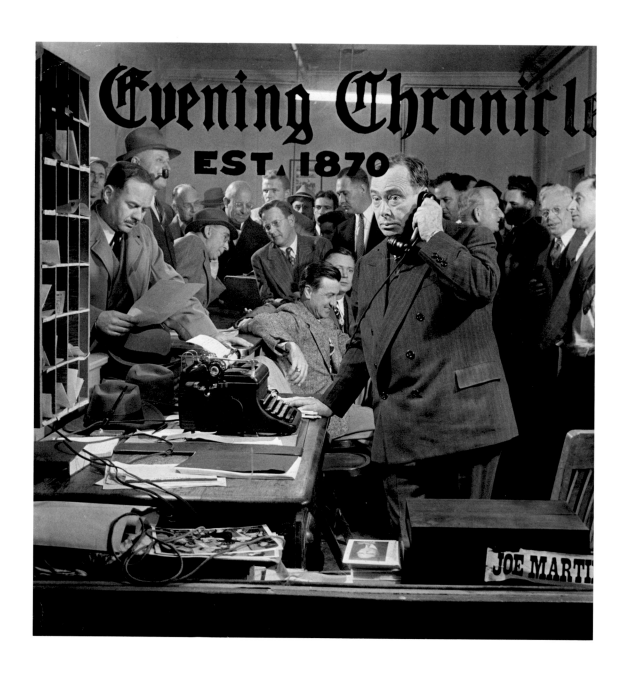

Allan Grant (born 1919)/Graphic House. **Congressman Joseph W. Martin Jr.** November 5, 1946

"Congressman Joseph W. Martin Jr. (Republican from North Attleboro, Mass.) on election night Nov. 5, 1946. He is in office of the Evening Chronicle of which he is the publisher." Gelatin-silver print. 10¹¹⁄₁₆ x 10⁹⁄₁₆" (27.2 x 26.9 cm). Lent by the Time Inc. Picture Collection

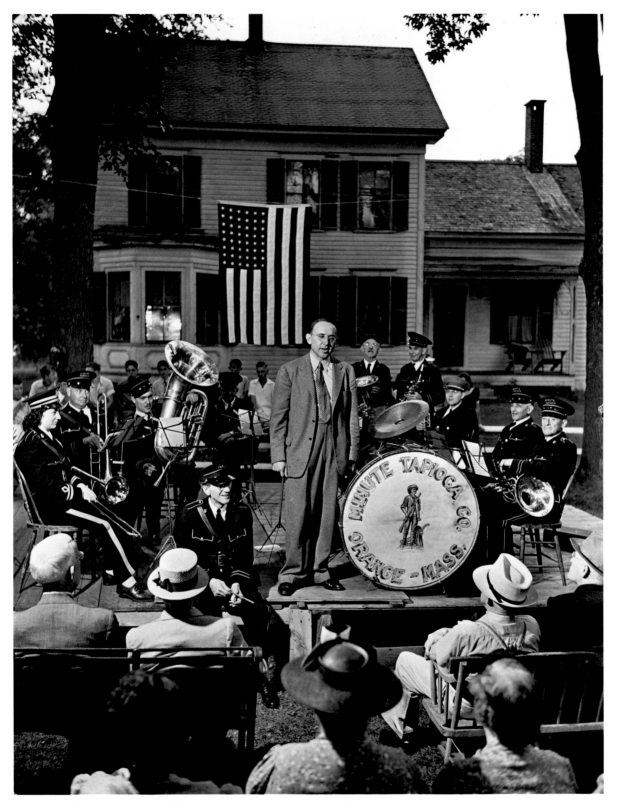

Herbert Gehr (Edmund Bert Gerard) (American, born Germany, 1911–1983)/*Life* Magazine. **On Green New England Lawns Like This One.** 1942

"On green New England lawns like this one, in North Orange, Mass., candidate Raymond Leslie Buell is conducting his campaign for Congress. He avoids political name calling, asks his audiences to think hard about the best ways to improve Congress." Gelatin-silver print. 13 1/16 x 10 3/16" (33.2 x 25.9 cm). Lent by the Time Inc. Picture Collection

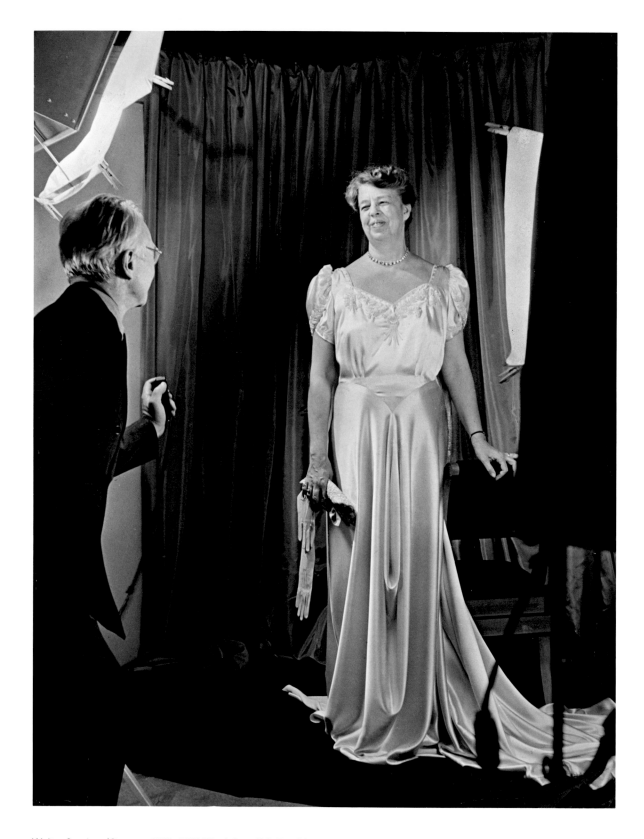

Walter Sanders (German, 1897–1985)/Black Star. **U.S. President's Wife Eleanor Roosevelt.** January 1941

"U.S. President's Wife Eleanor Roosevelt posing for photographer Edward Steichen (left), wearing gown designed by Lucille Mahoney which she will wear to F. D. R.'s third Inaugural Ball, at Arnold Constable department store, New York City." Gelatin-silver print. 13⁷⁄₁₆ x 10½" (34.2 x 26.8 cm). Lent by the Time Inc. Picture Collection

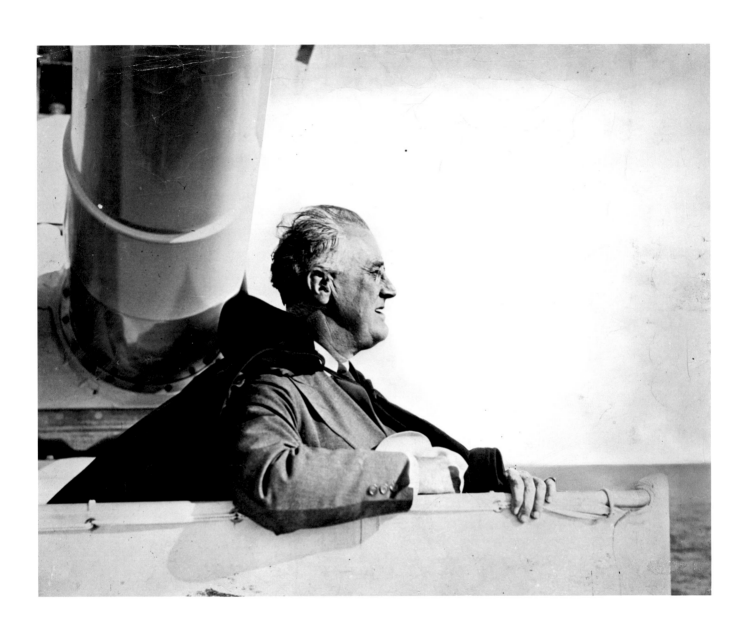

Wide World Photos. **President Roosevelt Reviewing U.S. Fleet from Bridge of U.S.S. Houston**. 1938

Gelatin-silver print. 10⅝ x 13½" (27.1 x 34.4 cm). Lent by the Time Inc. Picture Collection

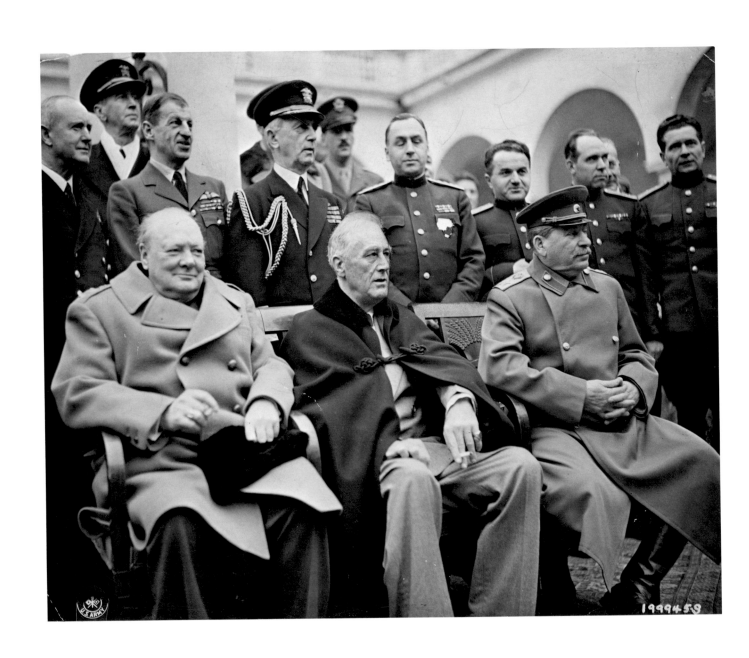

U.S. Army Signal Corps. **Crimean Conference.** February 1945

"Prime Minister Winston Churchill, President F. D. Roosevelt, and Premier Joseph Stalin, in the patio, at the palace, in Yalta where the 'Big Three' met. Rear, are Admiral Sir Andrew Cunningham, Admiral Ernest King, Air Marshal Portal, and Admiral William D. Leahy, with other high-ranking Allied officers." Gelatin-silver print. 7⅝ x 9⁷⁄₁₆" (19.4 x 24.1 cm). Lent by the Time Inc. Picture Collection

United Press International/Bettmann. **Career Woman**. 1943

"Photographers' lights surround the Connecticut Congresswoman as she holds her first Washington press meeting in 1943, just after she was elected as Republican representative. Newsmen spoke of blonde Clare Booth Luce's exceeding charm and modesty." Gelatin-silver print. 9⁵⁄₁₆ x 7⁹⁄₁₆" (23.2 x 19.3 cm). The Bettmann Archive

Charles Corte/United Press International. **President Truman and Lauren Bacall at the Press Club Canteen**. 1945
Gelatin-silver print, printed later. 9⁵⁄₁₆ x 7⁷⁄₁₆" (23.2 x 19 cm). The Museum of Modern Art, New York. Purchase

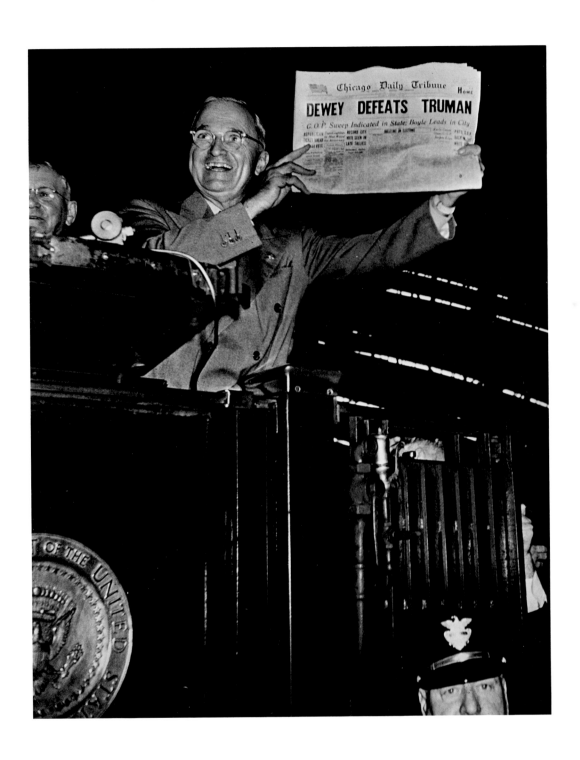

W. Eugene Smith (1918–1978)/*Life* Magazine. **Jubilant President Truman Holds Up a Copy of a Newspaper Extra.**
November 1948

"The jubilant president holds up a copy of a newspaper extra which overconfident Republican editors rushed into print on night of the election." Gelatin-silver print. 13 x 10⁷⁄₁₆" (33.1 x 26.6 cm). Lent by the Time Inc. Picture Collection

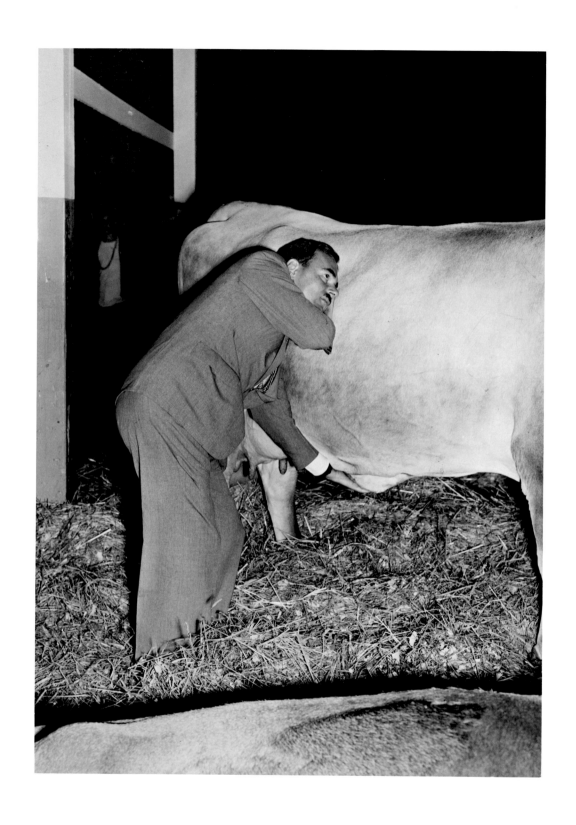

Arthur Z. Brooks (1913–1967)/Associated Press. **Governor Dewey Examines Cow at Massachusetts Fair and Puts Out a Bold Feeler for Dairy Farmers' Vote**. September 15, 1947

Gelatin-silver print. 13 9/16 x 9 3/4" (34.5 x 24.8 cm). Lent by the Time Inc. Picture Collection

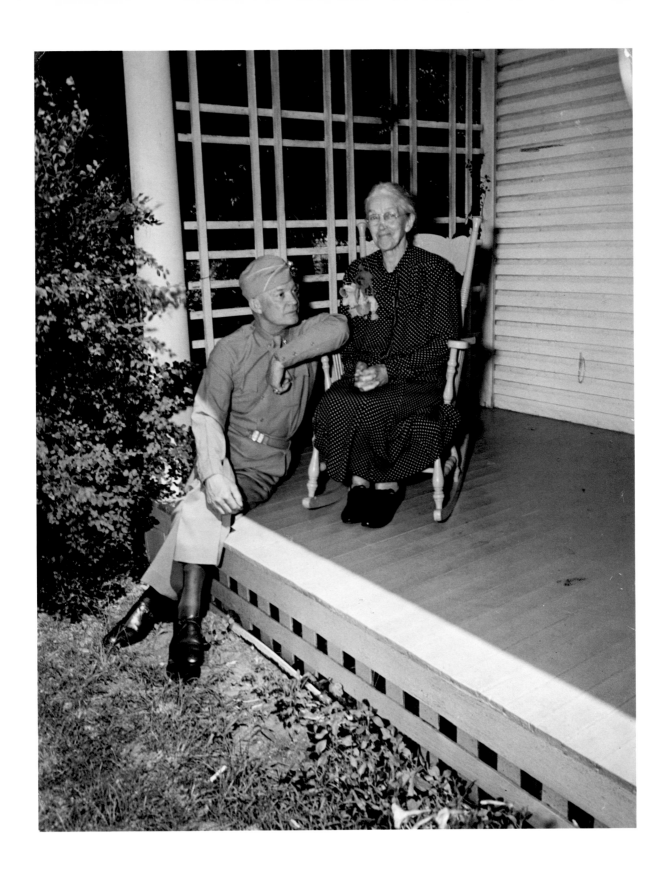

Myron Davis (born 1919)/*Life* Magazine. **Eisenhower's Homecoming, Abilene, Kansas.** 1945

"Dwight Eisenhower and his mother, Ida." Gelatin-silver print. 13⁵⁄₁₆ x 10⁵⁄₈" (33.9 x 27.1 cm). Lent by the Time Inc. Picture Collection

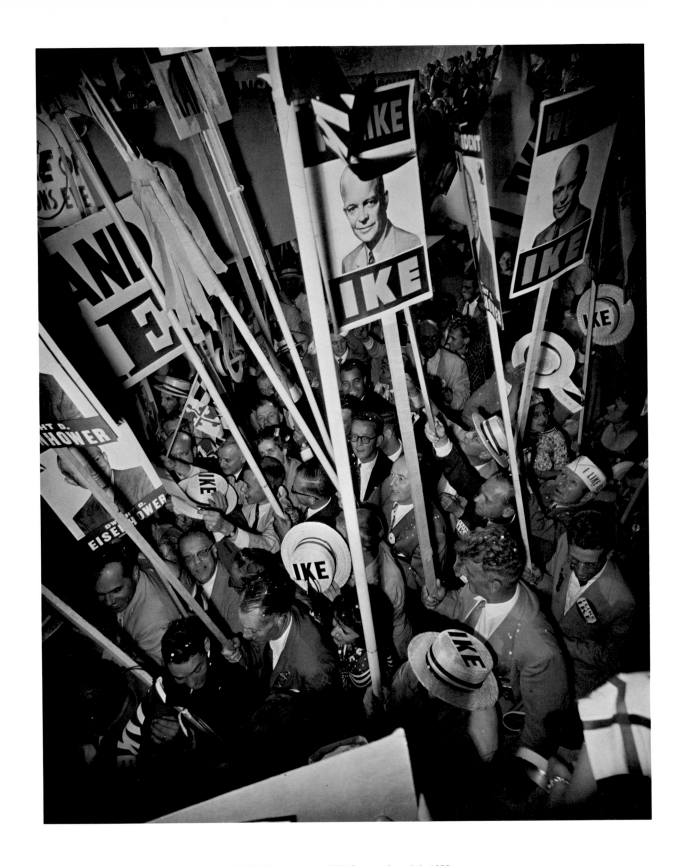

Gjon Mili (American, born Albania, 1904–1984)/*Life* Magazine. **GOP Convention.** July 1952

"No sooner had each nomination speech ended than the wild demonstrations began and the hall of the convention burst into a frenzy of whistles and sirens." Gelatin-silver print. 13 x 10¾" (33.1 x 27.4 cm). Lent by the Time Inc. Picture Collection

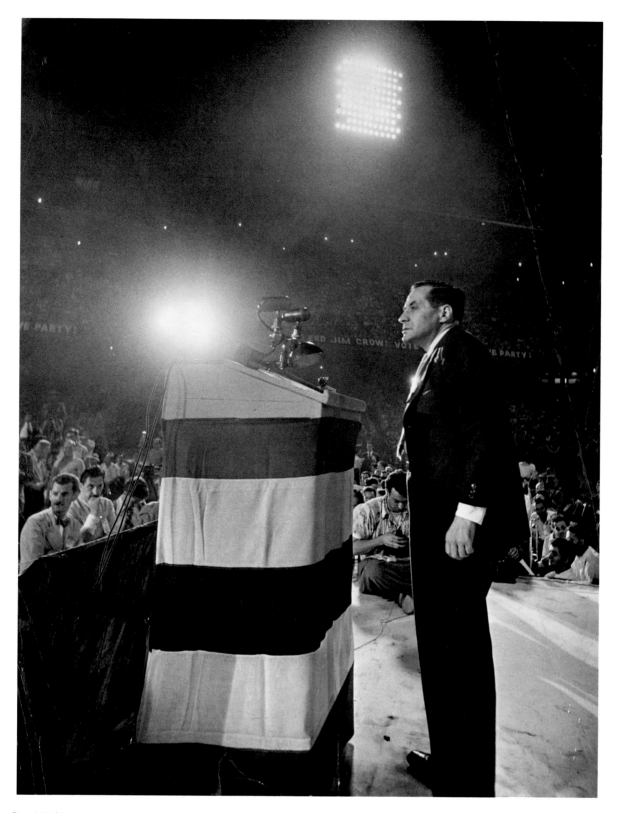

Gjon Mili (American, born Albania, 1904–1984)/*Life* Magazine. **Henry Wallace's Progressive Party Convention, Philadelphia, Pa.** July 25, 1948

"At rally Vito Marcantonio who follows the Communist line in Congress and runs his NYC district like an old-time political boss, coldly appraises the crowd of 30,000 before starting his speech." Gelatin-silver print. 13$\frac{1}{16}$ x 10$\frac{1}{4}$" (33.2 x 26.1 cm). Lent by the Time Inc. Picture Collection

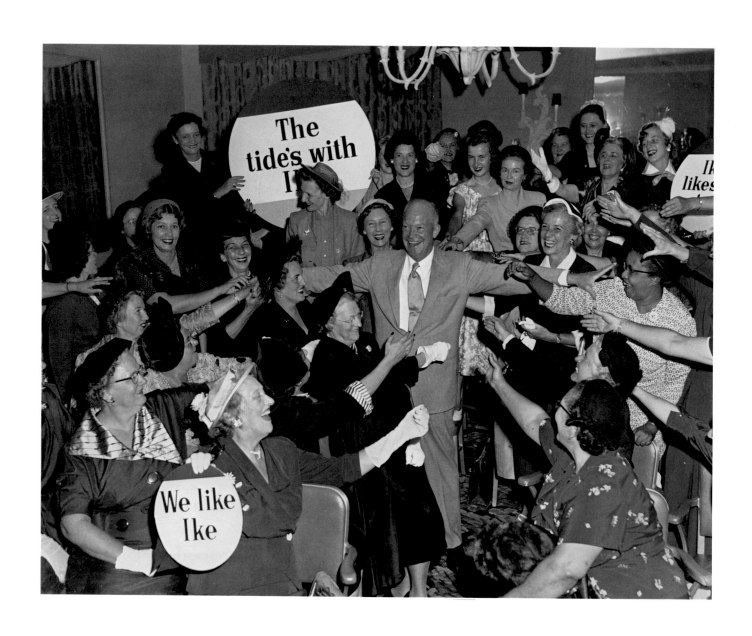

Bettmann. **General Eisenhower Hosts National Committee Women from Eleven States When They Called at His Commodore Hotel Headquarters, New York**. 1952

Gelatin-silver print. 7³⁄₈ x 9³⁄₈" (18.8 x 23.9 cm). The Bettmann Archive

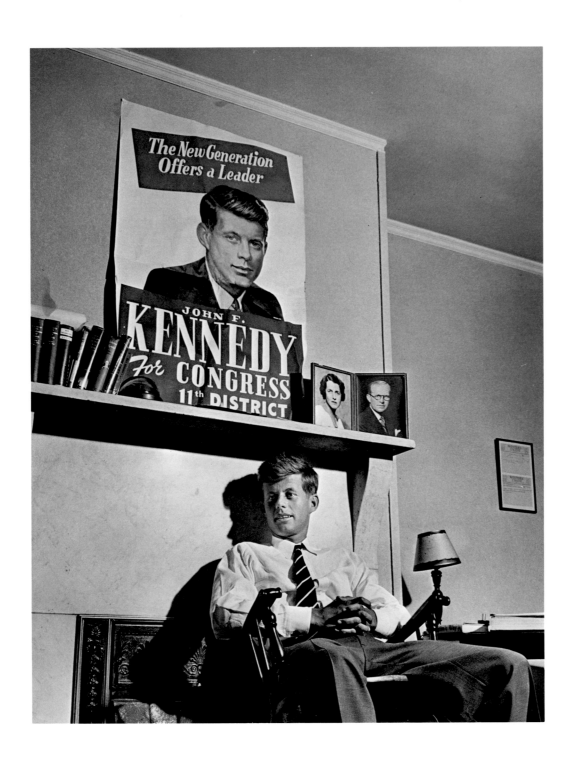

Yale Joel (born 1919)/*Life* Magazine. **John F. Kennedy (Jos. Kennedy's Son) Campaigns in Boston for Congress**. 1946

Gelatin-silver print. 13⁷⁄₁₆ x 10⁵⁄₈" (34.2 x 27.1 cm). Lent by the Time Inc. Picture Collection

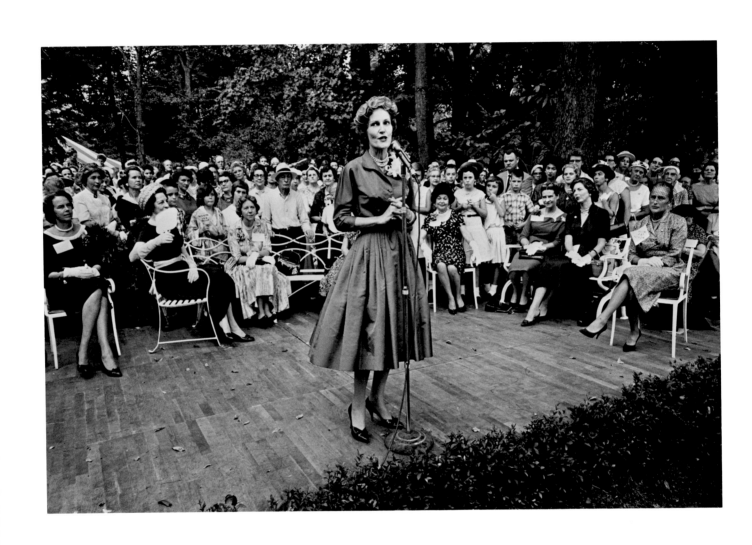

Edward Clark (born 1911)/*Life* Magazine. **Pat Nixon**. 1950s

Gelatin-silver print. 8⅞ x 13⅜" (20.1 x 34 cm). Courtesy Keith de Lellis, New York

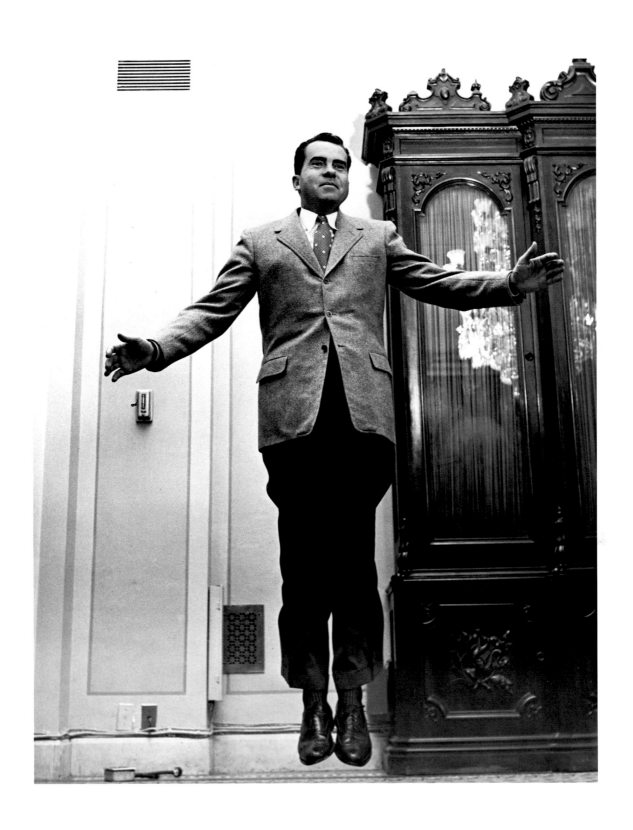

Philippe Halsman (American, born Latvia, 1906–1979). **Vice President Nixon, White House**. 1955
Gelatin-silver print. 19½ x 15½" (49.5 x 39.3 cm). Collection Harry H. Lunn, Jr., Paris

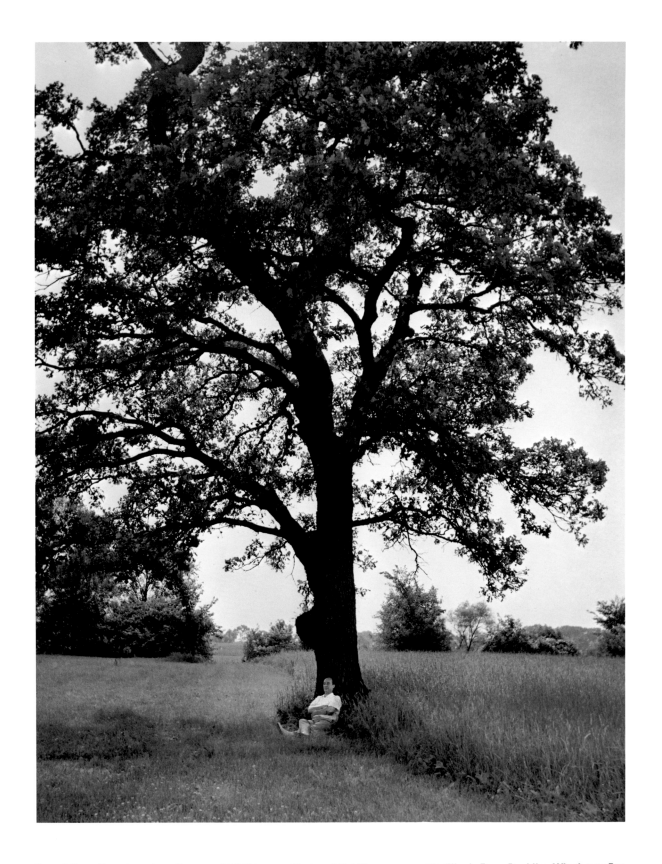

Cornell Capa (American, born Hungary, 1918)/Magnum Photos. **Adlai Stevenson, on His Illinois Farm, Deciding Whether to Run for the Presidency**. 1952

Gelatin-silver print, printed later. 12⅞ x 10⅛" (32.8 x 25.8 cm). Courtesy Magnum Photos, Inc., New York

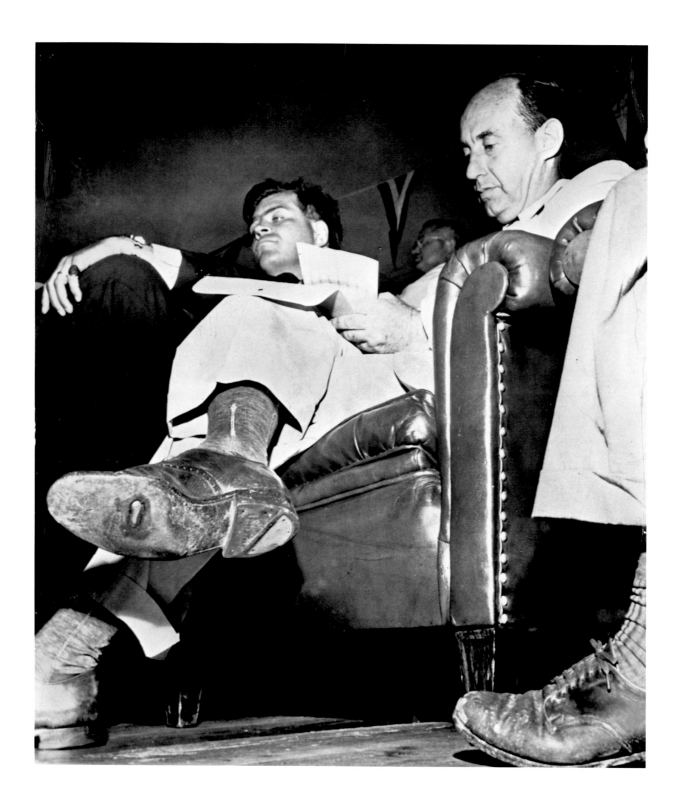

William Gallagher/Associated Press. **Gov. Adlai Stevenson, Democratic Presidential Nominee, Bares a Worn Sole to His Labor Day Rally Audience**. September 2, 1952

"Michigan Governor G. Mennen Williams appears worn from the whirlwind politics and labor tour that took in five Michigan cities in 12 hours. This picture was taken on the speakers' platform before Gov. Stevenson spoke." Gelatin-silver print. 8⅞ x 7¾" (22.5 x 19.8 cm). Lent by the Time Inc. Picture Collection

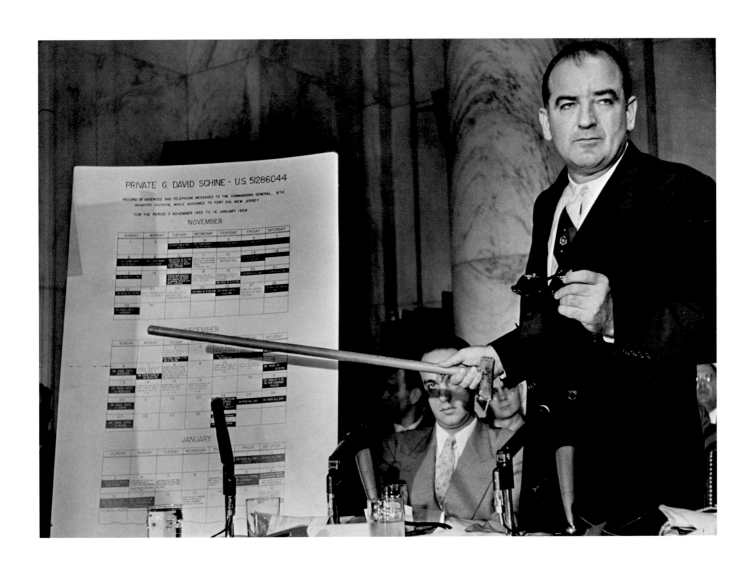

Henry G. (Hank) Walker (American, born Canada, 1922)/*Life* Magazine. **Joe McCarthy. An Ogre with a Kind of Innocence**. May 1954

Gelatin-silver print. 9½ x 13⁷⁄₁₆" (24.2 x 34.2 cm). Lent by the Time Inc. Picture Collection

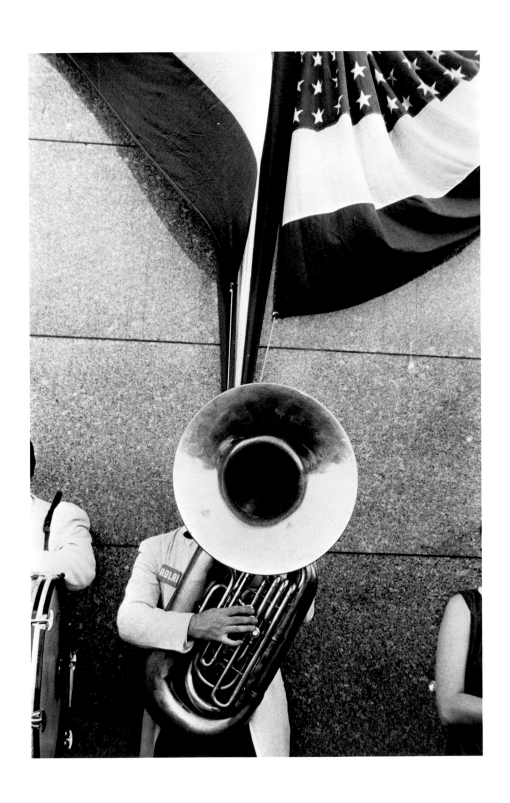

Robert Frank (American, born Switzerland, 1924). **Political Rally, Chicago**. 1956
Gelatin-silver print. 18⅜ x 12⁵⁄₁₆" (46.7 x 31.2 cm). The Museum of Modern Art, New York. Purchase

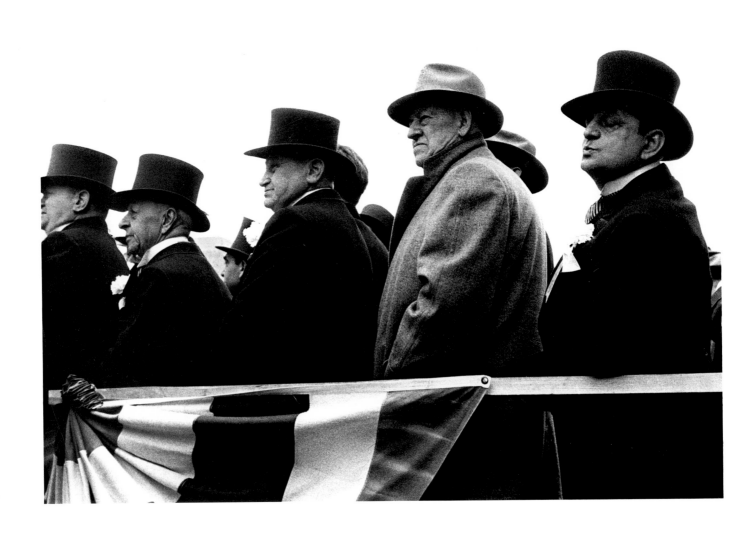

Robert Frank (American, born Switzerland, 1924). **City Fathers—Hoboken, New Jersey**. 1955–56
Gelatin-silver print. 9 x 11½" (22.9 x 29.3 cm). Private collection

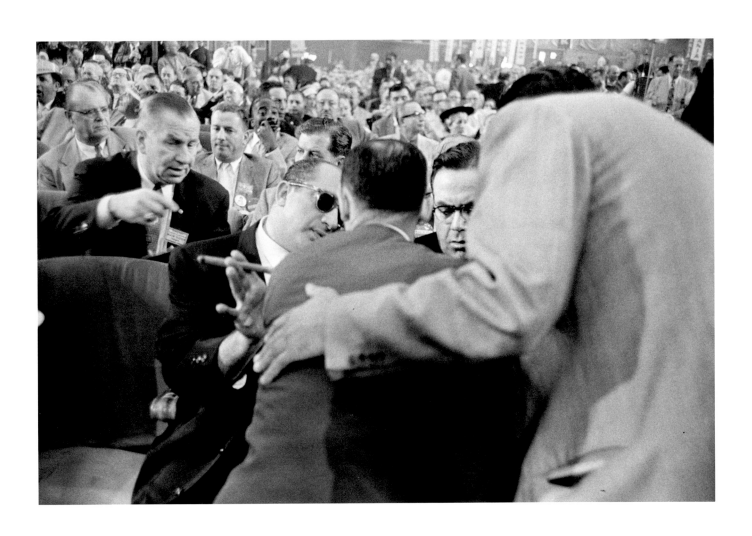

Robert Frank (American, born Switzerland, 1924). **Convention Hall—Chicago**. 1956
Gelatin-silver print. 6 x 8⅞" (15.2 x 22.5 cm). Courtesy Pace/MacGill Gallery, New York

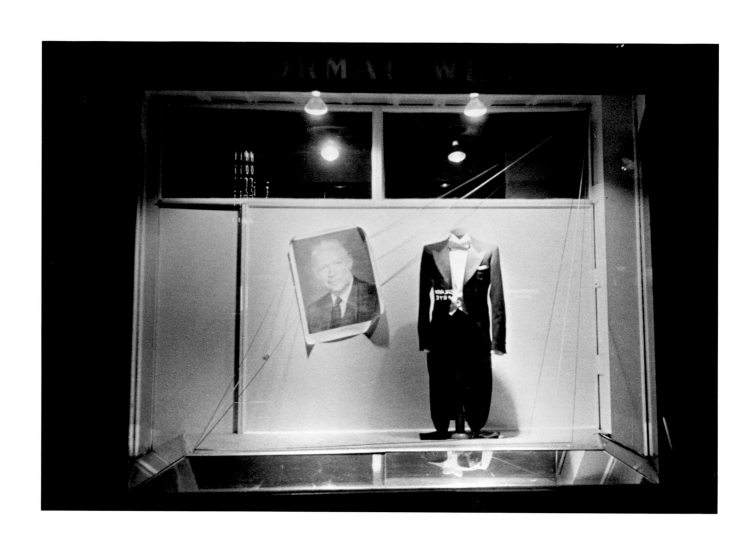

Robert Frank (American, born Switzerland, 1924). **Store Window—Washington, D.C.** 1957
Gelatin-silver print. 9 x 13¼" (22.9 x 33.6 cm). Courtesy Pace/MacGill Gallery, New York

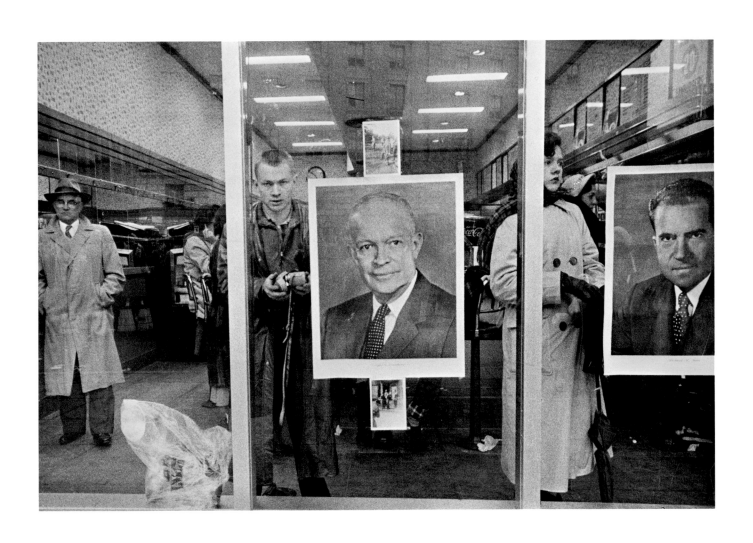

Robert Frank (American, born Switzerland, 1924). **Pennsylvania Avenue, Washington, D.C.** 1957
Gelatin-silver print. 12 x 17¹⁵⁄₁₆" (30.5 x 45.5 cm). Courtesy Pace/MacGill Gallery, New York

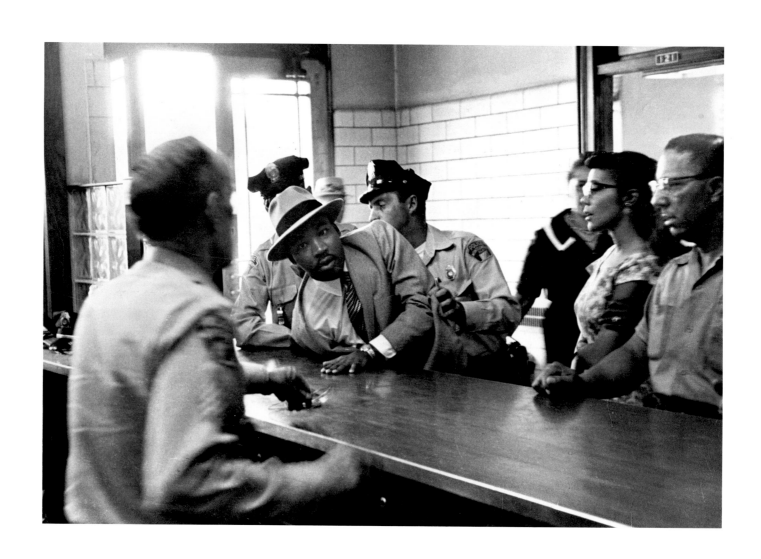

Charles Moore (born 1931)/Black Star. **Martin Luther King Arrested**. 1958

"Rev. Martin Luther King Jr. being pushed against desk at police station during his arrest for loitering outside courthouse, Montgomery, Alabama." Gelatin-silver print. 8⅜ x 12³⁄₁₆" (21.4 x 31 cm). The Museum of Modern Art, New York. Gift of Harriette and Noel Levine

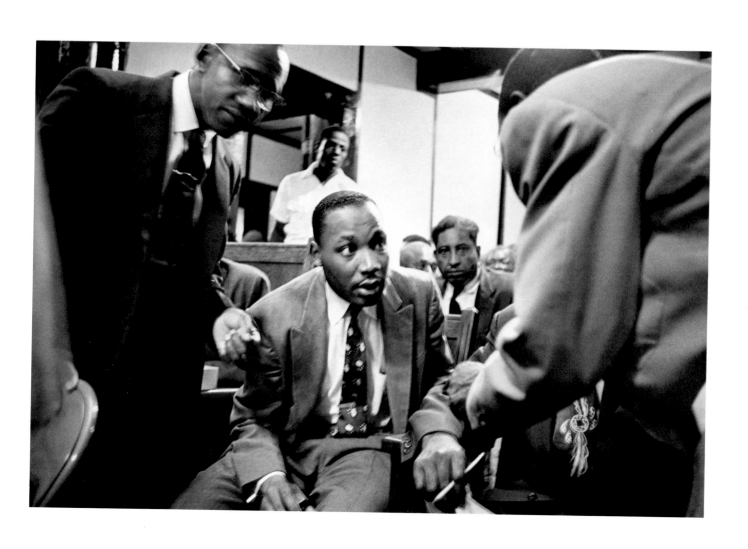

Dan Weiner (1919–1959). **Martin Luther King.** 1956

Gelatin-silver print. 8¹⁵⁄₁₆ x 13³⁄₈" (22.8 x 34 cm). The Museum of Modern Art, New York. Anonymous Purchase Fund

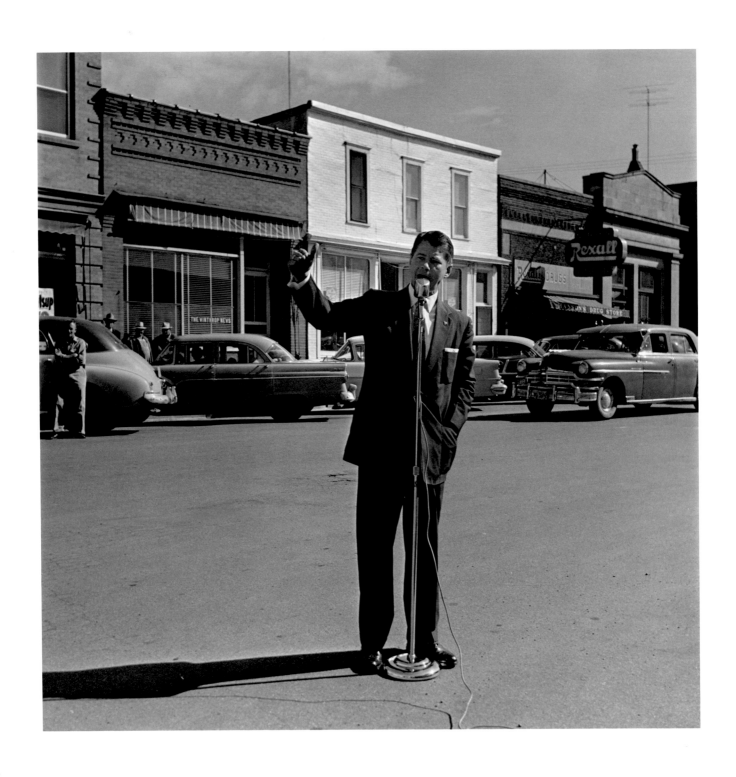

Jerome Liebling (born 1924). **Orville Freeman Campaigning for Governor, Winthrop, Minnesota**. 1956

Gelatin-silver print, printed later. 10³⁄₁₆ x 10¼" (25.9 x 26.1 cm). The Museum of Modern Art, New York. Lois and Bruce Zenkel Fund

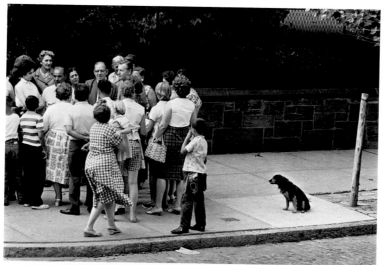

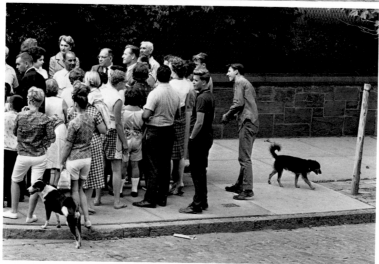

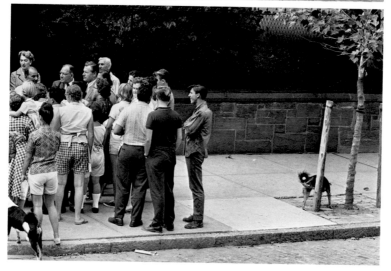

Elliott Erwitt (born 1928). **Albany, New York**. 1962

Three gelatin-silver prints. Each 8 x 11^{15}/$_{16}$" (20.4 x 30.4 cm). Lent by the photographer

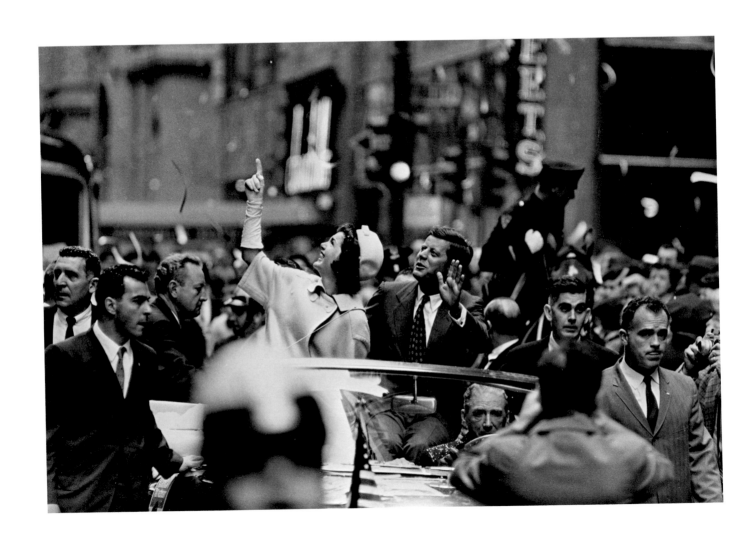

George Zimbel (Canadian, born United States, 1929). **Jacqueline and John Kennedy, New York City**. 1960
Gelatin-silver print, printed later. 11⅛ x 16⅝" (28.3 x 42.3 cm). The Museum of Modern Art, New York. The Family of Man Fund

Cornell Capa (American, born Hungary, 1918)/Magnum Photos. **John F. Kennedy Shaking Hands**. 1960

Gelatin-silver print. 9 x 14" (23 x 35.7 cm). The Museum of Modern Art, New York. Gift of the photographer

Jacques Lowe (American, born Germany, 1932). **Airport, Portland, Oregon**. Fall 1959

Gelatin-silver print, printed later. 11⁵⁄₁₆ x 16¾" (28.8 x 42.3 cm). The Museum of Modern Art, New York. The Family of Man Fund

Jacques Lowe (American, born Germany, 1932). **Diner, Oregon**. Fall 1959
Gelatin-silver print, printed later. 11⅛ x 16⁹⁄₁₆" (28.3 x 42.1 cm). The Museum of Modern Art, New York. Joel and Anne Ehrenkranz Fund

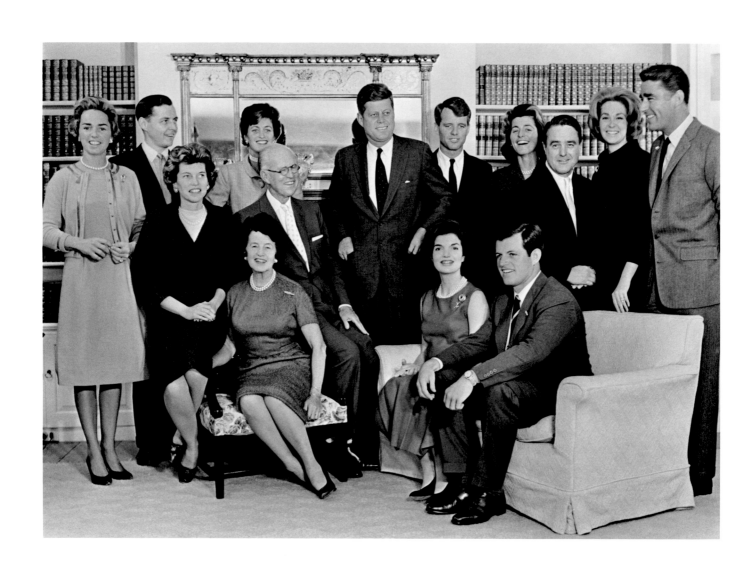

Jacques Lowe (American, born Germany, 1932). **A Victorious Clan Day after Election, Hyannis Port, Massachusetts**. November 9, 1960
Gelatin-silver print, printed later. 11¹⁵⁄₁₆ x 16¹⁵⁄₁₆" (30.4 x 43.1 cm). Lent by the photographer

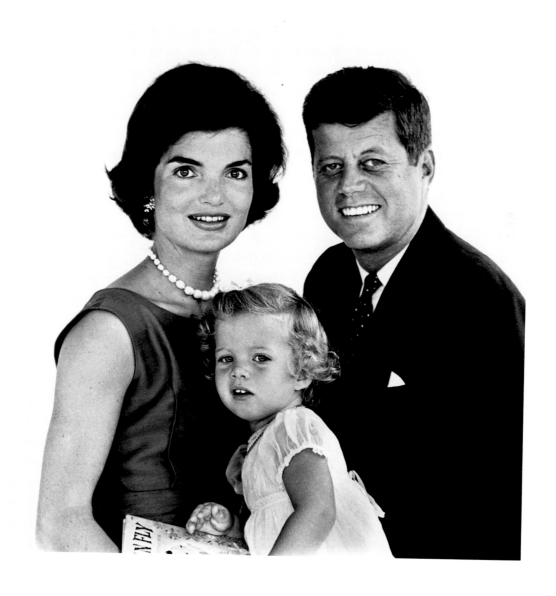

Jacques Lowe (American, born Germany, 1932). **Christmas Card**. 1960
Gelatin-silver print, printed later. 13½ x 13⁷⁄₁₆" (34.4 x 34.2 cm). Lent by the photographer

Richard Pipes (born 1936). **Campaign 1960**. August 1960

"Senators Kennedy and Johnson with their wives taken in Amarillo, Texas in August, 1960." Gelatin-silver print. 14 x 11" (35.6 x 28 cm). The Museum of Modern Art, New York. Gift of the photographer

Charles Gorry (1911–1976)/Associated Press. **U.S. President Lyndon Johnson Displays Scar from His Gall Bladder and Kidney Stone Operation**. 1965 "Surgeon General George Hallenbeck sitting at left, Bethesda Naval Hospital, Maryland." Gelatin-silver print. 10⅝ x 13⁹⁄₁₆" (27.1 x 34.5 cm). Lent by the Time Inc. Picture Collection

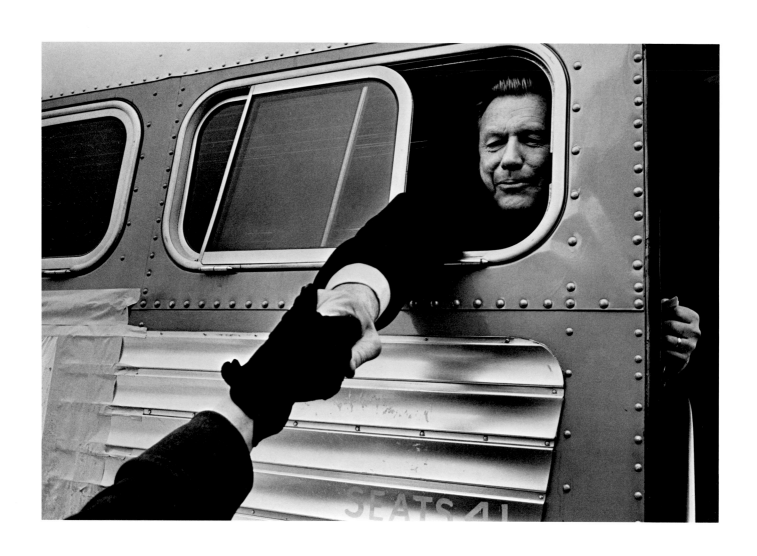

Paul Seligman (born 1924). **New Hampshire**. February 1964

Gelatin-silver print. 9⅜ x 13¾" (23.9 x 34.9 cm). The Museum of Modern Art, New York. Gift of the photographer

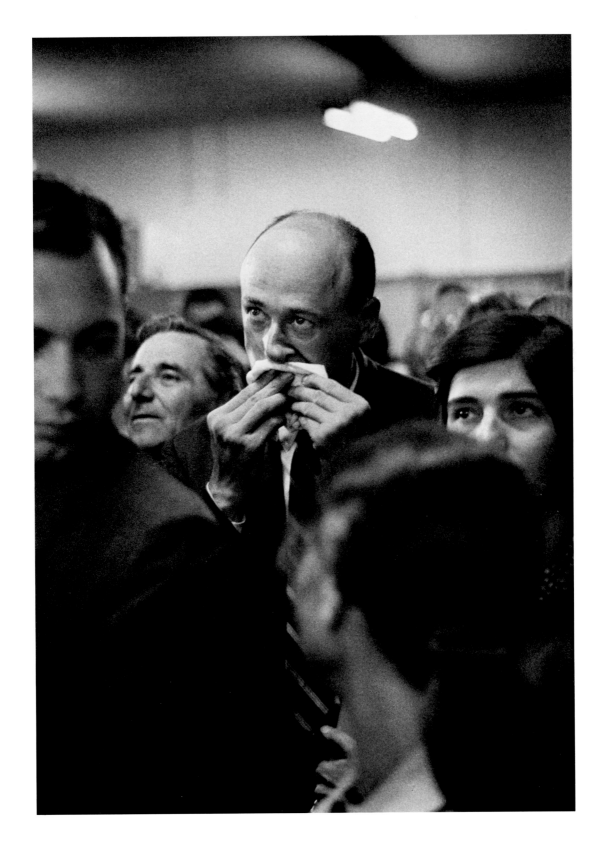

Paul Seligman (born 1924). **Ed Koch Sweating Out the Returns of His Seminal Victory Over Carmine DeSapio for Democratic District Leader of Greenwich Village**. 1963

Gelatin-silver print. 9¹¹⁄₁₆ x 7¹⁄₁₆" (24.6 x 17.9 cm). Lent by the photographer

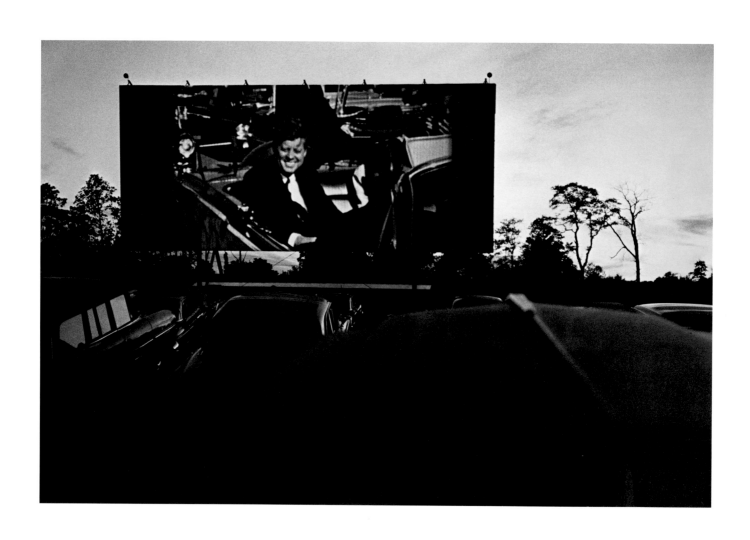

Lee Friedlander (born 1934). **Monsey, New York**. 1963

Gelatin-silver print, printed later. 14^{15}⁄$_{16}$ x 22^{7}⁄$_{16}$" (38 x 57 cm). Courtesy Fraenkel Gallery, San Francisco

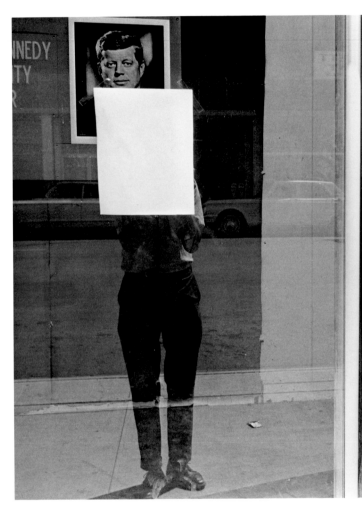

Lee Friedlander (born 1934). **Colorado**. 1967
Gelatin-silver print. 6¾ x 9¾" (17.2 x 24.8 cm). The Museum of Modern Art, New York. Purchase

Lee Friedlander (born 1934). **Tampa, Florida**. 1970
Gelatin-silver print, printed later. 7⁷⁄₁₆ x 11⅛" (18.9 x 28.3 cm). Courtesy Fraenkel Gallery, San Francisco

Diane Arbus (1923–1971). **Senator Eugene McCarthy on Election Night**. 1968
Gelatin-silver print. 15¾ x 15½" (40 x 39.3 cm). Courtesy Robert Miller Gallery, New York

Richard Avedon (born 1923). **Dwight David Eisenhower, Palm Springs, California**. January 31, 1964
Gelatin-silver print, printed later. 15¾ x 15¾" (40 x 40 cm). Courtesy of the photographer

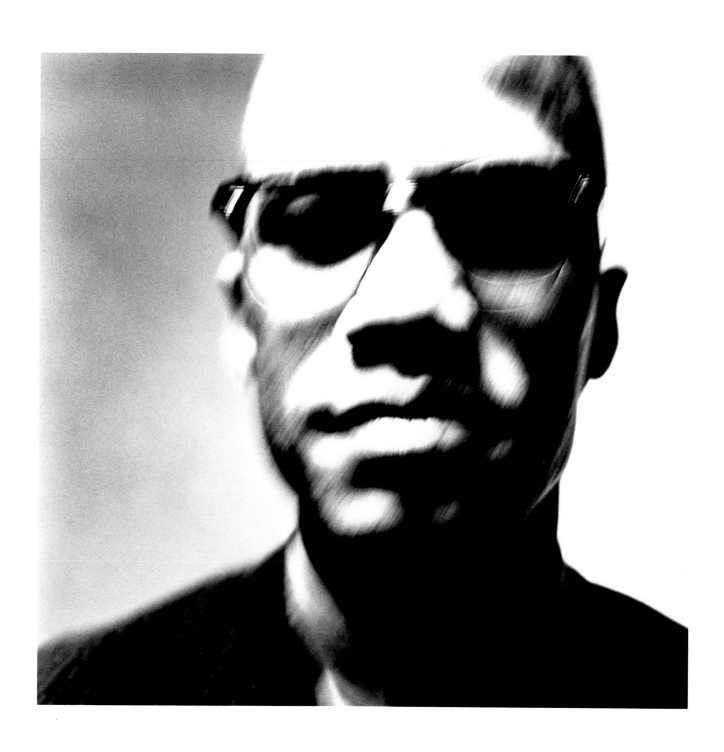

Richard Avedon (born 1923). **Malcolm X, New York City**. March 27, 1963
Gelatin-silver print, printed later. 14½ x 15" (36.9 x 38.1 cm). Courtesy of the photographer

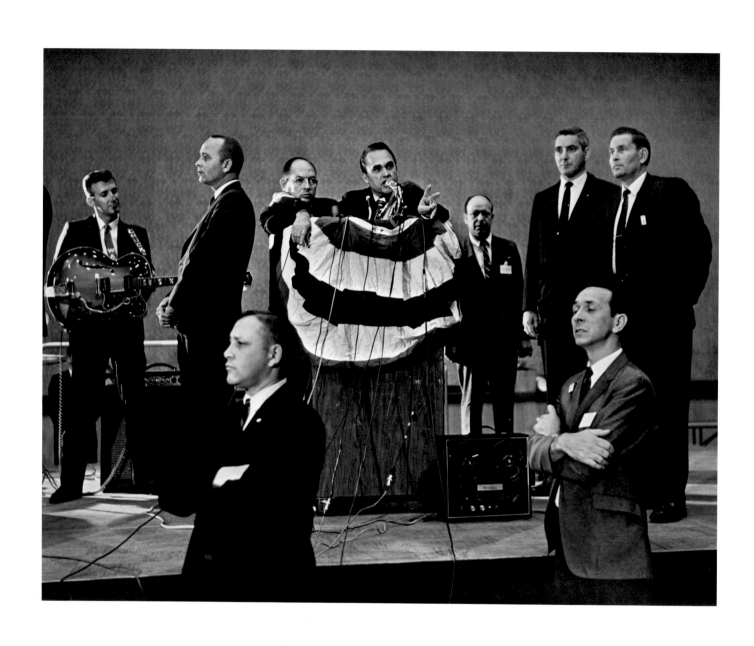

Jerome Liebling (born 1924). **Governor George Wallace, Minneapolis, Minnesota**. 1968
Gelatin-silver print, printed later. 9⅝ x 12¼" (24.5 x 31.2 cm). The Museum of Modern Art, New York. The Family of Man Fund

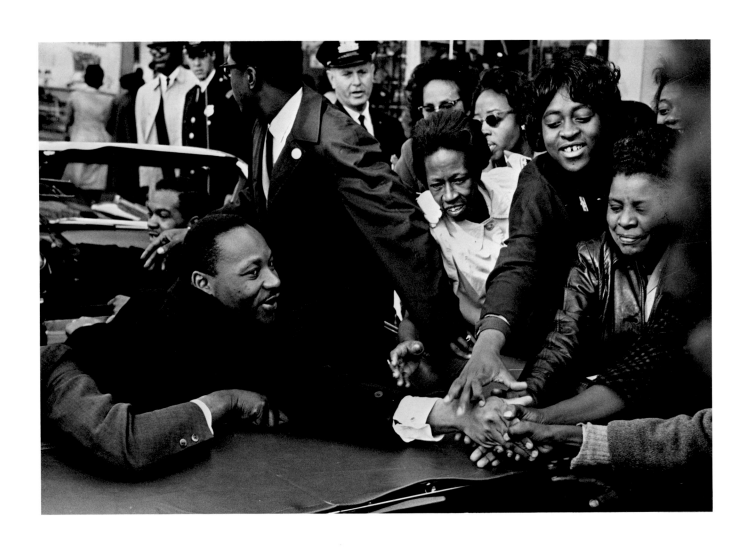

Leonard Freed (born 1929)/Magnum Photos. **Martin Luther King, Jr., after Receiving the Nobel Peace Prize, Baltimore**. 1963

Gelatin-silver print. 6 7/16 x 9 3/8" (16.4 x 23.8 cm). Courtesy Magnum Photos, Inc., New York

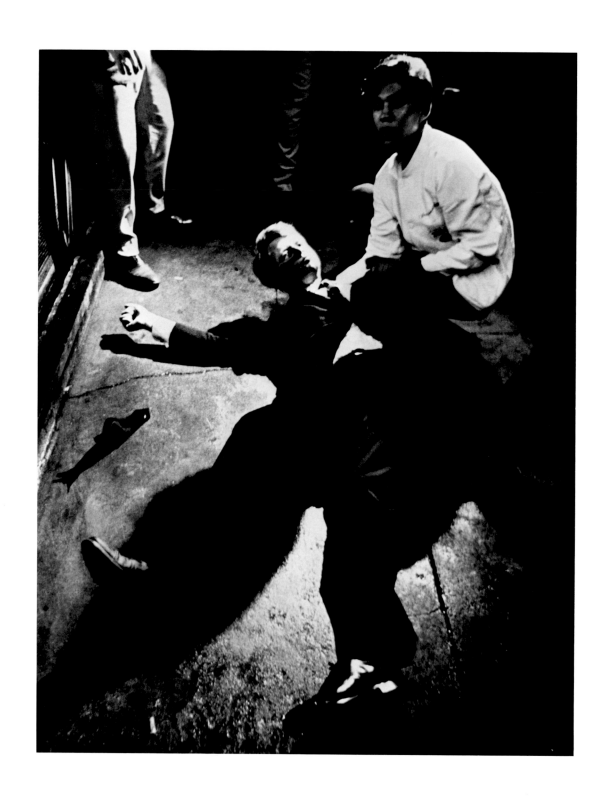

Boris Yaro (born 1938). **The Shooting of Robert F. Kennedy**. June 5, 1968

Gelatin-silver print. 10¾ x 8⁹⁄₁₆" (27.3 x 21.8 cm). The Museum of Modern Art, New York. Samuel J. Wagstaff, Jr. Fund

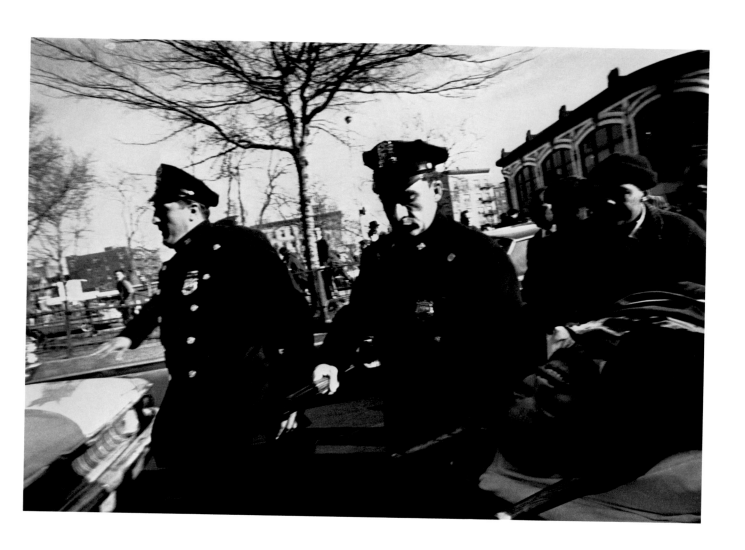

United Press International/Bettmann. **Malcolm X Shot.** February 21, 1965

"Malcolm X, Negro nationalist leader, is wheeled on stretcher atop a rolling bed from the Audubon Ballroom after he was shot (Feb. 21). He was pronounced dead at a hospital where he was taken for treatment." Gelatin-silver print, printed later. 6⁷⁄₁₆ x 9½" (16.4 x 24.3 cm). The Bettmann Archive

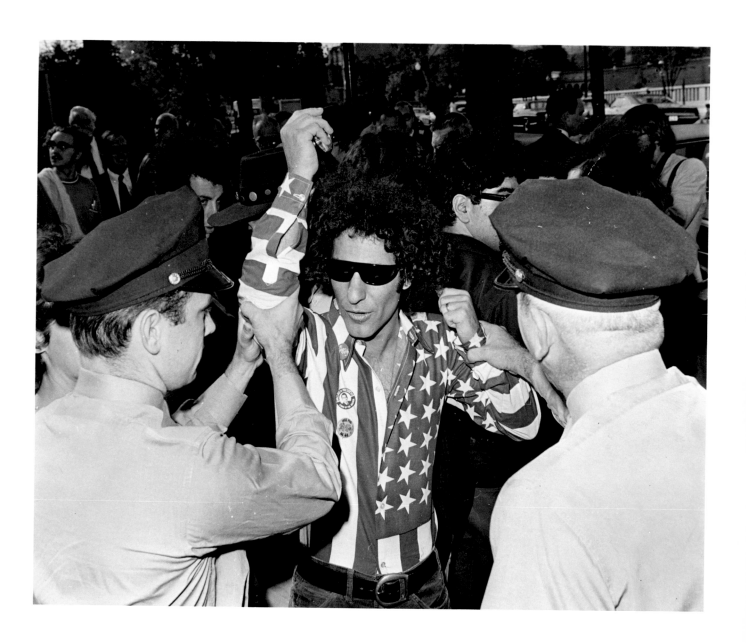

United Press International. **Yippie Arrested on Flag Desecration Charge.** October 3, 1968

"Washington, D.C.:—Abbie Hoffman, a leader of Youth International party, is being arrested as he attempted to enter a building where a subcommittee of the House Un-American Activities Committee was holding hearings, Oct. 3. Hoffman was wearing a red, white and blue striped shirt that resembled an American flag. He was charged with desecrating the American flag under a law passed earlier this year that makes it a Federal crime to cast 'contempt' upon the flag. The committee is investigating possible subversive influence in Chicago disorders during the Democratic National Convention in August." Gelatin-silver print. 7⅝ x 9⅜" (19.4 x 23.9 cm). George R. Rinhart Collection

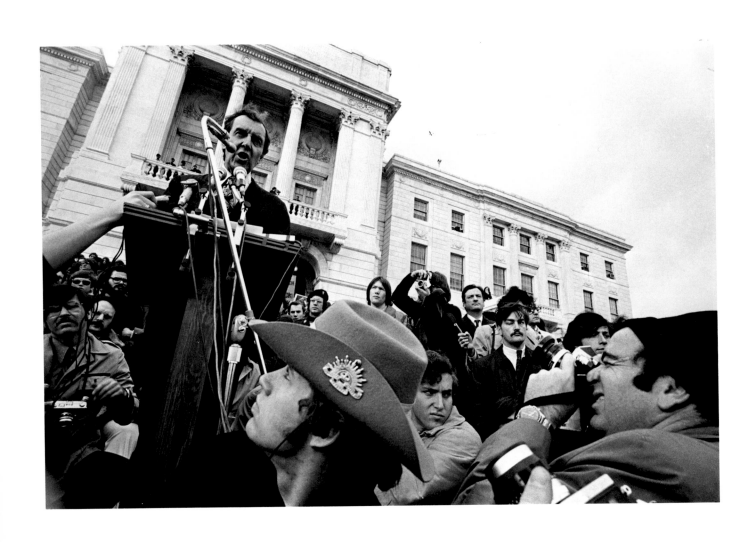

Garry Winogrand (1928–1984). **Presidential Candidates' Rally, Statehouse, Providence, R.I.** 1971

Gelatin-silver print. 10³⁄₈ x 15¹³⁄₁₆" (26.4 x 40.3 cm). Courtesy Fraenkel Gallery, San Francisco and the Estate of Garry Winogrand

Garry Winogrand (1928–1984). **Airport Arrival, Cape Kennedy, Florida**. 1969

Gelatin-silver print. 10⅝ x 16" (27.1 x 40.7 cm). Courtesy Fraenkel Gallery, San Francisco and the Estate of Garry Winogrand

Garry Winogrand (1928–1984). **Nixon Victory Celebration, Republican Headquarters, New York**. 1972

Gelatin-silver print. 10⅝ x 15¹³⁄₁₆" (27.1 x 40.3 cm). Courtesy Fraenkel Gallery, San Francisco and the Estate of Garry Winogrand

Garry Winogrand (1928–1984). **Jesse Jackson Operation PUSH Dinner, Chicago**. 1972

Gelatin-silver print. 10⅝ x 15¹³⁄₁₆" (27.1 x 40.3 cm). The Museum of Modern Art, New York. Purchase

Garry Winogrand (1928–1984). **Mayor John Lindsay, Central Park, New York**. 1969

Gelatin-silver print. 10⅝ x 15⅞" (27.1 x 40.3 cm). Courtesy Fraenkel Gallery, San Francisco and the Estate of Garry Winogrand

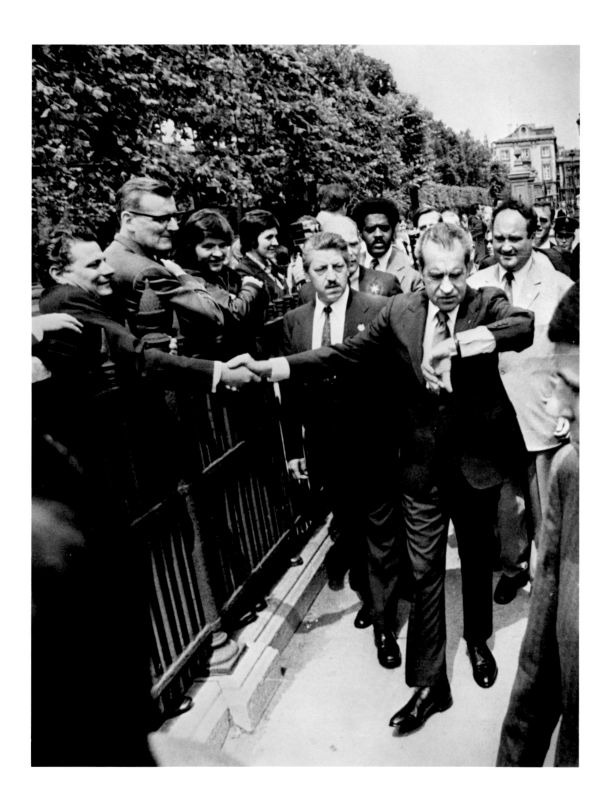

Charles Tasnadi (American, born Hungary, 1925)/Associated Press. **President Richard Nixon.** 1974

"President Richard Nixon checks his watch while shaking hands with Belgians as he heads for the Royale Palace and a luncheon date given by King Baudouin of Belgium." Gelatin-silver print, printed later. 9½ x 7½" (24.2 x 19.1 cm). Courtesy Associated Press Photo Library

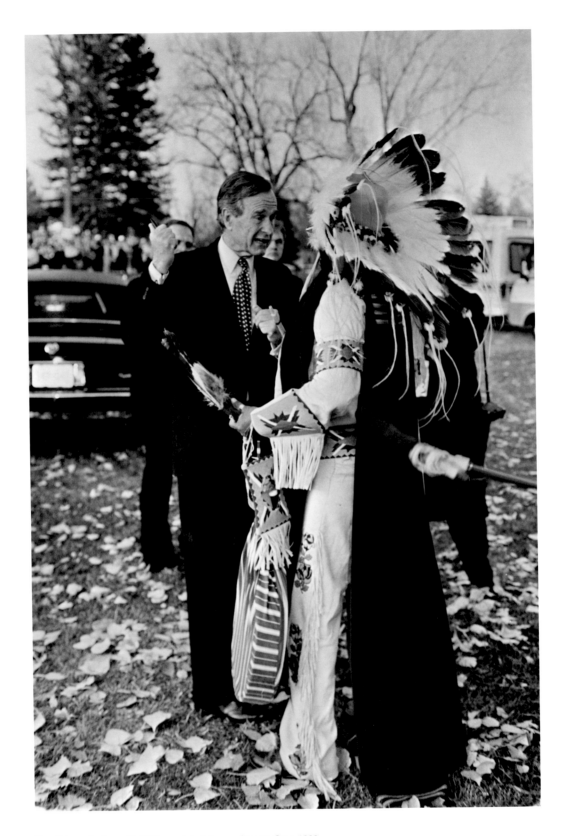

Ron Edmonds (born 1946)/Associated Press. **One on One**. 1992

"President George Bush speaks with Floyd Realbird of the Crow Indian tribe as he departs a Sunday campaign stop in Billings, Mont. Realbird, a medicine man, gave Bush a ceremonial pipe." Gelatin-silver print, printed later. 9³⁄₈ x 6⁵⁄₁₆" (23.8 x 16.1 cm). Courtesy Associated Press Photo Library

Michael E. Samojeden/Associated Press. **Test Ride**. 1988

"Democratic presidential candidate Michael Dukakis gets a free ride in one of General Dynamics' new M1-A-1 battle tanks at its land systems division in Sterling Heights Tuesday afternoon. Dukakis took time out to talk to General Dynamics workers [to prove] that he's not soft on defense." Gelatin-silver print, printed later. 6⁵⁄₁₆ x 9³⁄₈" (16.1 x 23.8 cm). Courtesy Associated Press Photo Library

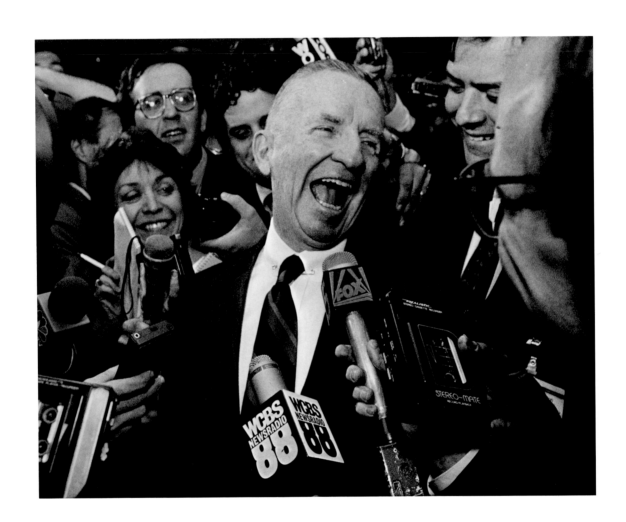

Richard Drew (born 1946)/Associated Press. **Perot Keeps Laughing**. 1992

"Texas billionaire Ross Perot laughs after saying, 'Watch my lips,' in response to reporters asking him when he plans to formally enter the presidential race, Tuesday morning in New York City. Perot made a speech to the American Newspapers Publishers Association telling them he plans to slack off on public appearances for the next few weeks to gear up for a presidential run." Chromogenic color print, printed later. 7⁹⁄₁₆ x 9⁹⁄₁₆" (19.2 x 24.3 cm). Courtesy Associated Press Photo Library

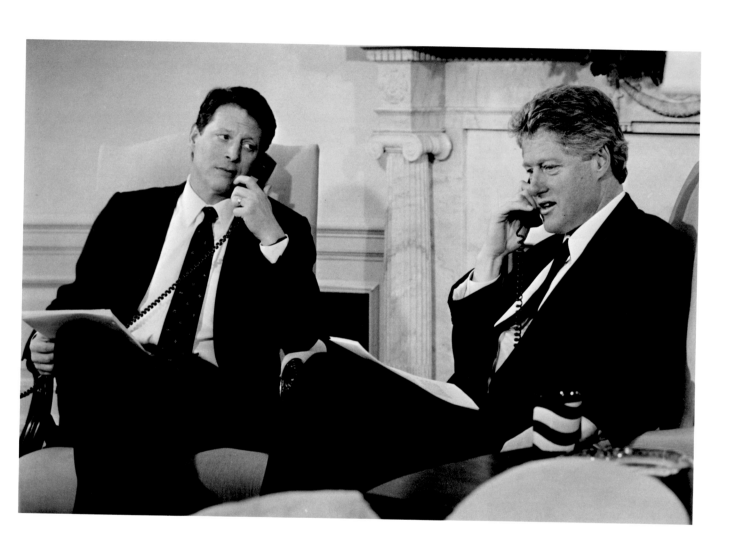

Greg Gibson (born 1962)/Associated Press. **Family Help**. 1993

"President Clinton and Vice President Gore talk on telephones in the Oval Office of the White House Friday to families who were forced to choose between their jobs and time off to care for children or ailing parents. After the conference call, the president said 'these ten stories say more than I ever could.'" Gelatin-silver print, printed later. 6⁵⁄₁₆ x 9⁵⁄₁₆" (16.1 x 23.7 cm). Courtesy Associated Press Photo Library

P. F. Bentley (born 1952)/*Time* Magazine. **Bill and Hillary Clinton Holding Hands Aboard Plane During 1992 Presidential Campaign Trip.** February 13, 1992

Gelatin-silver print, printed later. 8⅞ x 13" (22.6 x 33.1 cm). Courtesy Time Picture Syndication, New York

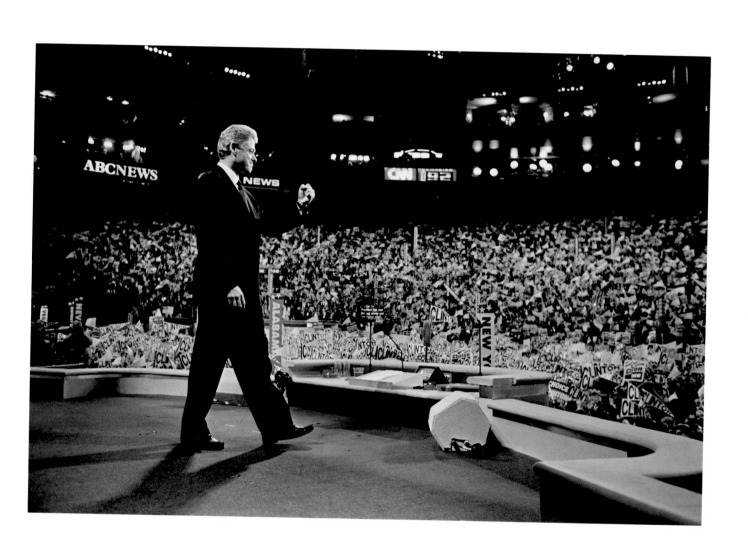

P. F. Bentley (born 1952)/*Time* Magazine. **Bill Clinton at Democratic National Convention, Madison Square Garden, New York.** July 16, 1992
Gelatin-silver print, printed later. 8⅝ x 12⅞" (21.9 x 32.7 cm). Courtesy Time Picture Syndication, New York

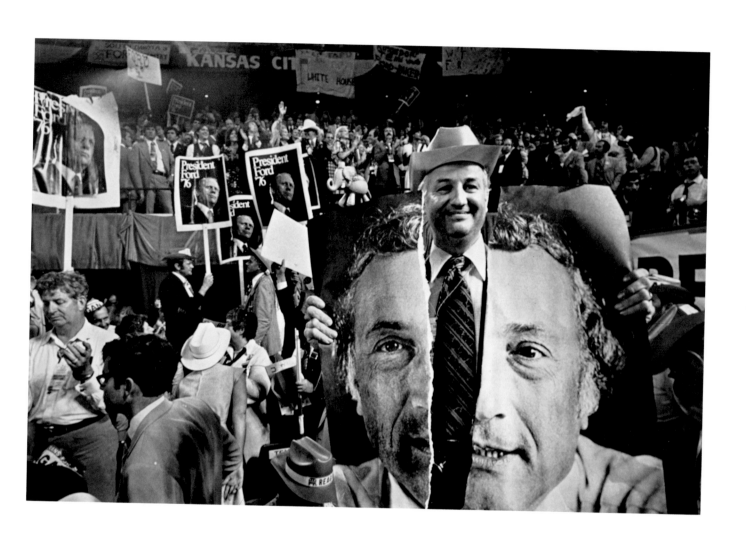

Gilles Peress (French, born 1946). **Republican Convention, Kansas City, Missouri.** 1976

Gelatin-silver print, printed later. 25³/₁₆ x 38" (64 x 96.5 cm). Courtesy Howard Greenberg Gallery, New York

Rosalind Solomon (born 1930). **Governor Ross Barnett and Friend, Neshoba County Fair**. 1977

Gelatin-silver print. 15¹⁄₁₆ x 15" (38.4 x 38.2 cm). The Museum of Modern Art, New York. Gift of the photographer

Larry Fink (born 1941). **Hillary Rodham Clinton and Pat Schroeder, Washington, D.C.** May 1993
Gelatin-silver print. 14³⁄₈ x 14⁷⁄₁₆" (36.5 x 36.7 cm). Lent by the photographer

Teresa Zabala (born 1938). **President Carter and Congressional Leaders at a Press Conference**. 1977
Gelatin-silver print. 6¾ x 12¾" (17.2 x 32.4 cm). The Museum of Modern Art, New York. Gift of the photographer

Judith Joy Ross (born 1946). **Senator Robert C. Byrd, Democrat, West Virginia.** 1987

Gelatin-silver printing-out-paper print. 9¾ x 7¾" (24.6 x 19.6 cm). The Museum of Modern Art, New York. Purchased as the gift of Shirley C. Burden

Judith Joy Ross (born 1946). **Senator Strom Thurmond, Republican, South Carolina**. 1987

Gelatin-silver printing-out-paper print. 9¾ x 7⅝" (24.7 x 19.5 cm). The Museum of Modern Art, New York. Purchased as the gift of Shirley C. Burden

Judith Joy Ross (born 1946). **Congresswoman Pat Schroeder, Democrat, Colorado.** 1987

Gelatin-silver printing-out-paper print. 9⅝ x 7¾" (24.5 x 19.6 cm). The Museum of Modern Art, New York. Purchased as the gift of Shirley C. Burden

The Image of the American Politician

The following chronology provides a frame of reference for the photographs discussed in this publication. Advances in the technology and methods of transmission of photography and related media are given, together with dates marking notable events affecting the image of the American politican.

1826 French physicist Joseph-Nicéphore Niépce creates the first photograph, but his process never produces a sharp image. In 1829 he enters into partnership with Louis-Jacques-Mandé Daguerre.

1837 Daguerre invents a method to create a direct positive in the camera. Publicly reported in January 1839, daguerreotypy produces a highly detailed image that captures the popular imagination, making it the prevailing technique of portraiture until the mid-1850s. Notable figures such as politicians are among the first to be photographed.

January 25, 1839 William Henry Fox Talbot announces invention of the photogenic drawing. With his process, many positive prints can be made from one negative, a principle basic to modern photography.

1839 The daguerreotype process is brought to the United States by Samuel F. B. Morse.

1840 In New York City, A. S. Wolcott and John Johnson open the first photographic studio in the United States. Dr. William Draper produces the first daguerreotype portrait made in the U.S.

1841–42 Photography is used as an advertising medium: a daguerreotype of patrons drinking at a Philadelphia restaurant is hung outside to attract customers, but is taken down when some protest its corrupting influence on the public.

1843 The first known photograph of a president of the United States is made by Bishop and Gray of John Quincy Adams fourteen years after he left office.

1841–44 John Tyler is the first president photographed while in office.

1844 The earliest American news photograph, a daguerreotype of the Native-American riots in Philadelphia, is made.

1846 James Knox Polk is the first president photographed in the White House.

1848 Frederick Scott Archer invents the collodion wet-plate process, the standard way to make a photographic negative until the early 1880s, and publishes his findings in 1850 and 1851. The process permits much faster exposure times, and a single negative may be used to make an unlimited number of prints. Photographs made with this method are generally printed on the recently invented albumen paper. ★ The New York Associated Press (AP) is formed, enabling members to get dependable reports from other cities by telegraph.

1851 The first flash photograph is taken by Talbot; with the introduction of practical methods for making flash pictures, beginning with the use of flashlight powder in the late 1880s, it became possible for photographs to be taken regardless of available light.

1854 André-Adolphe-Eugène Disdéri patents the carte-de-visite, an inexpensive, easily produced, card-mounted photograph. Cartes are introduced in the U.S. in 1859 by C. D. Fredericks and George C. Rockwood.

1860 Mathew Brady makes a portrait of presidential candidate Abraham Lincoln. It is reproduced as a carte-de-visite and widely distributed. Another of Lincoln, with his running mate Hannibal Hamlin, is made into a campaign pin, launching the use of photographs in campaign advertising.

1861 Thomas Sutton patents the first single lens reflex (SLR) camera, allowing photographers to see exactly what they are photographing. He also makes the first color photograph. ★ Abraham Lincoln's presidential inauguration is the first to be photographed.

December 2, 1873 The first halftone reproduction of a photograph appears in the *New York Daily Graphic*. It will be two decades before the use of photographs in newspapers is common.

1875 Roll film photography is born with the development by Leon Warnerke of a film paper coated with emulsion, which enables photographers to make many images without reloading the camera.

1876 The telephone is patented by Alexander Graham Bell.

1877 The first news dispatch by telephone is sent to the *Boston Globe*. ★ Thomas Edison invents the microphone, which will allow politicians to speak to larger audiences.

1879 Pre-coated gelatin emulsion plates are in production at 14 photographic supply companies. In November, J. W. Swan patents a machine that coats plates automatically and more consistently than by hand. Because photographers need not carry a darkroom with them, the craft is simplified and photography is opened to the amateur market.

1881 Thomas Bolas patents the first hand-held plate camera, called a "detective" camera, presumably because the box, lacking a tripod, would not be recognized as being a camera. ★ James A. Garfield becomes the first U.S. president to use a telephone.

1884 The first portable SLR camera, the Monocular Duplex Camera, is designed by Calvin Rae Smith.

1886 George Eastman produces stripping film, a paper film coated with gelatin, which can be printed quickly.

1888 Eastman introduces a simple roll film camera, called the Kodak Camera.

1891 The first telephoto lens is patented by Thomas Rudolf Dallmeyer in England. ★ Thomas Edison develops the first practical system for creating and viewing motion pictures: the Kinetograph motion picture camera, which uses 35mm roll film, and the Kinetoscope motion picture projector.

1893 Max Levy of Philadelphia revises and perfects a crossline screen, producing the first commercially successful halftone screen for photographic reproduction, and permitting publishers to combine pictures and type.

1896 Underwood and Underwood is established as the first U.S. stock picture agency. ★ Guglielmo Marconi patents a radio transmitting and receiving system, which he brings to the U.S. in 1899.

1897 A portrait in the *New York Tribune* of New York Senator Thomas C. Platt is the first halftone reproduction of a politician in a daily paper.

1900 The Brownie camera, designed to be used by amateurs and even children, is developed by Frank Brownell for Eastman.

1901–09 Theodore Roosevelt is the first president to take full advantage of published halftone reproductions of photographs to project a political image.

1903 The Autochrome, a type of color photograph, is developed by Auguste and Louis Lumière of France; it is put on the market in 1907.

1905 Professor Alfred Korn of Munich invents a system for wire transmission of photographs. ★ United Press (UP), a wire service for reporting and selling news, is founded by Edward Wyllis Scripps. ★ Agencies such as UP and AP are the principal sources of up-to-the-minute information about news events before the advent of radio.

July 10, 1908 William Jennings Bryan is filmed in Fairview, Nebraska, receiving congratulations after his nomination as presidential candidate—the first politi-

cian to be seen in a motion picture, which is shown on July 12 in New York City.

1909 The first radio broadcasts are transmitted from San Jose, California, by Doc Herrold.

August 9, 1910 The aftermath of the shooting of New York Mayor William J. Gaynor is photographed by William Warnecke; this is believed to be the first assassination attempt captured on film. ★ In November, the first newsreel, the Pathé Weekly, is produced by Herbert Case Hoagland. At the height of their popularity, newsreels reach 40 million patrons a week and include campaign-sponsored reels as well as news event coverage.

1912 The Speed Graphic, a hand-held plate film camera, is introduced by Folmer and Schwing (a division of Eastman Kodak); it becomes the standard 4-by-5-inch press camera for the next 40 years.

March 15, 1913 Woodrow Wilson holds the first formal presidential press conference in the executive offices of the White House eleven days after his inauguration. He is dismayed that reporters ask frivolous and personal questions.

1917 President Wilson institutes the Committee on Public Information after America enters World War I. The committee is set up to coordinate the flow of government information about the war and to rally support for American intervention.

1919 Wilson delivers the first presidential speech broadcast by radio. ★ On June 26 *The New York Daily News* is established as America's first tabloid, with the intent to "astonish, bemuse, dazzle, or horrify the reader." Images of politicians in increasingly unflattering poses and compromising situations begin to be published.

August 31, 1920 Radio station WWJ in Detroit broadcasts election returns.

Early 1920s Wire photographs begin to be sent between London and New York using the Bartlane cable picture system.

1921 Press photographers are admitted to the White House on a regular basis; the White House News Photographers Association is formed.

1922 President Warren G. Harding has a radio installed in the White House.

1923 President Calvin Coolidge delivers the first State of the Union address broadcast by radio. ★ On March 3, the first photograph to be sent overland by radio to a distant point is transmitted from Washington, D.C., to Philadelphia.

1924 Coolidge makes the first live Presidential radio speech. Later in the same year he is the first president to broadcast from the White House. ★ The first television transmission is achieved by Bell System scientists. ★ A color photograph, consisting of three color separations, is transmitted by wire from Chicago to New York. ★ The Ernemann Ermanox, a high speed compact camera that helps pioneer the field of candid photography, is introduced. ★ On August 11, Theodore W. Case and Lee De Forest make the first talking motion pictures of presidential candidates President Calvin Coolidge, on the White House grounds, and Senator Robert Marion LaFollette, on the steps of the Capitol. In September the newsreel is shown in movie theatres.

1925 Dr. Paul Vierkötter patents the first flash bulb. ★ The inauguration of Calvin Coolidge as president is broadcast by radio. A photograph of the event is transmitted across the country by radio. ★ The Leica camera is introduced and quickly becomes the 35mm camera of choice for photojournalists.

1927 The Associated Press News Photo Service is formed, distributing packages of news photos to its members by mail. This is the first time the delivery of news in pictures and news in words is coordinated. ★ On April 7, Secretary of Commerce Herbert C. Hoover reading a speech becomes the first political event transmitted by television.

1928 Political advertisements are heard on the radio as part of Herbert Hoover's presidential campaign. All across the

country, six thousand "minute men" deliver five-minute talks on behalf of the candidate, inaugurating radio as a medium for dissemination of a political message. ★ In a scientific experiment, engineers supervise a live television broadcast, from Albany to Schenectady, New York, of a campaign speech by presidential candidate Al Smith.

1929 A room in the White House is reserved exclusively for the use of press photographers. ★ Johannes B. Ostermeier develops the Photoflash lamp, which is used to photograph President Herbert Hoover signing the Unemployment Relief Bill.

1931 President Hoover is photographed in the White House by Erich Salomon, a German photographer considered to be the father of candid photography. The resulting, "casual" image becomes the preferred style for politicians.

1932 Radio coverage of the presidential campaign brings complaints by listeners that the politicians' speeches are too long. Thereafter, length of speeches and appearances by politicians is dictated by the format of the half-hour radio show.

1934 The Robot, the first still-image 35mm camera with motor-driven film advance, is developed. ★ Newsreels are used to slander Upton Sinclair, who is running for governor of California.

1935 On January 1, the Associated Press Wire Photo network is inaugurated. ★ Time Inc. begins production of *March of Time* newsreels, film versions of its popular, entertainment-style radio news program. ★ Using a Leica, Thomas McAvoy makes 20 photographs of President Franklin D. Roosevelt as he prepares to sign a trade treaty. Thirteen prints are published in *Time* magazine with the claim that they are the first candid photographs of a president at work. ★ Kodachrome, a positive color transparency film, is introduced to the market in a 16mm movie film format; and as 35mm roll film in 1937. Kodacolor negative film is widely available by 1941, making color photography cheaper and easier for both amateurs and photojournalists.

1936 NBC begins experimental television broadcasts in New York City. ★ The campaign between Roosevelt and Alfred E. Landon is the first to be professionally directed for radio. Roosevelt changes his speaking style and Landon hires a voice coach. ★ In November, *Life* magazine commences publication.

1937 A series of unflattering photographs of Roosevelt, taken at a baseball game, make him seem ill. As a result, president's press secretary bans candid cameras from the White House.

1939 Roosevelt has a television installed in the White House. On April 30, he is the first president to appear on television, but is seen by fewer than 100,000 viewers. ★ Congress establishes a gallery for radio correspondents because print journalists will not allow them in their gallery.

August 3, 1945 The first color news photograph sent by wire, of President Harry Truman and Soviet leader Joseph Stalin at the Potsdam Conference, is transmitted by radiotelephone.

1946 The National Press Photographers Association is founded. ★ During Ohio campaign for U.S. senate, a photograph of Robert A. Taft is reproduced in an issue of the CIO news beside a photograph of Nazi leaders. The caption reads "Robert A. Taft and 'friend'." Taft later testifies before the Senate Elections Subcommittee that it is the "grand-daddy of all composite photographs."

February 21, 1947 The Polaroid camera is invented by Edwin H. Land; it is put on the market in 1948.

1948 Candidates Harry S. Truman and Thomas E. Dewey purchase television time to influence voters. ★ The first color newsreel is produced by Warner Brothers–Pathé News. The transistor is developed by Bell Laboratories.

1950 During the reelection campaign of Maryland Senator Millard Tydings, a faked photograph, purporting to show him in a meeting with Communist party leader Earl Browder, is reproduced in the tabloid *From the Record*. It is

believed to have cost Tydings the election.

1951 The first presidential press conference to be recorded on audiotape is held by President Harry Truman at the White House. He introduces recording equipment to keep the record straight, allowing parts of the recordings to be broadcast later. ★ Eastman introduces Kodak Tri-X film, a high-speed black-and-white film immediately accepted by press photographers. ★ A transcontinental cable is experimentally inaugurated, permitting nationwide television networks to form.

1952 Republican and Democratic presidential conventions are televised for the first time, with speeches adapted to television audiences rather than the delegates in attendance. ★ The first video recording on magnetic tape is produced. ★ On September 23, vice presidential candidate Richard M. Nixon delivers the "Checkers" speech, often considered one of the most effective political statements ever produced. ★ Republicans are the first to use 60-second television commercials, known as spot ads, a departure from the practice of buying half-hour segments of broadcast time.

April 22–June 17, 1954 The Army-McCarthy hearings take place. Exposure on television of Senator Joseph McCarthy's unsavory tactics help bring about his downfall.

January 19, 1955 The first presidential news conference to be recorded on videotape is held by President Dwight D. Eisenhower. Later the tapes are edited to correct mistakes. ★ On June 6, Eisenhower's address at a West Point reunion is the first presidential telecast in color.

1956 Wire services switch from 4-by-5-inch to 35mm photography during the 1956 presidential conventions in response to the candid style of reporting that has become popular.

1957 Russell A. Kirsch and colleagues at the National Bureau of Standards succeed in scanning a photograph, converting it into digital code, storing it in a computer, and displaying it on an oscil-

loscope. ★ The second inauguration of Eisenhower is the first nationally televised videotaped broadcast.

1960 A photograph of Eisenhower, originating from a dish antenna in Cedar Rapids, Iowa, is bounced off the satellite Echo 1, orbiting 1,000 miles above, to standard AP wirephoto receiving equipment in Dallas. ★ The first televised presidential debates, between John F. Kennedy and Richard Nixon, are also the first presidential debates ever to occur during a campaign. When Nixon narrowly loses to Kennedy, politicians take note to carefully cultivate their television image.

1960s Marshall McLuhan's phrase "the medium is the message" becomes a popular way of describing the power of television to affect and transform events.

January 25, 1961 President Kennedy holds the first live, televised press conference, drawing an audience of 65 million and turning the event into political entertainment for the television audience by speaking over reporters' heads to the cameras.

September 24, 1963 The first authorized photograph of the Senate is taken by National Geographic Society photographers for the U.S. Capitol Historical Society. ★ In November, stills from the Zapruder film of Kennedy's assassination and images of Jacqueline Kennedy and her children at the president's funeral become landmark images of the decade.

1964 In Johnson's campaign against Barry Goldwater, strategists produce the most famous political television commercial, known as the Daisy Spot, which juxtaposes a child with a nuclear blast to create voter anxiety about Goldwater. It is shown only once because of protest over its controversial content. ★ President Johnson appoints Yoichi Robert Okamoto, a United States Information Agency (USIA) photographer, to be the first civilian personal photographer to a president.

1965 Sony introduces the first home video tape recorder.

1966 Television networks switch to color film for news broadcasts. The impact of this switch is illustrated in comments that Nixon, during the 1968 campaign, projected a much more positive appearance in color than he did on black-and-white TV. Robert MacNeil writes, "Nixon's whole countenance had a more cheerful cast. It is intriguing to speculate that this man might have been kept out of the White House in 1960 by a tiny lag in technology."

1968 The Nixon campaign is the first to be orchestrated to play on the evening news.

1969 Nixon press secretary Ron Ziegler coins the phrase "photo opportunity," meaning a brief, controlled photo session in which the president is shown at his best. ★ The White House Office of Communications is established with the intention of controlling the flow of information from the entire executive branch and focusing carefully manipulated attention on the president.

1972 TVTV, an ad hoc group of videomakers, produces *Four More Years* for cable television, an hour-long documentary videotape of the Democratic and Republican Conventions, making video history by providing national viewers with an iconoclastic, alternative vision of American politicians. ★ Nixon hires Carroll Newton, an advertising executive, to form the "November Group," the first political public relations agency created for the duration of a presidential campaign.

1973–74 The Watergate scandal becomes a national obsession. The White House Press Office is tarnished when it is used to disseminate misleading reports. Senate Watergate Committee hearings are televised live six hours a day in the summer of 1973.

1974 The Senate authorizes the first congressional television and radio broadcast, featuring the swearing-in of Nelson A. Rockefeller as vice president.

1977 CBS news broadcasts a presidential call-in, "Ask President Carter," moderated by Walter Cronkite. President Jimmy Carter answers telephone calls from listeners around the country.

1977 The House of Representatives agrees to proceed with media broadcasts of regular House proceedings. News organizations begin carrying these sessions on the radio in June 1978. The House sets aside an hour for one-minute speeches made-to-order for members' districts in an effort to disseminate controlled images of House politicians on a nationwide basis.

1979 C-SPAN, a cable channel devoted to live congressional proceedings, begins broadcasting. Cameras are controlled by congressional staff rather than reporters in order to keep firm control over what is seen. ★ President Carter has a photograph instead of a painting as his official portrait; it is made by Ansel Adams.

1981 The first electronic still video camera, the Mavica, is introduced by Sony. Not until an improved model is released in 1988 does the camera begin to gain consumer acceptance.

June 2, 1986 C-SPAN II (Senate coverage) begins.

1988 The news media make manipulation of the images of presidential candidates George Bush and Michael Dukakis the focus of news coverage for the first time, popularizing terms like "sound bites," "photo opportunities," "media gurus," and "spin control." ★ Bush's supporters produce a spot featuring Willie Horton, a convict who, furloughed while serving a life sentence for murder, committed a rape in Massachusetts. The ad maintains that this demonstrates Massachusetts governor Dukakis's soft approach to crime. The ad becomes the epitome of negative campaigning.

1990 The Dycam, the first truly digital camera, with images stored not on film but entirely on computer chip, is introduced. ★ In the 1990s, satellite systems make possible nearly instant transmittal to news media of images of political events occurring anywhere in the world.

Bibliography

Aaland, Mikkel, with Rudolph Burger. *Digital Photography*. New York: Random House, 1992.

Baynes, Ken, ed. *Scoop, Scandal and Strife: A Study of Photography in Newspapers*. New York: Hastings House, 1971.

Bennett, Edna. "History of 35mm." Parts 1, 2. *Camera 35* (December–January 1959–60, February–March 1960): 23–35, 280–81; 56–67.

Buckland, Gail. *First Photographs*. New York: Macmillan, 1980.

Carruth, Gorton. *The Encyclopedia of American Facts & Dates*. 8th ed. New York: Harper & Row, 1987.

Coe, Brian. *Cameras, from Daguerreotypes to Instant Pictures*. New York: Crown, 1978.

Coe, Brian. *Colour Photography: The First Hundred Years 1840–1940*. London: Ash & Grant, 1978.

Collins, Douglas. *The Story of Kodak*. New York: Harry N. Abrams, 1990.

Congressional Quarterly's Guide to Congress. 4th ed. Washington, D.C.: Congressional Quarterly, 1991.

Darrah, William C. *Cartes-de-Visite in Nineteenth Century Photography*. Gettysburg, Pa.: W. C. Darrah Publishers, 1981.

Diamond, Edwin, and Stephen Bates. *The Spot: The Rise of Political Advertising on Television*. 3d ed. Cambridge, Mass.: MIT Press, 1992.

Eder, Josef Maria. *History of Photography*. Translated by Edward Epstean. New York: Columbia University Press, 1945.

Encyclopaedia Britannica. Chicago: Encyclopaedia Britannica, 1973.

Faber, John. *Great News Photos and the Stories Behind Them*. 2d ed., rev. New York: Dover, 1978.

Felknor, Bruce L. *Political Mischief: Smear, Sabotage, and Reform in U.S. Elections*. New York: Praeger, 1992.

Fulton, Marianne. "Bearing Witness: The 1930s to the 1950s." In Marianne Fulton, ed., *Eyes of Time: Photojournalism in America*. Boston: Little, Brown, 1988.

Gassan, Arnold. *A Chronology of Photography*. Athens, Ohio: Handbook Company, 1972.

Gernsheim, Helmut, and Alison Gernsheim. *The History of Photography: From the Camera Obscura to the Beginning of the Modern Era*. New York: McGraw-Hill, 1969.

Gilbert, Robert E. *Television and Presidential Politics*. North Quincy, Mass.: Christopher Publishing House, 1972.

Goldberg, Vicki. *The Power of Photography: How Photographs Changed Our Lives*. New York: Abbeville Press, 1991.

Gordon, Gregory, and Ronald E. Cohen. *Down to the Wire—UPI's Fight for Survival*. New York: McGraw-Hill, 1990.

Greenough, Sarah, et al. *On the Art of Fixing a Shadow: 150 Years of Photography*. Washington, D.C.: National Gallery of Art, and Chicago: Art Institute of Chicago, 1989

Hamilton, Charles, and Lloyd Ostendorf. *Lincoln in Photographs: An Album of Every Known Pose*. Norman, Okla.: University of Oklahoma Press, 1963.

Jamieson, Kathleen Hall. *Packaging the Presidency: A History and Criticism of Presidential Campaign Advertising*. New York: Oxford University Press, 1984.

Jones, Bernard E., ed. *Encyclopedia of Photography*. New York: Arno Press, 1974.

Kane, Joseph Nathan. *Famous First Facts: A Record of First Happenings, Discoveries, and Inventions in American History*. 4th ed. New York: H. W. Wilson, 1981.

Lacayo, Richard, and George Russell. *Eyewitness: 150 Years of Photojournalism*. New York: Time, Oxmoor House, 1990.

Lothrop, Eaton S., Jr. *A Century of Cameras from the Collection of the International Museum of Photography at George Eastman House*. Dobbs Ferry, N.Y.: Morgan & Morgan, 1973.

Maltese, John Anthony. *Spin Control: The White House Office of Communications and the Management of Presidential News*. Chapel Hill, N.C.: University of North Carolina Press, 1992.

Martin, Rupert, ed. *Floods of Light: Flash Photography 1851–1981*. London: Photographers' Gallery, 1982.

Mayer, Robert A. "Photographing the American Presidency." *Image 27*, no. 3: 1–36.

McCandless, Barbara. "The Portrait Studio and the Celebrity." In Martha A. Sandweiss, ed., *Photography in Nineteenth-Century America*. Fort Worth, Tex.: Amon Carter Museum, 1991.

Mitchell, William. *The Reconfigured Eye: Visual Truth in the Post-Photographic Era*. Cambridge, Mass.: The MIT Press, 1992.

Morgan, Douglas O., ed., et al. *Leica Manual: The Complete Book of 35mm Photography*. 15th ed. Hastings-on-Hudson, N.Y.: Morgan & Morgan, 1973.

Newhall, Beaumont. *The History of Photography*. Rev. ed. New York: The Museum of Modern Art, 1982.

"150 Years of Photography: Pictures That Made a Difference." *Life* 11, no. 10 (Fall 1988).

Patton, Phil. "Disk-Drive Democrats." *The New York Times* (November 28, 1993): sect. 5.

Press, Charles, and Kenneth VerBurg. *American Politicians and Journalists*. Glenview, Ill.: Scott, Foresman, 1988.

Rosenblum, Naomi. *A World History of Photography*. New York: Abbeville Press, 1984.

Salomon, Erich. *Erich Salomon*. Millerton, N.Y.: Aperture, 1978.

Sipley, Louis Walton. *A Half Century of Color*. New York: Macmillan, 1951.

Szarkowski, John. *Photography Until Now*. New York: The Museum of Modern Art, 1989.

Time-Life Books. *Color*. Rev. ed. Alexandria, Va.: Time-Life Books, 1981.

Time-Life Books. *Photojournalism*. Rev. ed. Alexandria, Va.: Time-Life Books, 1983.

Welling, William. *Photography in America: The Formative Years, 1839–1900*. Albuquerque: University of New Mexico Press, 1987.

Acknowledgments

As noted earlier, this exhibition and its accompanying publication are supported in part by a generous grant from Agnes Gund and Daniel Shapiro. I am especially grateful to them, to the numerous lenders to the exhibition—both public and private—and to the photographers whose work is included herein. Several lenders opened their archives and lent original photographs for the first time. Among those who facilitated my unusual loan requests were Philip Gefter, Picture Desk Staff Editor, and Nancy Lee, Picture Editor, *The New York Times*. Beth Zarcone, Director, Time Inc. Picture Collection, and Mary Ann Korneley, Director, *Life* Picture Sales, made it possible for me to exhibit and reproduce works from the collection of Time Inc. Jane Waisman, Photo Researcher, Bettmann Archive, demonstrated great patience in the face of myriad requests. Kevin Kushel, Director, Associated Press Picture Library, Vince Alabiso, Executive Picture Editor, and Patricia Lantis, Director, AP/Wide World Photos, were uncommonly generous in providing time and energy toward the project. I extend my warmest thanks and deep appreciation to George P. Rinhart and Frank DeMauro for their hospitality, knowledge of American history, and great generosity in allowing me to review the works in their massive collection and in providing loans to the exhibition.

I would like to thank the following individuals who shared with me their knowledge of the collections for which they are responsible, and for facilitating loans from their collections. I have been able to depend on their generosity in many ways: Sally Pierce, Curator of Prints and Photographs, and Catharina Slautterback, Assistant Curator, The Boston Athenaeum; Ray Collins, Brown Brothers, Sterling, Pa.; Pamela Powell, Photo Archivist, and Margaret Bleecker Blades, Museum Curator, Chester County Historical Society, West Chester, Pa.; Larry Viskochil, Curator, Prints and Photographs, Chicago Historical Society; Corrine P. Hudgins, Curator of Photographic Collections, The Museum of the Confederacy, Richmond, Va.; Marianne Fulton, Chief Curator, Joe Struble, Assistant Archivist, and Janice Madhu, Assistant Archivist, George Eastman House, Rochester, N. Y.; Weston Naef, Curator, Gordon Baldwin, Associate Curator, and Jean Dooley, Curatorial Assistant, The J. Paul Getty Museum, Santa Monica, Ca.; Howard Gilman, Chairman, and Pierre Apraxine, Curator, Gilman Paper Company, New York; John A. Lawrence, Curator of Photographs/Director of Museum Programs, The Historic New Orleans Collection; Miles Barth, Curator, Archives & Collections, International Center of Photography, New York; Richard K. Lieberman, Director of Archives, David Osborne, Assistant Project Director, and Susan Deninger, Research Assistant, LaGuardia Community College, New York; Bernard O'Reilly, Curator of Popular and Applied Art, Verna Curtis, Curator, Tambra Johnson, Exhibitions Registrar, Jacqueline Manapsal, Preparations, and Christine McKimmie, Photographic Duplication Service, The Library of Congress, Washington, D.C.; Richard Rinaldi, Picture Researcher, Magnum Photos, Inc.; Maria Morris Hambourg, Curator of Photography, and Jeff Rosenheim, Research Assistant, Photography, The Metropolitan Museum of Art, New York; Leslie Nolan, Curator, and Robert MacDonald, Director, Museum of the City of New York; the staff of the Still Pictures Branch of the National Archives; Elva Crawford, Archivist, and Mrs. Donald Shattuck Blair, President General, National Society Daughters of the American Revolution, Washington, D.C.; David Haberstich, Photographic Archivist, National Museum of American History, Washington, D.C.; Mary Panzer, Curator of Photographs, and Ann Shumard, Assistant Curator of Photographs, The National Portrait Gallery, Washington, D.C.; Albina DeMeio, Registrar, Jack Rutland, Exhibitions Registrar, Dale Neighbors, Assistant Curator of Photography, Print Room, and Jim Francis, Coordinator of Rights and Reproductions, The New-York Historical Society; Julia Van Haaften, Curator of the Photography Collection, The New York Public Library; Howard Dodson, Director, Mary Yearwood, Curator, and James Huffman, Photographs and Prints Division, Schomburg Center for Research in Black Culture, The New York Public Library; Marie Helene Gold, Curator of Photographic Collections, The Arthur and Elizabeth Schlesinger Library on the History of Women in America, Radcliffe College, Cambridge, Mass.; Lorna Conden, Curator of Library and Archives, and Richard Nylander, Chief Curator, Society for the Preservation of New England Antiquities, Boston; and John Pultz, Curator of Photography, and Margaret Killeen, Curatorial Intern, Department of Photography, Spencer Museum of Art, The University of Kansas, Lawrence, Kan.

At The Museum of Modern Art I owe a special debt of gratitude to the following members of the staff. Beverly Joel, a student in the Bachelor of Fine Arts program at The Cooper Union for the Advancement of Science and Art, New York, has assisted me ably and cheerfully on all aspects of the book and exhibition, from the initial review of collections to the selection of work and the details of the installation. She also created the research for the basis of the Chronology, which was completed with the assistance of Jane Marsching. In the Department of Photography, I would like to thank Virginia Dodier, Study Center Supervisor, whose careful attention to the titles and captions for the works and whose assistance on loans for the exhibition were exceptional during a time of pressure. I am also grateful to Amy Romesburg, Secretary, and Yuri Tsuzuki, who assisted with aspects of the book. Peter Galassi, Chief Curator, Department of Photography, read an early version of the text and made suggestions that were essential to my understanding of the subject. He also relieved me of many of my routine responsibilities in the department so that I could have the time and freedom to concentrate on this project.

For their work on the exhibition I am especially grateful to Karen Meyerhoff, Assistant Director, and Robert Stalbow, Frame Shop Supervisor, Department of Exhibition Production and Design. The completion of this volume depended greatly on the expertise of the following members of the Museum's Department of Publications. For initial planning and supervision of the project I wish to thank Osa Brown, Director of the department, and Harriet Schoenholz Bee, its Managing Editor. I especially thank Christopher Lyon, Editor, who skillfully edited the texts under unusually stringent time constraints; he was ably assisted by Jessica Eber and Christine Liotta, Assistant Editor. Amanda W. Freymann, Production Manager, expertly supervised the reproduction of the photographs and the printing of the book. The halftone negatives were prepared with exceptional skill by Robert Hennessey. Jody Hanson, Assistant Director, Department of Graphics, designed the publication so that the broad selection of photographs from so many disparate sources has an elegance and coherence that would not have been possible without her imagination.

And finally, I am grateful to the following individuals for their assistance: Jeffrey Fraenkel, President, and Frish Brandt, Director, Fraenkel Gallery, San Francisco; Howard Greenberg, President, and Steven Kasher, Associate, Howard Greenberg Gallery, New York; Peter MacGill, President, and Margaret Kelly, Director, Pace/MacGill Gallery, New York; Howard Read, Director, Robert Miller Gallery, New York; Jo C. Tartt, Jr., The Tartt Gallery, Washington, D.C.; Doon Arbus; Tom Bamberger; Keith de Lellis; Mary Drugan; Bob Felner; Nisa Geller, Photography Editor, *Scientific American*; Jane Halsman Bello and Yvonne Halsman; Jack Harris, Visual Logic, Hockessin, Del.; William Hunt; Professor Julian Kantor, Political Commercial Archive, University of Oklahoma, Norman, Okla.; Carole Kismaric; Mr. and Mrs. Ronald S. Lauder; Dimitri Levas; Meryl Levin; Harry Lunn; Donna Mussenden–Van Der Zee; Edward Robinson; Norma Stevens and Andrew S. Thomas, Richard Avedon Studio, New York; Harvey Tulcensky; and Sandra Weiner.

Susan Kismaric